DRAWING AND PAINTING
BIRDS
MARINE CREATURES AND INSECTS

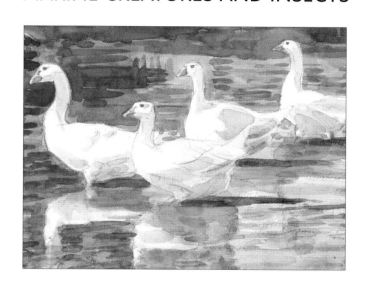

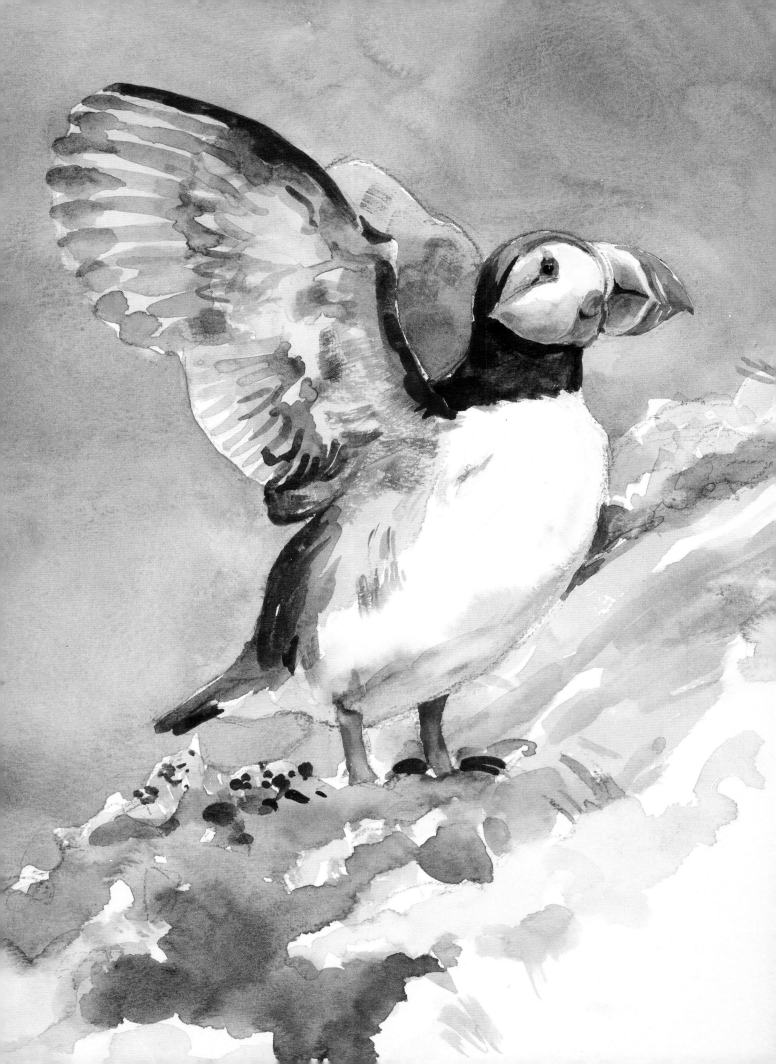

DRAWING AND PAINTING
BIRDS
MARINE CREATURES AND INSECTS

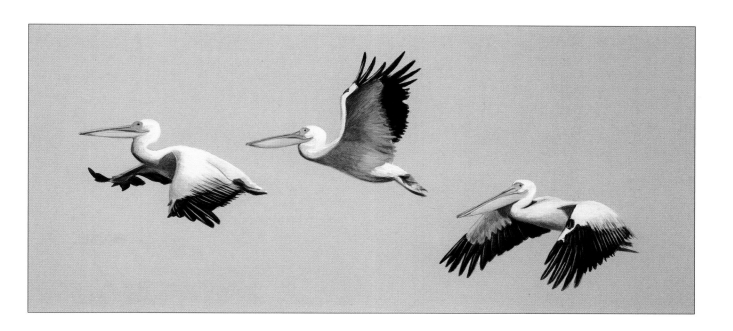

How to create beautiful artworks of birds, fish, beetles and butterflies, with expert tutorials and 15 projects shown in more than 480 photographs and illustrations

JONATHAN TRUSS AND SARAH HOGGETT

southwater

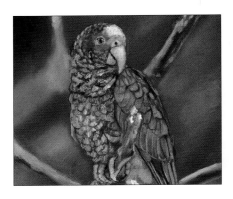
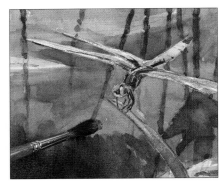
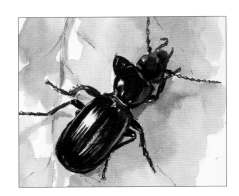

This edition is published by Southwater
an imprint of Anness Publishing Ltd
Blaby Road
Wigston
Leicestershire LE18 4SE
info@anness.com

www.southwaterbooks.com
www.annesspublishing.com

If you like the images in this book and would
like to investigate using them for publishing,
promotions or advertising, please visit our website
www.practicalpictures.com for more information.

© Anness Publishing Ltd 2012

A CIP catalogue record for this book
is available from the British Library.

Publisher: Joanna Lorenz
Senior Editor: Felicity Forster
Photographers: Martin Norris and Jessica Madge
Designer: Ian Sandom
Cover Design: Nigel Partridge
Production Controller: Mai-Ling Collyer

Previously published as part of a larger volume,
A Masterclass in Drawing & Painting Animals

Special thanks to the following artists for producing the sketches
and step-by-step demonstrations used in this book:
Lucie Cookson: 54–9; 98–103.
Martin Decent: 27 (bottom right).
Paul Dyson: 26 (bottom); 42–7.
Timothy Easton: 29 (bottom).
Abigail Edgar: 23; 66–9.
Trudy Friend: 16 (top); 18 (bottom); 21 (both).
Robert Greenhalf: 60–5; 88–93.
Suzy Herbert: 38–41.
Wendy Jelbert: 32–7; 70–3; 74–7; 78–83.
Beverley Johnston: 104–9.
Jonathan Latimer: 10 (top); 30 (bottom right); 48–53; 94–7.
John Raynes: 84–7.
Ian Sidaway: 17.
Jonathan Truss: 6 (top); 7 (top left and top right); 13; 15; 16 (bottom);
20 (top); 27 (bottom left).

Thanks also to the following for permission to reproduce photographs:
Pat Ellacott (www.patellacott.co.uk): 31 (top).
Tracy Hall (www.watercolour-artist.co.uk): 30 (top and bottom left).
Jonathan Hibberd: 12 (bottom); 38 (left); 70 (top).
iStockphoto: 8–9; 54; 60 (left); 66 (left); 74 (left); 78; 88 (both).
Jonathan Latimer (www.jonathanlatimer.com): 26 (top); 31 (bottom).
David Miller (www.davidmillerart.co.uk): 7 (bottom); 28 (both); 29 (top).
Martin Ridley (www.martinridley.com): 27 (top).
Jonathan Truss (www.jonathantruss.com): 15 (top left).

PUBLISHER'S NOTE

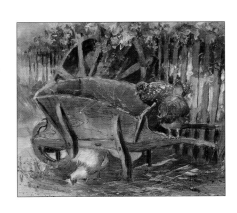

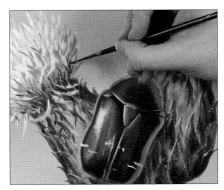

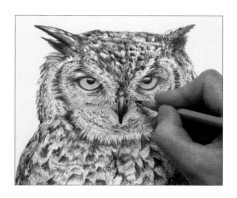
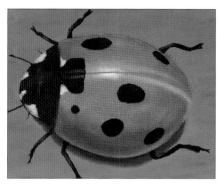
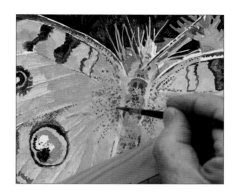

Contents

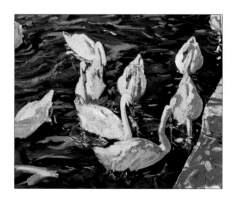

Introduction

Wildlife paintings are among the oldest surviving forms of pictorial representation on earth – there are numerous examples of rudimentary cave drawings created thousands of years ago that depict birds and other creatures. Wildlife was, however, largely ignored by Western artists as potential subject matter for many centuries. There are notable exceptions, of course. The works of the German artist Albrecht Dürer (1471–1528), for example, include wonderfully detailed watercolours of birds that remain unsurpassed to this day. There is also a long history of painting flora and fauna in the interests of scientific research. Illustrators accompanied many of the great explorers on their voyages in order to make visual records of the new flora and fauna they discovered. And there are many wonderful illustrations by naturalists such as the American John James Audubon, whose *Birds of America* was published in the 1840s.

Wildlife in the history of art

Historically speaking, birds have featured in paintings more often for their symbolic meaning (particularly in the religious art of the Middle Ages and Renaissance) than for any other reason. Even paintings in which they are the main subject, such as the works of Sir Edwin Landseer (1803–73), often tend to portray animals in an idealized,

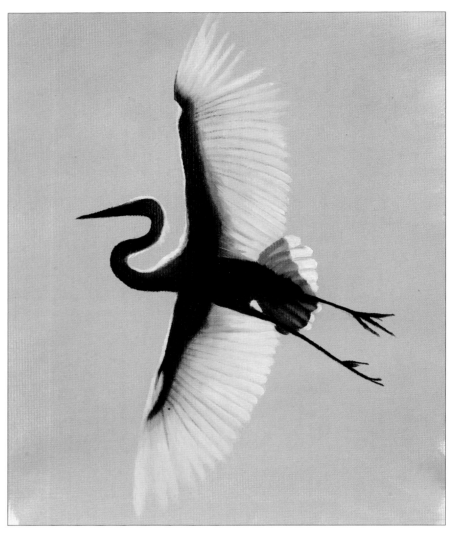

romanticized landscape that says more about the individual artist's view of the world than about the creatures themselves.

It is only relatively recently – perhaps in the last 100–150 years or so – that wildlife art has become widely accepted as a subject in its own right. The German painter Friedrich Wilhelm Kühnert (1865–1926) was perhaps one of the first European artists to specialize in painting wildlife, and travelled widely in east Africa in order

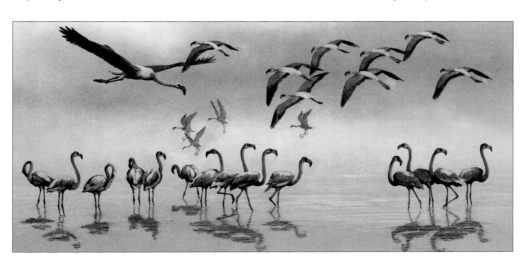

▲ Strong shapes
Even though little detail is discernible in this oil sketch, the streamlined shape of this flying egret creates a strong graphic image. Light filtering through the wings adds to the sense of atmosphere.

Tonal awareness ◄
The pale colours in the background of this painting of flamingoes gives the impression of sky and water.

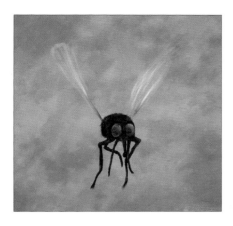

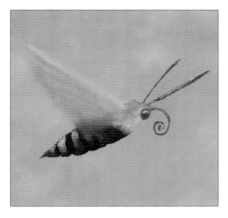

A sense of movement ◄
In these paintings of a fly and a moth, the insects' fast-moving wings have been 'frozen' in motion, painted with quick, deft brushstrokes. The blurred effect gives a sense of movement. The soft, slightly mottled backgrounds allow us to focus on the insects, in the same way that an out-of-focus background in a photograph does. Insect eyes are difficult to study in any detail without magnification, so the artist used macro photographs as references.

to paint animals in their natural habitat. Maybe this growing interest in wildlife is a result of people seeing more of the wonders of the natural world – through their own travels or through natural history documentaries; at the same time, they have also become more aware of the importance of biodiversity and conservation. Either way, more and more people are entranced by the beauty of the natural world and the creatures that we share it with.

Anyone who has painted a scene full of birds, fish or insects knows about the detail involved in producing 'wildlife art'. The wildlife artist has to think about exactly the same things as any other artist – composition, light, tones, colour, shadows, and so on. But he or she also has to contend with topics that are peculiar to wildlife subjects, such as how to paint feathers, beaks or scales, and how to make sure that the creatures are appropriate to the scene in which they're placed – and so the whole subject area provides many challenges that are quite unique to wildlife art.

How this book is organized

This book is designed to provide a thorough introduction to drawing and painting birds, marine life and insects. The book begins with a tutorials section that sets out some of the technicalities, from capturing the texture of eyes, beaks, claws, feathers, scales and hard shells to creating your own wildlife compositions and the pros and cons of working from photographs. Here you will find short practice exercises that

you can use as a starting point alongside sketches and studies by professional artists. If you're a complete beginner, it's a good idea to work through this chapter page by page to give yourself a thorough grounding. If you've already done some wildlife painting, turn to it for a refresher course whenever you need extra guidance on specific topics.

The next part of the book begins with a gallery of works by professional artists that you can use as a source of inspiration, followed by a series of step-by-step demonstrations covering a range of subjects in different media, from farmyard chickens and flying pelicans to pond dragonfiles and tropical fish. All the demonstrations are by professional artists with many years' experience.

Even if the subject does not appeal to you, or the artist works in a medium with which you are not familiar, take the time to study them. You'll glean all kinds of useful tips and insights that you can include in your own work.

You will also quickly realize that you do not have to fly to an exotic location to find interesting birds, marine life and insects; even in your own garden or local park there will be an abundance of creatures to draw and paint, from tiny bugs and butterflies to common birds that many artists might overlook in favour of more unusual and eye-catching species.

The book concludes with an overview of the tools and materials available, from pencils and pastels to paints and brushes.

Capturing the beauty of the natural world is an engrossing challenge, and this book will help you to produce studies and artworks of all kinds of fascinating birds, marine and insect life.

Light and shade ▼
The sunlight filtering through from above gives this image a wonderful sense of light and shade and picks up the vibrant orange colour of the fins, while the ripples in the water create a lovely feeling of underwater motion.

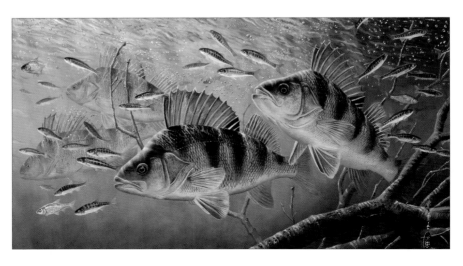

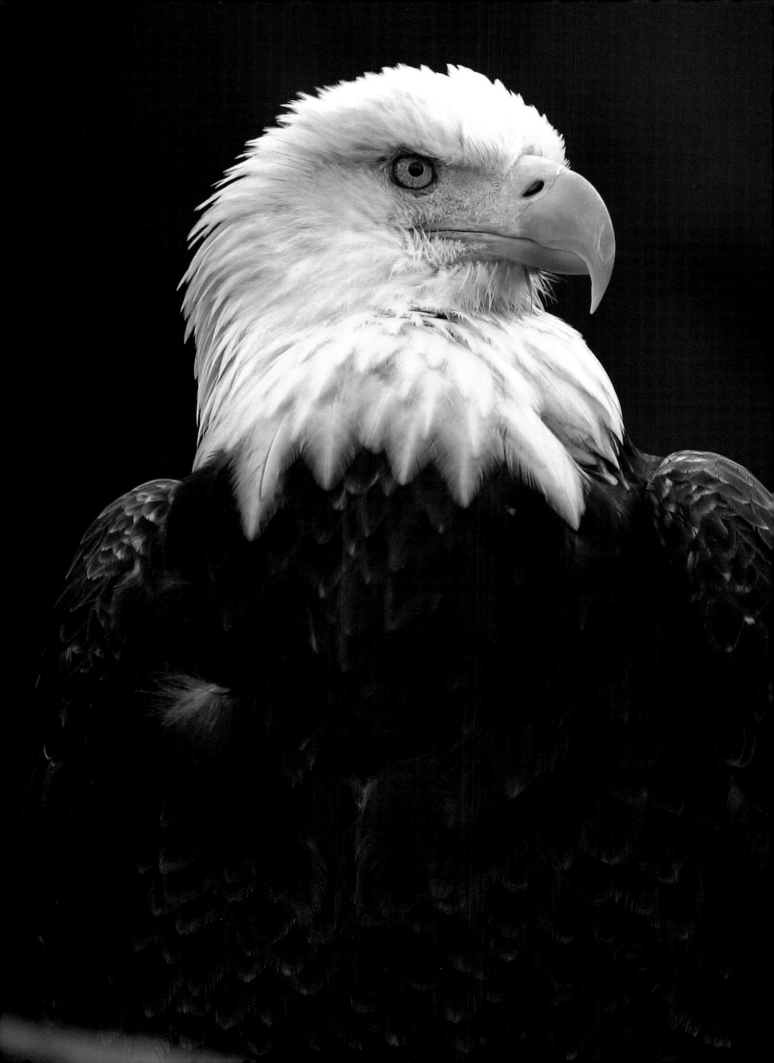

Tutorials

The natural world provides an infinite supply of subjects to draw and paint and it's impossible to cover every species in detail – in reality, you do not need a detailed knowledge of wildlife anatomy in order to be a good artist. The purpose of this chapter is to encourage careful observation and to provide some practical guidance that will help you tackle unfamiliar wildlife subjects. From getting the basic shape right to capturing anatomical details, textures and markings, this section provides a solid yet easy-to-follow grounding in the technicalities of wildlife art. There are also a number of short exercises that give you a chance to put your new-found skills into practice. Whether you're a complete beginner or a more experienced artist looking for a refresher course on particular aspects of drawing and painting birds, marine life and insects, these tutorials are an invaluable resource that you can turn to time and time again.

Birds

From eagles with a wingspan of several feet to tiny hummingbirds, the diversity of birds is enormous. Very often, however, you can tell a lot about a bird simply by looking at it. The shape of the body and beak, the size of the wings, the length of the legs, the way the claws are arranged: all these things give you clues as to how the bird lives and what it eats. Conversely, if you already know a little about the bird you're drawing or painting – whether it's an insect eater or a seed eater, for example, or a waterbird or a bird of prey – you will know what characteristics make it special and be able to emphasise these features when you are sketching.

Field guides, used by all keen birdwatchers, are an invaluable source of reference, particularly when you're drawing a species for the first time. However, there's no substitute for going out and making your own sketches.

Start by observing a bird near where you live – a robin or a blackbird in your garden, for instance. Ask yourself a few key questions: How big is the bird? Is it a similar size to a bird that you are familiar with? What shape is the bill? Is the body rounded, like a robin, or tall and slender, like a heron? How long are the legs in relation to the rest of body?

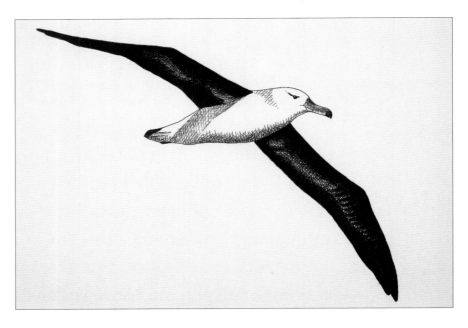

Massive wingspan and streamlined body ▲
Black-browed albatrosses are one of the most marine of all birds, traversing the oceans of the southern hemisphere and only returning to land to breed. Their long, slim wings and streamlined body make it possible for them to spend long periods in the air. When sketching a bird such as this, try to capture it with its wings fully outstretched, so that you convey not only the size of the wings but also the way it appears to glide almost effortlessly through the air.

Instead of taking reference photos, use your eyelids as a 'shutter'. As you see the bird flying, close your eyes and lock the image in your mind; then try and put the image you saw on paper in a very quick 10-second sketch. You're not attempting to draw a masterpiece, but simply trying to record what you saw. You will learn more than you expect and when you come to put a composition together, you will find that you instinctively know what looks right.

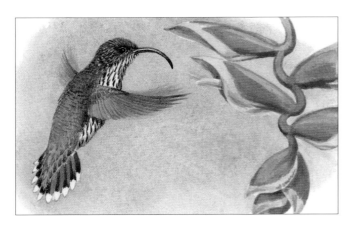

Small body and specialized bill ▲
Hummingbirds have tiny bodies, and their rapid wing beats enable them to hover in mid-air. Their bill is specially adapted to penetrate into the throats of flowers to extract the nectar; this one has a curved bill for feeding on curved flowers.

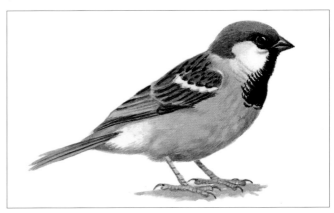

Short wings and rounded body ▲
The house sparrow's wing span is relatively small and its body rounded; as it tends to fly only relatively short distances and hops from branch to branch, it does not require a particularly streamlined shape. Note also the short, thick beak.

Although birds vary enormously, it's worth knowing a little bit about their general anatomy, as this will help you interpret what you are looking at. The bodies of most birds have evolved largely for one purpose: flight. The skeleton is very lightweight, but strong, and birds that fly have many hollow bones, thus reducing the weight.

Most birds have around 175 muscles, the largest of which are the pectorals, or breast muscles, which are used in flight; these muscles are attached to the sternum, or breastbone, and naturally affect its shape. In flying birds, the width and height of the sternum are nearly equal. Birds that swim tend to have a wide sternum, whereas flightless birds, which do not have highly developed pectoral muscles, generally lack a pronounced keel on the sternum.

Just as mammals' teeth and jaws vary depending on what they eat, so too does the shape of birds' beaks. Birds that need to crack open seeds, such as canaries and finches, tend to have long, thick beaks, while insect eaters such as bee eaters tend to have short, thin beaks. Hummingbirds' bills are adapted to penetrate deeply into the throats of flowers to extract nectar. Birds of prey have sharp, hooked beaks for tearing apart chunks of meat. A pelican's pouch is used to scoop up fish; when the fish is caught, the pouch contracts to squeeze out water. Getting the shape and size of the bill right are crucial in establishing the bird's character.

Most birds have four digits on their feet, with the first one being at the back of the foot and the other three pointing forwards. However, this is something of a generalization and there are many differences between species. In waterbirds, the three front digits are connected by a web and the back 'thumb' is barely visible, while in birds of prey such as eagles, the 'thumb' is used to grip prey and is very powerful.

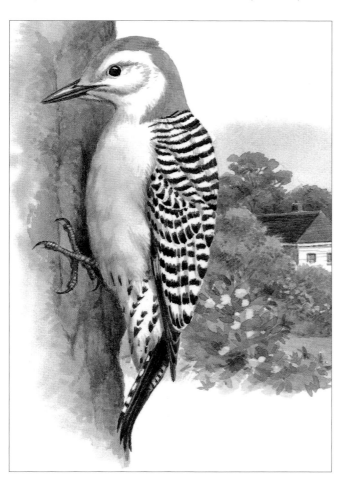

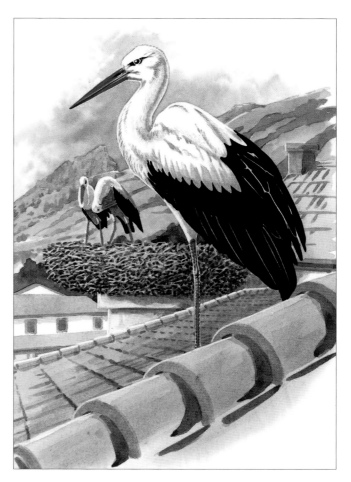

Short-billed insect eater ▲
Woodpeckers live in woodlands and parks, and sometimes visit urban gardens. They depend on old trees for their food (mostly insects and grubs) and nesting sites. Note the beak shape, which is relatively short and thin. Woodpeckers hop rather than climb along tree branches, leaping forward with one foot just in front of the other, using the 'thumb' at the back of the foot to maintain their balance.

Long legs for wading ▲
The white stork breeds in the warmer parts of Europe, north-west Africa and south-west Asia; like all wading birds, its legs are long in relation to its body size. For long-distance flight during its winter migrations, it relies on movement between thermals of hot air – hence the wide wingspan of 155–200cm (60–80 inches). It feeds on fish, frogs and insects, but also eats small reptiles, rodents and smaller birds.

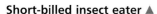

Eyes

The success or failure of your painting can depend entirely on how you paint the gaze of your subject, as the eyes are probably the first thing that the viewer will notice.

One of the most common mistakes is to make the eyes too small or too close together; conversely, making the eyes too big will give your painting a cartoon-like effect. However, the position of the eyes varies from species to species: in birds of prey such as owls, for example, the eyes are set on the front of the head, while in many other birds they are set on the side of the head. Whatever the position, each eye has to be in the correct position relative to the other and positioned symmetrically in relation to the beak. Measure the size of the eyes and compare the distance between them. If you take the size of the eye as being one unit, then the distance between them may be as much as four units. You can then follow the same procedure to get the beak in the correct place.

Putting the pupils in the right place is also an important factor; the painting may look awkward if they do not face in the same direction. Always lightly map out the position, size and shape of the eyes and make sure they are correct before you begin to apply colour.

It's also important to make eyes look rounded. To do this, use light and dark tones to imply the curvature of the eyeball; needless to say, this requires very careful observation.

Reflections are important, too, as light is reflected in the glassy surface of the eyes and this is what makes them look shiny. Take particular care with reflections, however. If you are working from a photograph, then the reflection that you see could be that of the photographer or even, in the case of a zoo creature, the bars of the cage. Try to work out what is being reflected: if you know what you're painting, you'll find it easier to get it right. Remember, everything above the horizon will appear lighter in the reflection.

Similarly with highlights: you need to ask yourself if a highlight really is coming from the light source (the sun). It may just be a reflection of the flash from the camera, and if this is the case, then putting it in will look unnatural.

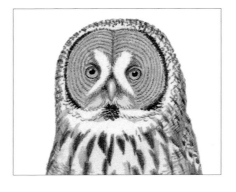

Eyes facing the front ▲
Owls' eyes are positioned on the front of their head. The pupils should be both rounded and symmetrical.

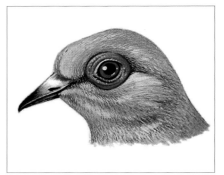

Eyes on the side ▲
Many birds' eyes are on the side of their head. The white dot in the eye of this dove conveys the light reflection.

Practice exercise: **Eagle eye in oils**

Making a small, quick sketch of individual features such an eye is a great way of sharpening your powers of observation. This sketch was done in oil paints; one benefit of opaque mediums such as oils and acrylics is that if you make a mistake – say, for example, in the shape or tone of a highlight area – it is easy to paint over it. If you were attempting the same exercise in watercolours, you would have to work from light to dark and leave the white of the paper for the brightest highlight.

Materials
- *Canvas paper*
- *3B pencil*
- *Oil paints: lamp black, burnt umber, cadmium red, titanium white*
- *Brushes: selection of filberts*

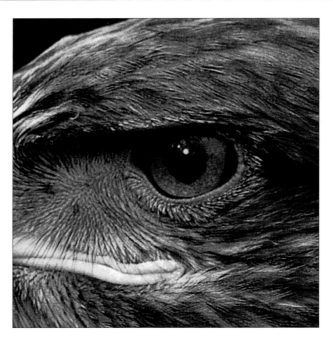

The subject
This is a close-up detail taken from a much larger photograph, but it provides the perfect opportunity to practise painting the detail of an eye; the bird's penetrating gaze also makes a dramatic subject in its own right.

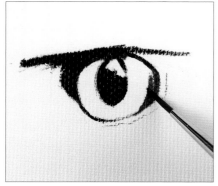

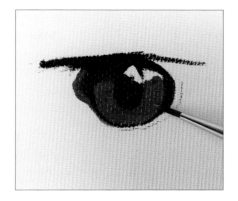

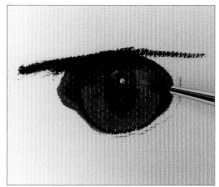

1 Using a 3B pencil, lightly sketch the outline of the eye and mark out any distinct areas, such as the eyelid and the small ring of tiny feathers just under the eye. Using a small filbert brush and lamp black oil paint, paint in the darkest parts of the eye – the pupil, the very dark area under the eyelid and the inside rim – leaving the highlight untouched. Blend in a little burnt umber for the browner tones.

2 Paint the iris in a mix of burnt umber and cadmium red, blending the colour wet into wet into the lamp black just under the eyelid; this area is darker than the rest of the iris, because of the shadow cast by the eyelid. Leave that part of the iris in which you can see a reflection untouched.

3 Now look carefully at where the eye picks up reflections, remembering that any reflection in the eye that is above the horizon line will be lighter than one below it: add more white to lighten the colour. Paint the reflection using a mix of cadmium red, lamp black and titanium white.

The finished painting
Complete the sketch by painting the rim of the eye in a mix of burnt umber and white and by adding feather detail around the eye. This is a lifelike painting in which the colours have been carefully blended wet into wet to create a textured surface. By carefully observing the way the tones change across the surface of the eye, the artist has managed to make the eye look shiny and convincingly realistic and three-dimensional.

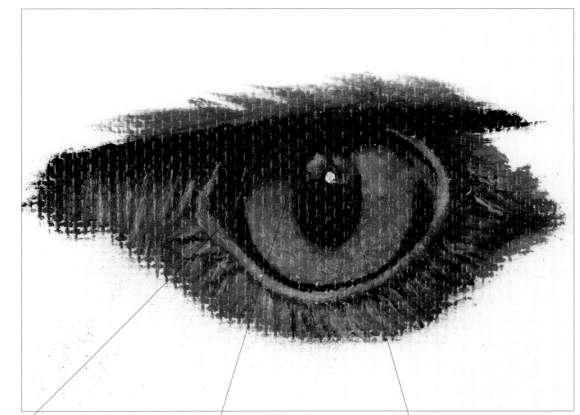

Note how the eyelid casts a shadow on the surface of the upper part of the eye.

It is rare for the entire surface of the eye to be visible: here, part of the upper rim is obscured by the line of the eyelid.

Note that anything reflected in the eye above the horizon line is paler than a reflection below it.

Beaks and claws

The hard surfaces of beaks and claws contrast with the softness of feathers, and if your bird drawings are to look lifelike, it's important that you master these textures.

Within the bird kingdom there are many differences in shape, of course. Birds of prey have sharp talons to grip their prey, and beaks that are turned down at the end to rip and tear off meat, whereas insect eaters have long, small beaks designed for catching their prey on the wing, but small claws that are only needed to grip the branches on which the bird perches. You can almost guess what a bird eats by the shape of its beak. Despite the marked differences, the techniques of drawing and painting these hard surfaces are actually the same.

The hard edge of beaks and claws reflect light in a particular way, getting darker towards the edges, and thus giving the beak or claw its shape. You can get a crisp, sharp-edged highlight with subtle darkening of tones towards the edges; this is what helps to convey the impression that the surface is hard and unyielding. Look closely at the way these hard edges reflect light. Pay attention to the colour, too: a very dark shiny surface can reflect the colours from its surroundings.

In pencil and charcoal, you can create this effect by lifting off the pencil with a kneaded eraser to reveal the white paper underneath. You can, of course, avoid pencilling in the lighter areas in the first place by varying the pressure you apply to it. With watercolour, mask off the very brightest area first, so that when you lift away the masking fluid it reveals the white of the paper underneath. For oils, acrylics and pastels the white or the lightest colour is the last thing you add.

When painting or drawing beaks, claws or talons, don't be daunted at how many examples you have to try before you are successful. Get the elements all in the right place first and treat each one separately when you paint them, getting each one right. There may be subtle variations in tones, but you will use the same colours for them all. You may find that the last one you paint will be the best, as you'll have gained experience by the time you get to it.

Hard edges ▲
Beaks and claws should have crisp outlines and darker tones towards the edges, as shown on this woodpecker.

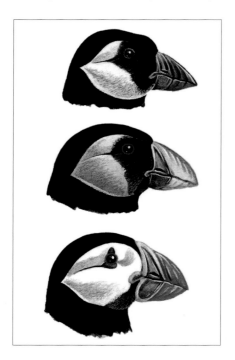

Different coloured bills ▲
These three paintings show the varied patterns of puffin bills. Once you get the shape right, experiment with colour.

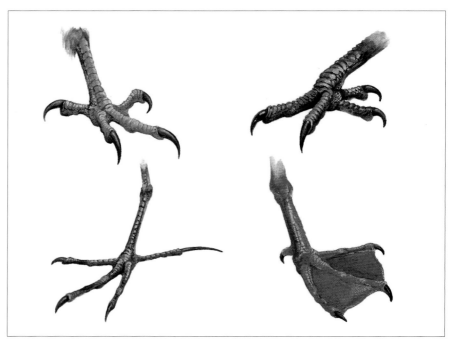

Claws, talons and webbed feet ▲
Feet shapes and structures are adapted for each bird's habitat and behaviour. Sharp talons are used for gripping tree branches and tearing prey apart, long claws help waders to forage among marshlands, and webbed feet allow aquatic birds to swim.

Practice exercise: **Bateleur eagle beak in soft pencil**

A soft pencil was chosen for this demonstration because of its versatility: you can create linear detail with the tip and block in broad areas of tone using the side of the lead, yet it is soft enough for you to be able to wipe out the highlights with a kneaded eraser. Soft pencils can also create a dense, black mark; hard pencils, on the other hand, tend to give a grey, rather than a black, mark.

Materials
• *Good-quality drawing paper*
• *3B or 4B pencil*
• *Kneaded eraser*

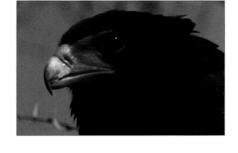

The subject
You need a hard, crisp outline to convey the texture of the beak. Note how the edge of the beak is darker at the point where the eagle turns away from the light.

1 Using a soft pencil, lightly map out the overall shapes. Begin blocking in the mid tones on the beak, leaving a gap for the highlight on the edge of the lower beak. Increase the pressure on the pencil and put in the dark feathers on the chest and the top of the head.

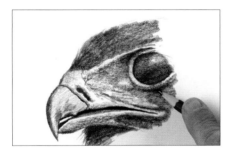

2 Continue blocking in the tones, using the side of the pencil and adjusting the amount of pressure you apply as necessary. Remember to leave spaces for the highlights. As the side of the pencil blunts, you will find that a sharp edge is formed which you can use for the darker tones, such as under the eye.

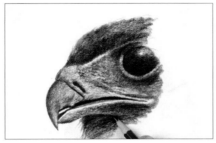

3 When you've put in all the mid tones, assess the tonal values of the drawing as a whole. You will probably find that the darkest areas (the pupil of the eye and the black feathers on the head and chest) need to be darkened still further in order for the brightest highlights to really stand out.

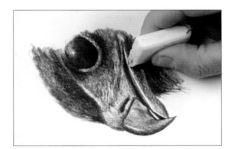

4 Finally, wipe out the highlights on the beak and in and around the eye, using a kneaded eraser. Take care not to overdo the highlights: they're lighter than the rest of the image, but it would be a mistake to make them really stark and bright.

The finished drawing
This simple sketch captures both the texture and the shape of the beak perfectly. Sharp, crisp lines are used for the hard edges of the beak, in contrast to the soft, diffuse edges of the feathers. Although we only see the beak in profile, it still looks three-dimensional: the areas of mid and dark tone next to the highlights indicate the changes of plane as the beak turns away from the light.

Note the mid tone along the edge, indicating the curvature of the beak as it turns away from the light and into shade.

The highlights have crisp, sharp edges, revealing the hard texture of the beak.

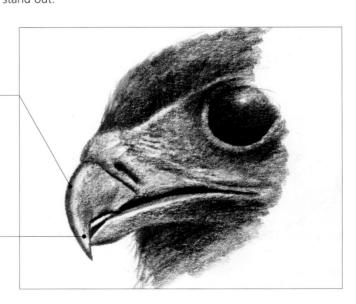

Feathers

With more than 10,000 different species of birds in the world, there is a huge variety of plumage. From the wonderful iridescent markings on a peacock's tail feathers to the feathers of the western screech owl, which are designed to provide camouflage, the plumage of birds is as varied in its coloration and patterning as the fur of mammals. There is the texture to consider, too: compare the large, strong flight feathers of a bird of prey such as an eagle with the soft down of a newly hatched chick. Whatever the species, however, the way you paint feathers depends largely on the amount of detail you portray.

If your composition is a wildlife landscape, then the birds may not be the most important element in the painting. A tropical rainforest scene full of different tones of greens can be brought to life with the splash of colours from a flock of yellow and blue macaws, even if they occupy only a small part of the picture space. But in this scenario, where the birds are just part of a wide composition, you will only need to paint or draw the overall shapes and colours.

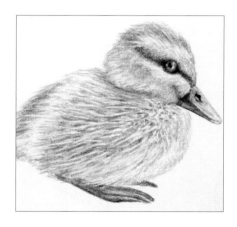

Chick in graphite pencil ▲
This sketch was made using a 3B pencil, which can create a broad range of tones from pale greys to dense blacks. Note how the paper has been left almost entirely white in parts, for the highlight in the eye and beak and the very palest feathers. For a sketch like this, which contains many fine lines, it's vital to keep the pencil tip sharp.

The nearer the bird is, the more detail you need to put in. You have to decide at what distance you start to notice detail and see the shapes of individual feathers. Go into your garden or park and look at the birds there. With some, you'll have to get very near or use binoculars to see the feathers in detail.

Remember that soft feathers of a single colour tend to lose all their detail, even close up; once again, don't put in what isn't there. Your brain tells you that there should be feathers, but your eyes tell you differently: paint what you can actually see.

There are two basic types of feather: vaned feathers, which cover the exterior of the body, and down feathers, which are underneath the vaned feathers. A vaned feather has a main shaft, fused to which are a series of branches, or barbs. These barbs have sub-branches of their own, called barbules, which contain a series of tiny hooks, invisible to the naked eye, that latch on to barbules from the next barb along the feather shaft and keep the feather together. There are about 300 million tiny barbules in one feather alone.

Texture depends in part on the function of the feathers. The outer ends of the flight feathers of an owl, for example, have no barbules and are thus very soft, so that its prey doesn't hear it coming as it swoops down to grab it. Compare this with the wing feathers of swans, where stealth is of no importance: you can hear their large wings coming from a long way off. The main function of down feathers, on the other hand, is to provide insulation: they are fluffy because they lack the barbules of vaned feathers, which allows the down to trap air and thus insulate the bird from the cold.

If you are painting a bird portrait, it's a good idea to practise painting an individual feather first in your preferred medium before committing to canvas or paper – so that you get the markings and colour right. This is important if you are working in watercolour, where there is no going back. After putting down a base coat, use a soft round brush with

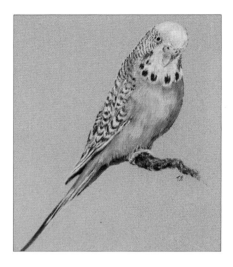

Budgerigar in soft pastels ▲
With soft pastels, you can blend colours to create delicate optical mixes – and that is what the artist has done here, overlaying mid green, light green, yellows and even a hint of orange for the bird's soft chest feathers. The harder wing feathers are scribbled in using short strokes, again overlaying colours to create the desired effect.

hardly any paint on it, lightly brushing across the top of the base coat to create the texture of the feather. Make sure you brush in the direction of the branches of the feather.

If one feather appears as a single colour, a group of the same-coloured feathers may not. The angle of the light hitting the feathers will change depending on the shape of the wing – and so the tone of the feathers will change, too. Pay attention to this, as it gives the wings their form.

Another important thing to note is that feathers are not completely solid. Note how the light filters through the wings of a bird in flight. An egret flying with the sun behind it will come to life, the feathers becoming almost transparent at the ends of the wings where they are less dense. To create this effect, blur the end of the wings with a very soft brush and a small amount of paint. Make sure that there are no hard edges and apply very little paint, so that you can see the background through the tips of the wings.

Practice exercise: **Feathers**

When you are drawing a bird, it is neither necessary nor advisable to put in every single feather – particularly if you are drawing a front view, as the chest feathers tend to be relatively small. Look instead for the blocks of feathers and think about their function: are they strong, primary feathers that are used for steering and to produce the power of flight as the wing is brought down through the air, or the softer, more pliable secondary feathers that lie above the primary feathers? Also think about the skeleton that lies underneath the feathers, as this will make it easier for you to get the shape of the body and head right.

Materials
• *Smooth drawing paper*
• *Fine liner pen*

The finished drawing
Using a liner pen can give a drawing a rather mechanical feel if you're not careful, and the trick is not to put in too much detail. Here, the artist has created the soft texture by drawing pen lines that follow the direction of the individual strands within the feathers.

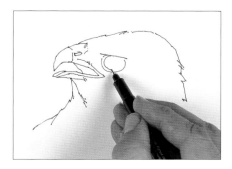

1 Using a fine liner pen, map out the main shape and features of the bird of prey's head. Use small, jagged strokes around the edge to convey the texture of the facial and neck feathers.

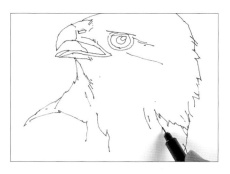

2 Draw in the position and shape of the main feather groups – the feathers at the base of the head and on the bird's chest.

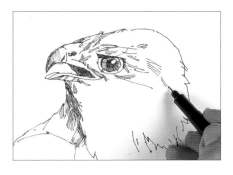

3 Elaborate the main feather groups, defining some of the feathers more clearly than others. Colour in the eye, remembering to leave the highlight untouched.

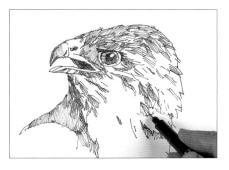

4 Build up the tones by increasing the density of the pen lines, carefully following the surface contours of the underlying body structure.

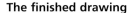

Make sure the beak looks hard and slightly shiny.

Even though some areas are left almost blank, the viewer's eye fills in the missing details.

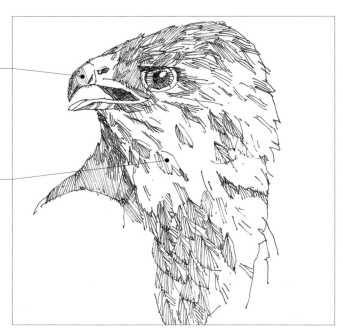

5 Finally draw the cluster of feathers that runs from the bird's neck over its chest. They help to give the subject a sense of solidity.

Fish

Most fish have a streamlined body, which allows them to swim rapidly. The fins are the most distinctive feature; they are made up of bony spines that protrude from the body, with skin covering them and joining them together in a webbed fashion, as in most bony fish.

The arrangement of the fins varies hugely from one species to another, but there are a few general points to note. The dorsal fins are located on the fish's back; there can be up to three of them. There are also two sets of paired fins on the side of the body – the pectoral and pelvic (or ventral) fins. Look carefully to see exactly where they are placed.

Look, too, at the shape of the tail fin. It may be rounded at the end, or end in a more or less straight edge, or it may curve slightly inwards or be shaped like a crescent moon. Remember that you will only see the fins in their entirety if you are viewing the fish from side on: if it is swimming towards or away from you, you may see very little of the fins. Some fins are translucent. To capture this feeling in your drawings and paintings, you need to be aware of the colours behind what you're painting: generally, the fins will be a little lighter.

The body shape varies considerably too. Does the fish have a rounded body or is it flat? If it's rounded, you need to convey this in your painting by looking at how the tone changes as the body is angled towards or away from the light. If it's relatively flat, then the tones are more likely to be uniform across the surface of the body.

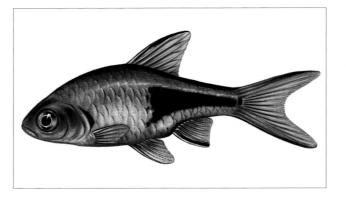

Fish vary in coloration and patterning, from pale greys and mottled browns to vibrant, almost psychedelic spots and stripes. It can be difficult to capture the brilliance of these colours in paint, so experiment with different mediums to see what you can achieve.

Most fish move by contracting paired sets of muscles alternately on either side of the backbone. These contractions form S-shaped curves that move down the body. As each curve reaches the back fin, backward force is created which, in conjunction with the fins, propels the fish forwards. If you are looking down on a swimming fish, you may well see these S-shaped curves, and capturing this shape in your drawing will convey a sense of movement.

However, the main challenge in drawing and painting fish is capturing the effect of light on the water. If your fish is near the surface, consider how the light streaming through the shallow water will dance across the top of the fish's body; leaving this out would be like omitting the shadow of an animal

on a sunlit day, and would leave the painting looking flat. If the water is shallow, put some refracting light across the ground as well, perhaps picking out parts of the surface. If the fish breaks the surface of the water, try to capture the splashes of water and water droplets: if you're using watercolour or acrylics, try spattering masking fluid on to the paper to reserve the white of the paper for the water droplets and let it dry completely before you apply the paint.

Body shape ◄
Look carefully at the shape of your subject's body, Most fish have a dorsal fin on the back, pectoral and pelvic fins on the side, and a tail fin, all of which can vary considerably in shape and position.

Mackerel ▼
For the pale tones on the underbelly, the artist lightly brushed clean water over the paper and then dropped in a pale blue-grey, allowing it to spread wet into wet so that no hard edges were created. On the upper back, the dark markings were applied when the base colour had dried slightly, so that the paint did not spread as much. The fins were painted using an almost dry brush with the hairs feathered out to create thin, individual lines.

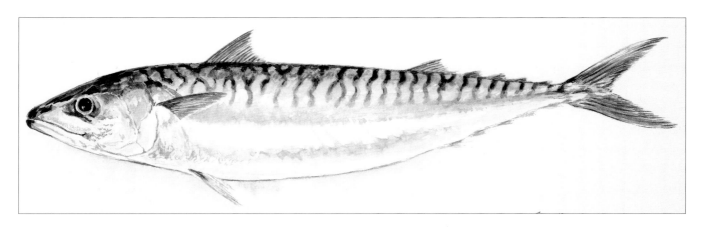

Scales

Fish bodies are covered in a series of tiny scales. It is worth knowing a little about scale patterns and their properties, as this may make it easier for you to draw and paint them.

Scale patterns vary from fish to fish. The size and shape can vary considerably. Remember to take note of how the scales appear to get smaller as they curve around the body. It can be difficult to get this right, so it is important that you take your time.

There may be hundreds of scales in different sizes on the body of a fish. All those scales act like mirrors, reflecting the colours around them, especially where direct sunlight hits the fish's body. Pay attention to these colours; they will be of a much lighter tone but they will all be there. You may think they are too subtle to matter, but it's these little details that will make the scales look correct.

Even if you're aiming for a photorealistic rendition, don't try to draw the detail of every single scale. Instead, try to give a general impression of the shapes and sizes. Try half-closing your eyes and squinting at your subject, so that some of the detail disappears.

Unless there are specific markings that need to be observed, it can be a good idea to put in all the base colours

across the entire fish body, and then draw or paint in the shape of the scales afterwards.

Applying pencil or pen-and-ink on top of paint to outline shapes works well. Other techniques that you might like to try include sgraffito (scratching into oil paint or oil pastels to create texture), and using an acrylic medium such as a glass-bead texture gel to create the scaly effect. Alternatively, find something that has the same general

Curving scales ▲
The scales on this pumpkinseed fish are darker and smaller at the top, giving its body a realistic, well-rounded shape. Getting this right takes some practice.

shape of the scales (perhaps a net bag of the type in which fruit are often sold), dip it into your chosen paint medium and press it on to your paper or canvas. This is a good subject on which to try out different techniques.

General impression ▲
You don't need to paint every scale individually. This angelfish has wide bands of colour that cause much of the detail of the scales to disappear.

Observing colours and patterns ▲
Once you can capture markings accurately, your species will be identifiable, as in this archerfish.

Insects

Insects are the largest and most diverse group of animals on Earth: scientists currently estimate that there are between four and six million different insect groups. The hard, shiny carapace of a beetle, an ant's antennae, the iridescent colours and patterns on a butterfly, the lace-like wings of a dragonfly: in insects, nature has created the most fantastic and beautiful details. With so much diversity, it can be hard to see any resemblance between species – but, in fact, despite the differences, the general anatomy of all insects is remarkably similar.

Insects' bodies are divided into three parts – the head, thorax and abdomen – with each part being further divided into segments. Typically, there are six segments in the head, three in the thorax and eleven in the abdomen. There are three pairs of walking legs on the thorax, one pair to each segment, and two or four wings. As many insects are so small, you may not be able to see all these details easily with the naked eye, but if you know a bit about the general anatomy, you will at least know what to look out for and where the different features are located.

Centipedes, millipedes and spiders are often thought of as insects, but they are, in fact, other types of

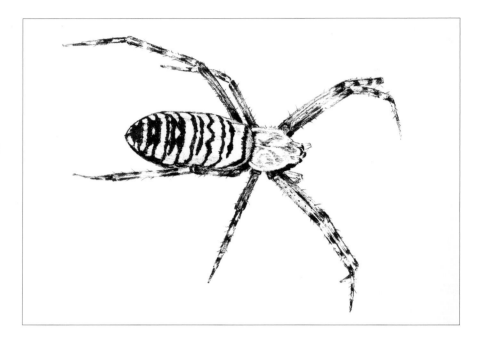

invertebrate. Despite this, although their anatomy is different to that of insects, the same general principles apply when it comes to drawing and painting them.

The first question you need to ask yourself is how much detail to include. If the insect is only a small part of a larger composition then you do not need to include very much; sometimes, just a flick of colour is enough to suggest that the insect is there.

Spider ▲
The spider in this drawing is viewed from directly overhead, its overlapping legs and bold body markings making a graphic shape against the pale background. Here, the artist has used a dip pen, which creates a slightly irregular, scratchy line. Note the tiny individual hairs on the spider's legs; a few small flicks of the pen are all that is needed to create them, but the effect is very lively.

The closer the insect is to you, the more detail you will see – so if it's to be the main subject of your painting, it's best to place it in the very foreground of the image. If it's taking up most of the picture space, you can put in all the fine detail, from the delicate antennae to the colours on the wings or carapace. In addition, you won't have to worry so much about keeping the background elements in scale with the insect.

Butterfly ◄
An intricately patterned butterfly, such as this painted lady, provides an inspirational subject for the wildlife artist. Careful observation is needed to capture the detail, and note that the iridescent wing colours will change depending on your viewing angle.

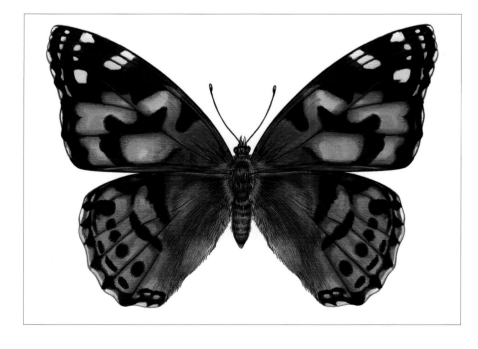

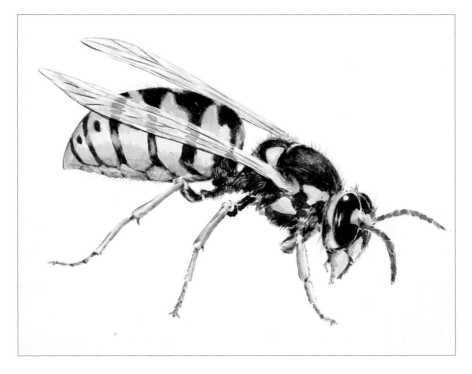

Wasp ◀

Here, the artist has created the soft, fur-like texture of the thorax by using a very fine brush and 'flicking' the paint outwards to create the impression of individual hairs. Contrast this with the harder covering of the abdomen, where there is a very delicate highlight. Note how well the artist has captured the wings by using lighter tones of the colours that can be seen through them.

Ladybird ▼

Here, the artist has put in a bright highlight along the centre of the body, between the two elytra (wing cases), and has painted the body a slightly darker tone of red around the edges, as the body curves away from the light. This, along with the shadow under the body, makes the insect appear three-dimensional.

A word of caution: if you're painting from a close-up or macro photograph as part of a larger composition, beware of putting in too much detail on the insect, even though it may be clearly visible in your reference material. It is difficult to see this much detail with the eye, so if you include it, it will look unrealistic.

One of the most fascinating things about painting insects is the wonderful range of iridescent colours that you see. At first glance, a butterfly's wings may seem to be just a single hue, but the colour will change depending on the angle from which the surface is viewed. Experiment to find which colours work best before you apply them to the canvas. You may find it difficult to match the brightest colours in paint, although some inks and liquid watercolours can come close. For very detailed oil or acrylic paintings where you want to convey the subtle shifts of hue, it's best to stipple the colour on with a brush. In watercolours, build up the layers gradually with very thin glazes. With coloured pencils or soft pastels, use short, fine strokes and allow the colours to intermingle on the paper to create different tones and hues.

When you're painting hard carapaces, remember to look for the highlights that will convey the surface texture.

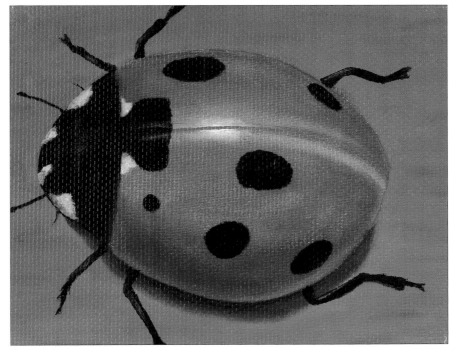

Fine lines such as antennae need particular care. Don't be tempted to draw or paint them as a single line. The way the light bounces off the antenna will break up the solid line, so leave tiny gaps where necessary. This will make it look as if the light has bounced off the bits you've left out and create the effect that it's reflecting its surroundings when in reality it's not there at all.

Finally remember that, despite its small scale, an insect needs to be made to look three-dimensional. Look for shadows under the body and legs, however slight they may be, that will help you create this illusion. It's easy to forget about this when painting an insect such as a butterfly at rest, with its wings outstretched, but it's an essential part of making your subject look real.

Hard shells

In crustaceans, turtles and some insects – such as stag beetles and ladybirds – the bodies are covered by a hard carapace, or shell. These carapaces are quite simple to draw and paint.

The most important thing is to observe how the light reflects off the shiny, hard surface; if you assess these tones properly, you can convey the curves and the changes of plane within the subject. A ladybird's carapace, for example, is smooth and rounded, but in order to convey the form you need to look for the different tones within it as the body curves gently away from the light. In cases like this, the tonal transition will be very gradual. A crab or lobster shell, on the other hand, is not uniformly smooth: there will be bumps and indentations in the shell and the transition from one tone to another will be far more pronounced.

With a graphite pencil, vary the amount of pressure you apply to create different tones. Start quite softly; once you're happy with the general shape, you can press a little harder. The darker the shell, of course, the harder you need to press. When using oil or acrylic paints, you can cover the whole shell with a mid tone colour and apply the lighter and darker tones once the initial paint has dried. Always test out your mixes on scrap paper before you apply a dark tone over your base coat, to see if they work.

The shells of turtles have interesting patterns. Whatever your chosen medium, it really helps to sketch out the patterns before you begin painting. Begin with very light pencil marks, as you'll probably have to adjust the pattern slightly before you get it right. There's no point in painting part of the pattern and then finding out you've misjudged how big or small it needs to be. Observe how the pieces interlock and how there seems to be a uniformity over the shell. This is the key to getting it right.

Once you've established the basic pattern, you can apply the colour. In oils, pastels or acrylics, try putting down some mid-toned base colours first. Once they have dried, you can apply the lighter and darker colours on top, following the direction of the pattern. In watercolour, allowing the base colours to bleed into each other wet into wet can create a lovely mottled effect.

Generally speaking, the surface of a turtle shell is rougher than an insect's shell, and therefore less shiny. The ridges on turtle shells are quite shallow, but need to be observed. To convey the roughness of the texture, look at the highlights along the edge of the ridges. Although the ridges are small, you'll see that there's a shaded and a lit side. Drybrush techniques (in watercolour or acrylics), sgraffito, pen-and-ink detailing on top of dry watercolour paint and oil pastel on top of watercolour are all techniques that you might like to consider trying.

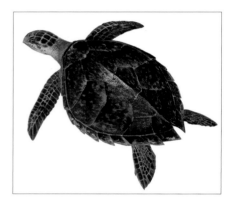

Turtle shell ▲
As well as the capturing the complex patterns of colour on a turtle's shell, note how light reflects off the surface. In this example, the shell has a ridge running all the way along the centre, shown by the lighter tones.

Practice exercise: **Beetle in line and wash**

With line and wash, you can combine the fine detailing of pen work with soft washes of colour. You must use waterproof ink for this technique, otherwise the pen lines will smudge when you apply the watercolour. Remember to leave the bright highlights unpainted.

Materials
- Smooth watercolour paper
- Fine-nibbed sketching pen
- Black waterproof ink
- Watercolour paints: ultramarine blue, alizarin crimson, yellow ochre, lamp black
- Brushes: medium round, fine round

The subject
With their spindly legs and antennae and hard, reflective shells, beetles make fascinating subjects for natural history studies. If you put in the background leaf, as the artist did here, keep the colours muted and the veining on the leaves quite faint, so that they do not detract from the main subject.

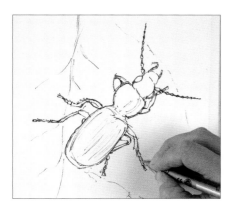 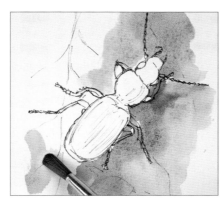 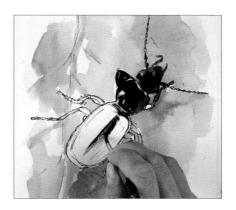

1 Using a sketching pen and black waterproof ink, sketch the subject and put in faint lines for the ridges on the shell. Put in some of the veining on the background leaf, making these lines fainter than those on the beetle so that the beetle stands out.

Tip: Plot the shapes by making tiny dots to check the placement before you commit to strong ink lines. Alternatively, make a pencil underdrawing first and then go over it in ink.

2 Mix very pale, dilute colours for the background: a purple from ultramarine blue and alizarin crimson and an orangey-brown leaf colour from alizarin crimson and yellow ochre. Using a medium round brush, wash these colours over the background, taking care not to apply any of the wash colours to the beetle.

3 Using a fine round brush and lamp black, block in the beetle, remembering to leave the highlights on the shell white. Add a little alizarin to the wash to soften the colour for those areas that are not quite so sharply in focus.

The finished painting
Through fine penwork and by carefully observing the shapes of the bright highlights, the artist has captured the hard texture of the beetle's shell perfectly. The soft washes of colour on the background leaf complement the main subject without detracting from it.

Using a fine-nibbed pen allows you to create delicate lines and fine detailing.

Note how one half of the shell is brighter than the other: this tells us that the shell is rounded, as one side is in relative shade.

A very thin highlight at the base of the shell separates the shell from the body.

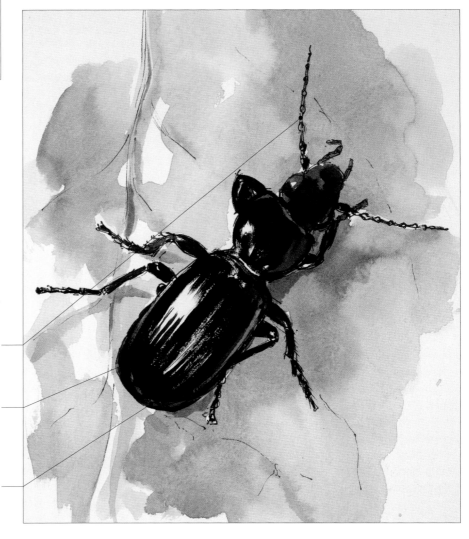

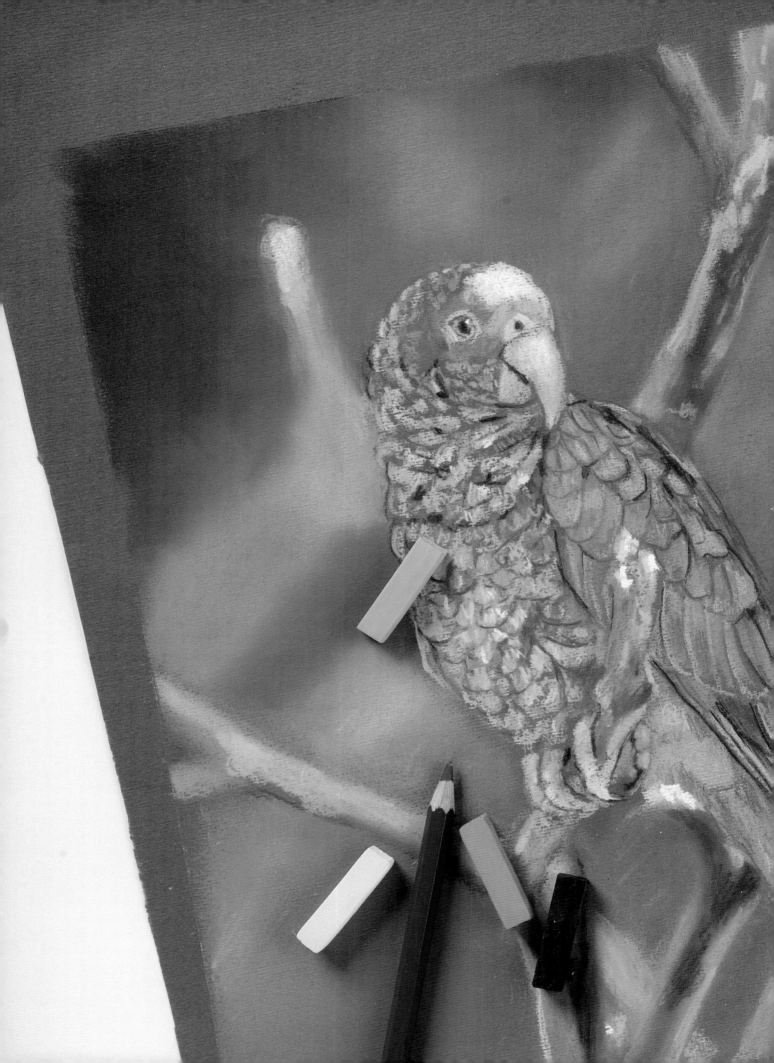

Projects

The natural world is infinitely varied and, although you may never have considered painting something as apparently insignificant as a bird or beetle from your backyard, this chapter demonstrates the potential for finding fascinating subjects in even the most mundane of settings. The chapter begins with a gallery of paintings, which gives you the opportunity to study the style and techniques of professional artists working in a number of different media. Next, there are fifteen detailed step-by-step drawings and paintings in all the main media, covering everything from farmyard chickens and wild pelicans to a pretty pond dragonfly and a vibrantly coloured butterfly. Copy them to hone your own skills, or simply study them closely to find out to how another artist (whose style may be very different from your own) has tackled the subject. Regular practice is important – it will both train your eye and sharpen your powers of observation.

Gallery

From a large-scale oil painting of a flock of gannets to a finely detailed study of a bumble bee, this section features works by a number of professional wildlife artists and illustrators. Some of the paintings depict birds and insects that you may come across every day in your garden or local park, such as swans on a river or a butterfly that has alighted in a colourful corner of a summer garden. Others may surprise you: who would have thought, for example, that a disease-carrying mosquito would make such a beautiful subject for a drawing?

The purpose of this section is to inspire you to experiment with both subjects and techniques that you may not have previously considered. Take the time to study these drawings and paintings carefully and see what you can learn from them. If you like an artist's style, try to work out what it is that appeals to you; similarly, think about why you may find other paintings less appealing. All these things will help you gradually to develop your own artistic style and vision.

Robin – Paul Dyson ▼
A wide, panoramic format has been chosen for this painting of a robin on a branch. At first glance, it might seem that the subject is quite insignificant and does not warrant such an extreme format, but exaggerating the width of the painting has introduced a tension that would be lacking if the more usual landscape format had been used. The clever device of the arching branch, which runs the entire width of the image, prevents the picture from appearing one-sided: the eye wanders along it and across the picture, but always returns to the brilliant flash of red on the robin's breast.

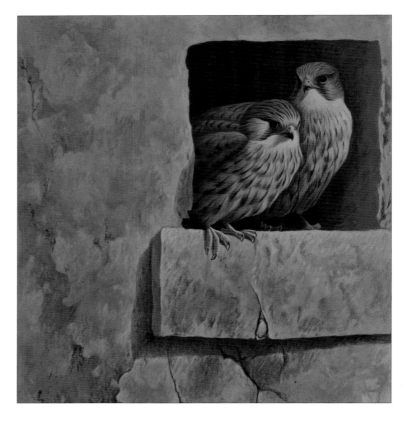

Common kestrels – Jonathan Latimer ▲
Placing the main subjects in the top right of the picture space is an unconventional composition, but here it suits the subject perfectly; as well as being a study of the birds themselves, it also tells us something about their nesting habits. Although the birds are almost the same colour as the stonework, they stand out well against the dark interior of the barn in which they are nesting and we can clearly see the difference in plumage between the male and the female. The stonework is loosely painted, but the texture of the walls is well conveyed.

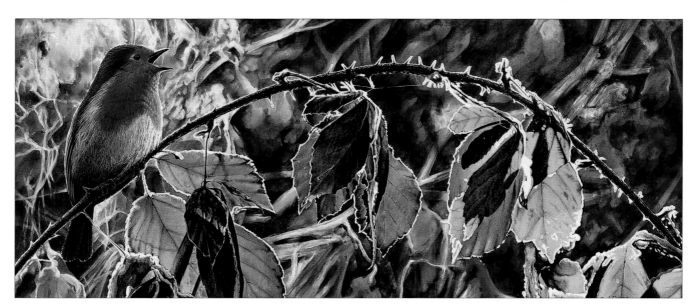

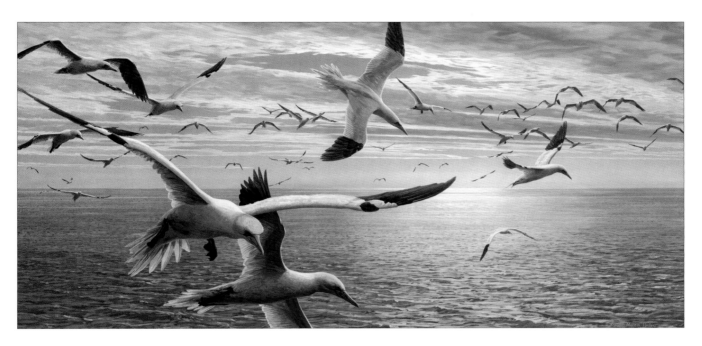

Over the shoal – Martin Ridley ▲

This large-scale oil painting of a flock of gannets has a wonderful sense of light, with sunlight sparkling on the water and the pink glow of a late afternoon sun reflected in the gently rippling waves. The birds in the distance are little more than silhouettes; only in the foreground birds can the true coloration of the feathers be seen. By deliberately excluding any land from the composition, the artist has created the feeling that the viewer is almost part of the flock, a feeling enhanced by the high viewpoint, which places the viewer virtually level with the birds.

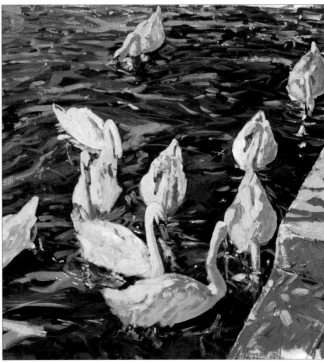

Swans – Martin Decent ▲

The ripples in the water and the sparkling sunlight give this gouache painting a lovely feeling of movement. Note how the artist has cropped out part of the two swans on the far left of the image: this enhances the feeling of movement, with the two birds moving out of the frame. The relatively high viewpoint, looking down on the birds from the river bank, makes this more of a pattern picture than a straightforward depiction of the swans. Although the birds are instantly recognizable, the painting also has a slightly abstract quality that is very appealing.

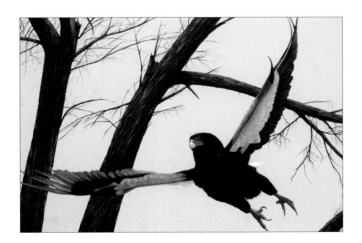

Bateleur eagle – Jonathan Truss ▲

This oil painting captures a precise moment during the bird's flight, when both wings are fully outstretched, allowing us to see the detail of the feathers. Note how the artist has used the branches of the trees to 'frame' the bird and direct our attention around the image: our eye is led up the second tree trunk, along the main branch and back around again in a kind of circle, which echoes the curving sweep of the bird's wings.

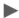

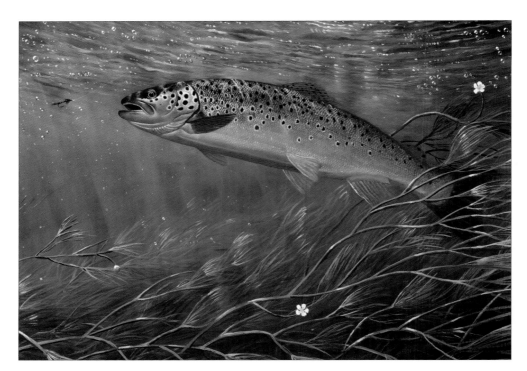

Chalk stream trout – David Miller ◄

This underwater painting enables the viewer to enter the fish's world. In contrast with the sense of speed shown in the marlin painting (below), the artist has here conveyed the gentle and relatively slow-moving current by showing how the underwater vegetation is bent by the flow of the water. The base colour of the fish itself was painted largely wet into wet, allowing subtle transitions of tone and colour without any hard edges, while the markings on the skin were added once the base colour was dry.

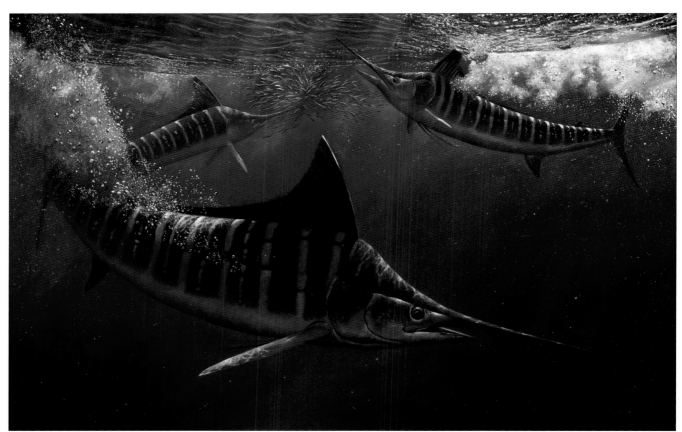

Marlin attack – David Miller ▲

Marlin are known to be incredibly fast swimmers, reaching speeds of about 68 miles (110 kilometres) per hour, and the white water in this painting, whipped up as the streamlined fish hunt their prey, certainly conveys that capacity for speed.

The viewpoint, from just below the surface and level with the fish, adds to the sense of drama. Note how the three fish are arranged almost in a circle: this is a very effective compositional device, which helps to lead the viewer's eye around the image.

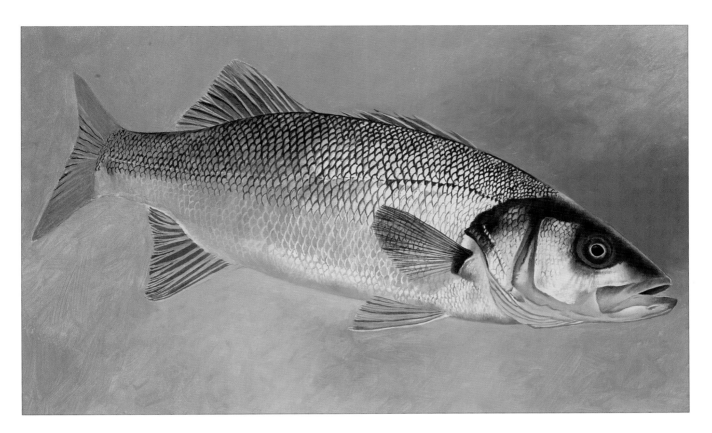

Bass study – David Miller ▲

This is a beautifully observed oil study of a saltwater bass. The silvery scales have been rendered in fine detail: note how the artist has made them appear three-dimensional, rather than as flat markings, by painting a slightly thicker line on one side than on the other. The background for natural-history studies such as this is often left white, but here it is a watery blue, with the proportions of titanium white and ultramarine blue being varied to add visual interest.

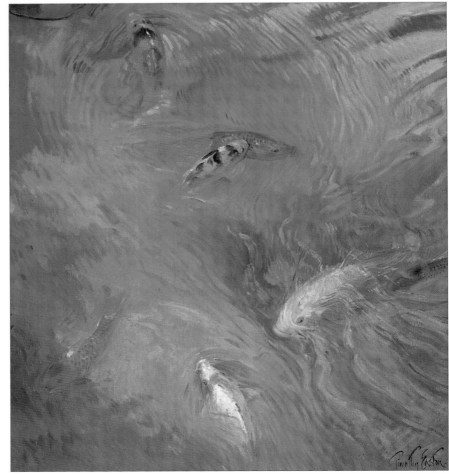

Turning fish – Timothy Easton ▶

This oil painting is, above all, a study of the effect of light on water. The fish are reduced to generalized shapes, their colours muted and their exact outlines distorted by the ripples; it is the ripples that convey the fact that the fish are moving. The artist's high viewpoint, looking directly down into the water, increases the semi-abstract quality of the work.

▶

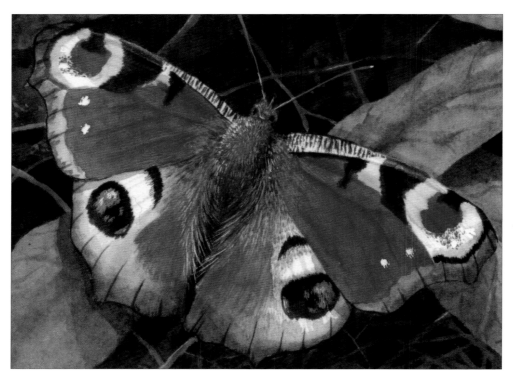

Peacock butterfly –
Tracy Hall ◄
This watercolour painting measures only 9 x 6.5cm (3½ x 2½in), so the butterfly is almost life size and the amount of detail in its wings is incredible. Placing the insect on a slight diagonal adds visual interest; note how the angle of the wings (sloping downwards, from top left to bottom right) is counterbalanced by the line of the leaf on the right, just under the butterfly's right wing. The background foliage is quite muted in colour, so nothing detracts from the vibrant markings of the butterfly.

Secret garden (detail) – **Tracy Hall** ◄
At first glance, it might appear as if the artist has simply painted the brightly coloured flowers as she found them, with little thought for the composition, but in fact this is a carefully thought-out arrangement. The riotous profusion of flowers and overlapping shapes in the top two-thirds of the painting are offset by the relatively uncluttered foreground; had the whole image been as 'busy' as the top part, there would have been nowhere for the viewer's eye to rest.

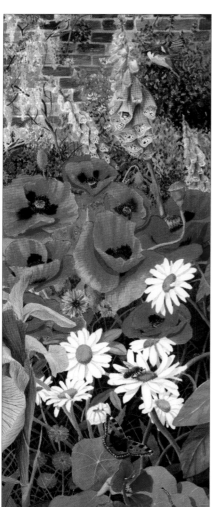

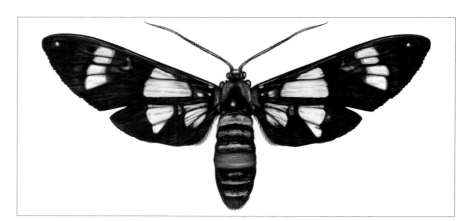

Basker moth – **Jonathan Latimer** ▲
Painted in acrylics on smooth white illustration board, this is a very traditional-style natural history illustration, the subject being viewed from directly overhead with its wings fully outstretched. Many moth and butterfly wings are covered in millions of tiny scales, arranged in partially overlapping rows, and one of the keys to painting them successfully is to have slightly wobbly lines where one colour changes into another, as the artist has done here. If you paint solid, straight lines, you will end up with something that looks more like a piece of stained glass than a real insect. Note how intense the tiny patches of iridescent blue are: if you find it hard to get anything near the right colour using acrylic paints, try using acrylic inks instead.

***Asian tiger mosquito
– Pat Ellacott*** ▶
One of the artist's aims is to make people look closely and see an inner beauty in something that is abhorrent, and this pencil and graphite drawing of a mosquito has a graphic quality that is very appealing. The solid mass of the head, body and wings is counterbalanced by the delicate spindly legs; note, in particular, how the legs and the spaces between them form jagged inverted V-shapes that help to give the drawing a wonderful sense of energy.

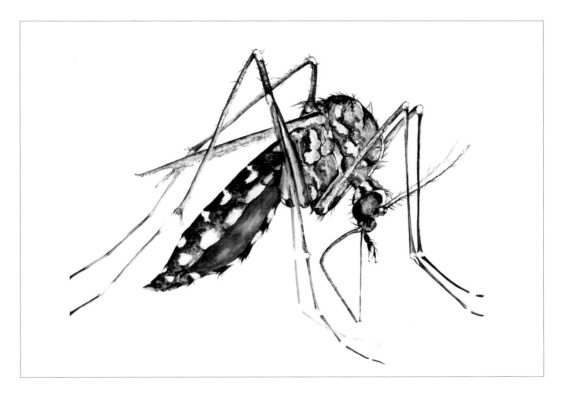

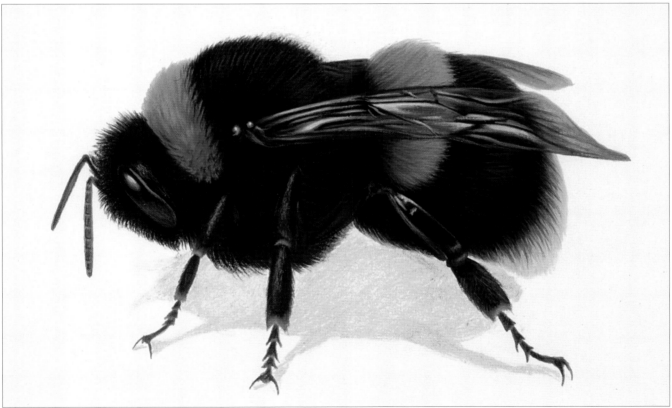

***Bumble bee* – Jonathan Latimer** ▲
Painted on primed board that has been sanded down to give an absolutely smooth surface, this image has something of the feel of a traditional natural-history illustration – but what makes it different is the side-on viewpoint and the slight shadows under the bee's legs. Note how well the artist has captured the furry texture of the bee's body by 'flicking' tiny strokes of other colours in the yellow and black stripes to give the impression of lots of very fine hairs.

Farmyard chickens in acrylics

Whether you are painting wild or domesticated animals, it can be interesting to paint them in their own environment – in this case, a corner of a farmyard, where the chickens are allowed to roam freely, pecking at grain from an old wooden wheelbarrow.

Before you begin painting, spend time observing how the chickens move. Although you might at first imagine their movements to be completely random, you will soon see a regular pattern emerging – a staccato rhythm of strutting and pecking, stabbing at the ground to pick up grains of wheat before throwing the head back to swallow. Try to fix this rhythm in your mind, as it will help you to anticipate what the bird is likely to do next. Look, too, at the way the movement of the head and legs affects the rest of the bird's body: when the head is tilted down, the rest of the body tilts up – and vice versa. Accurately capturing the angle of the body in relation to the head will give added veracity to your work.

This project also gives you the opportunity to practise a number of different ways of capturing texture in acrylics. By applying very thin layers of paint in glazes, you can build up the slightly uneven coloration of the rusting cartwheel in the background, while the woodgrain on the wheelbarrow is painted using just the tip of the brush. Spatters of paint on the gravelled area in the foreground and thick dabs of paint applied to the chickens with a painting knife also add textural variety to the painting.

Materials
- 300gsm (140lb) NOT or cold-pressed watercolour paper
- HB pencil
- Masking fluid
- Ruling drawing pen
- Acrylic paints: yellow ochre, raw sienna, burnt sienna, cadmium orange, cadmium yellow, Hooker's green, burnt umber, light blue violet, violet, cadmium red
- Brushes: medium chisel or round
- Small painting knife

The scene
Although this is an attractive scene, with lots of detail, the colours are a little subdued. The artist decided to boost the colours a little and make more of the sense of light and shade in her painting, in order to make a more interesting and better-balanced picture.

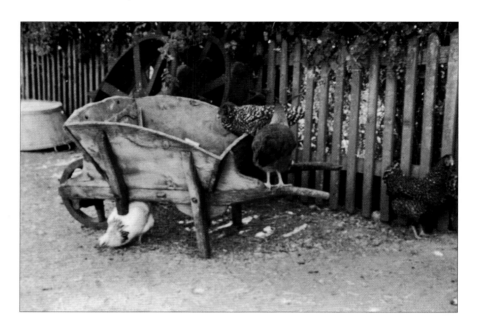

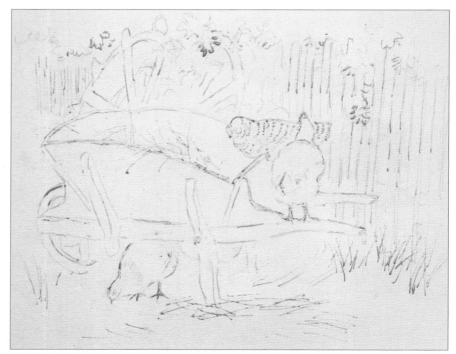

1 Using an HB pencil, make a light underdrawing of the scene to use as a guide. Dip a ruling drawing pen in masking fluid and outline the chickens. Mask out the lightest areas – the white dots on the chickens' feathers, the bright wisps of straw on the ground, and the brightest bits of foliage. Leave the masking fluid to dry completely.

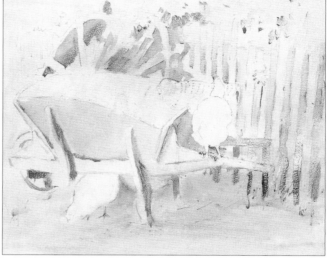

2 Mix up a dilute wash of yellow ochre and another one of raw sienna. Using a medium round brush, wash yellow ochre over the side of the wheelbarrow and the background foliage. Loosely brush raw sienna over the foreground, which is darker than the rest of the image. These two loose washes of warm colour establish the overall colour temperature of the scene.

3 Brush raw sienna over the fence posts. Add burnt sienna to the mixture and paint the triangular-shaped wedges inside the background cartwheel. Use the same mixture for the shaded portion of the wheelbarrow wheel and for the wooden supporting struts and handle of the barrow. In effect, what you are doing in these early stages is making a tonal underpainting of the scene.

4 Brush a dilute mixture of cadmium orange over the straw lying in the wheelbarrow and on the ground, using short brushstrokes. Brush the same colour over the spokes of the cartwheel and the body of the brown hen perched on the wheelbarrow handle. Add more pigment to the mixture and paint the brown hen's head.

Tip: Always vary the length and direction of your brushstrokes to suit the subject. Here, broad sweeps are used to block in large areas such as the wheelbarrow, while short, individual strokes are used for the wisps of straw.

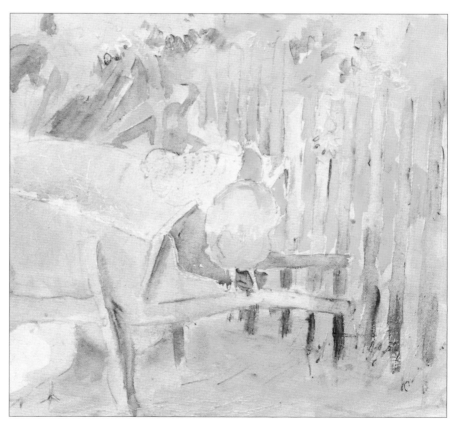

5 Mix a very pale yellowy green from cadmium yellow and a little Hooker's green and wash this mixture over the bushes behind the fence. Add a little burnt umber to the mixture in places to get some variety of tone. Leave to dry.

▶

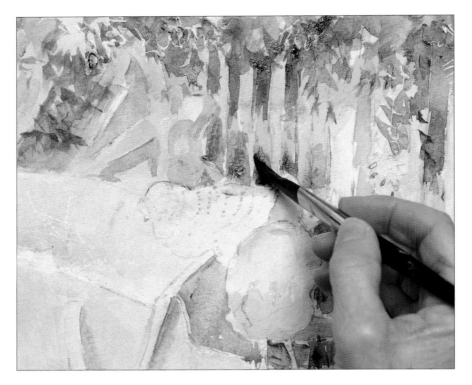

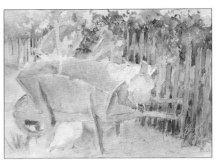

6 Mix a dark green from Hooker's green and burnt sienna and dab this mixture over the bushes, twisting and turning the brush to create leaf-shaped marks and allowing some of the underlying yellowy green from the previous step to show through. Note that some of the foliage pokes through the gaps and obscures part of the wooden fence posts.

7 Mix a purplish grey from light blue violet and burnt sienna and paint the shaded wheelbarrow interior and the shaded parts of the fence posts.

Tip: Neutral greys can be created by mixing together two complementary colours. This scene is relatively warm in temperature, and therefore two warm colours (light blue violet, which is a warm, red-biased colour, and burnt sienna, a warm reddish brown) were combined to produce the shadow colour. For a cool shadow colour (a snow scene, for example), mix cool, blue-biased complementaries.

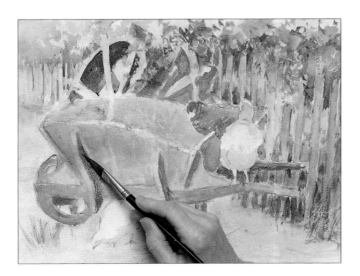

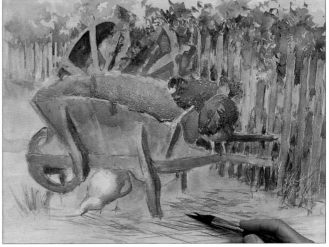

8 Mix a warm grey from violet and a little Hooker's green and paint the grey chicken on the wheelbarrow, leaving the beak untouched. Add burnt sienna to the mixture and paint the dark shadow areas inside the cartwheel and on the struts of the wheelbarrow.

9 Paint the dark feathers of the white chicken in light blue violet and brush the same colour loosely over the grey chicken on the wheelbarrow to create some variety of tone in its feathers. Mix a warm brown from burnt sienna and cadmium orange and paint the rim of the cartwheel. Brush burnt sienna over the body of the brown chicken on the wheelbarrow, allowing some of the underlying colour to show through. Splay out the bristles of the brush and brush thin lines of burnt sienna over the foreground.

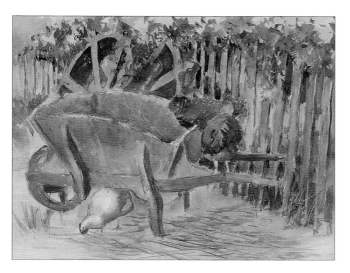

10 Paint the chicken combs in cadmium red. Mix a very dark green from violet and Hooker's green and dot this colour into the foliage, wherever there are really dark leaves or shaded areas. The different tones of green help to create a feeling of dappled light in the foliage.

11 Mix a purple shadow colour from violet and light blue violet, adding lots of water so that the mixture is very dilute, and brush this colour over the shadowed area underneath the wheelbarrow. When this is dry, brush thin, straw-like strokes of yellow ochre over the foreground.

Assessment time

Rub off the masking fluid. At this stage, the painting still looks rather flat and lifeless; the wheelbarrow and chickens do not stand out sufficiently from the background. You need to add more texture to both the foliage and the foreground areas and increase the contrast between the light and dark areas.

Stronger tonal contrast is needed in the foliage to help create a sense of light and shade.

More texture is needed – particularly on foreground elements such as the wooden wheelbarrow.

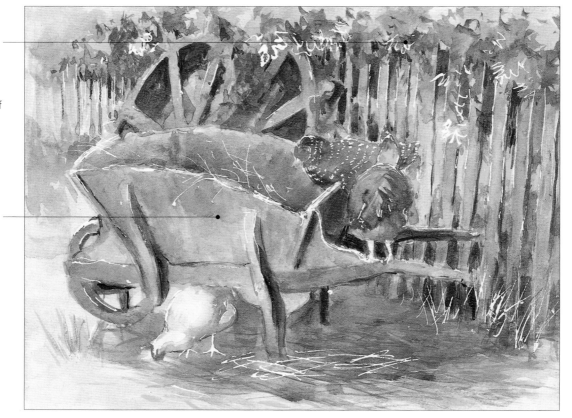

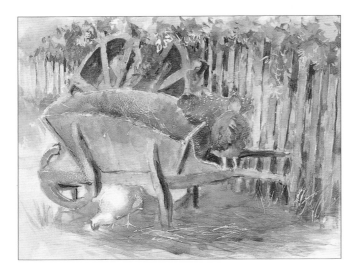
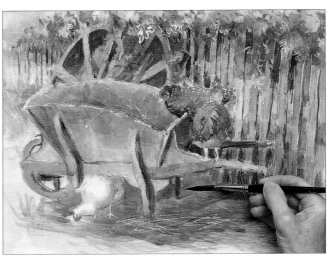

12 Mix a very dilute yellowy green from cadmium yellow, Hooker's green and a little yellow ochre and brush the mixture over the greenery at the top of the image to warm it a little. Brush pale yellow ochre over the exposed straw in the wheelbarrow and in the foreground. Brush very pale light blue violet over the grey chicken to tint the exposed dots.

13 Brush the purple shadow colour mix from Step 11 over the foreground to deepen the shadows and improve the contrast between the light and dark areas.

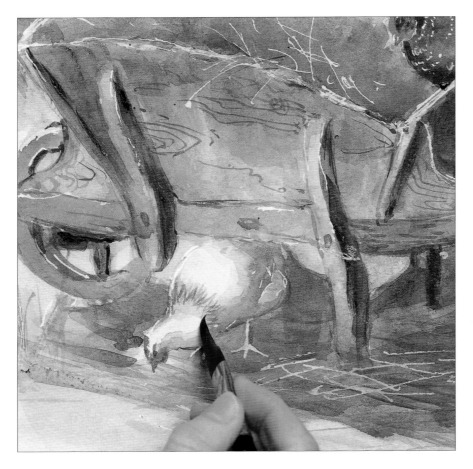

15 Spatter dark brown mixture over the foreground. Use the same colour to paint dark feathers on the brown chicken. Mix cadmium yellow with yellow ochre and apply light, textured strokes to the foreground.

14 Mix a dark brown from burnt sienna and violet and, using the tip of the brush, 'draw' in the wood grain on the wheelbarrow. Use the same colour to paint the 'ruff' of dark feathers on the white chicken in the foreground.

16 Dot thick white paint over the grey chicken's body and yellow ochre over the brown chicken's body.

The finished painting

This is a charming farmyard scene that exploits the versatility of acrylics to the full. The paint on the rusty metal cartwheel and wooden wheelbarrow is applied in a similar way to watercolour – in thin layers, so that the colour and subtle variations in tone are built up gradually. Elsewhere – on the bodies of the chickens and the straw-strewn ground, for example – relatively thick impasto applications create interesting textures that bring the scene to life.

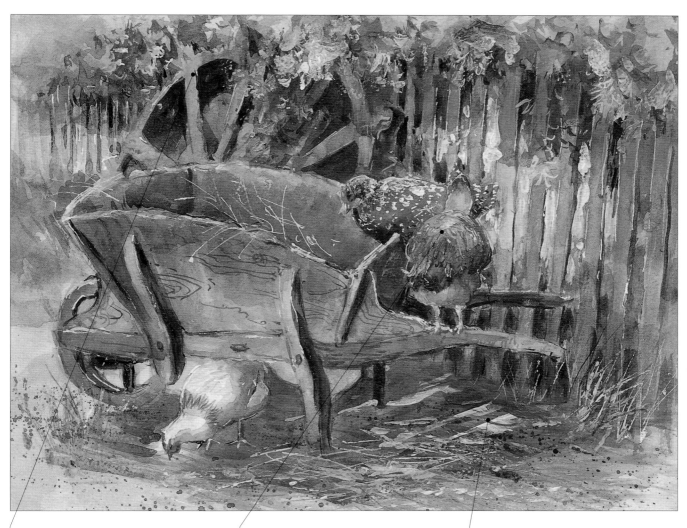

Note how the application of layers of colour, wet on dry, creates the texture of rusty metal.

Thick paint, applied using the tip of a painting knife, shows the texture of the ruffled feathers.

A range of techniques, from fine spatters to thick impasto work, is used to paint the pebble-strewn ground and loose straw.

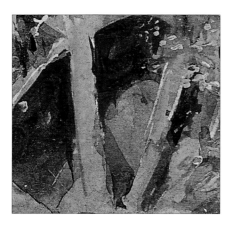

Spotted eagle owl in coloured pencil

Feathers and fur make wonderful subjects for a drawing. You don't even need to draw the whole animal: close-up details concentrating on the colours and patterns can make very striking semi-abstract works of art.

This drawing is made using coloured pencils, the fine tips of which enable you to capture the subtle coloration to perfection. Although on first glance it looks as if the bird is predominantly white and brown, there are many different colours within the dark areas – blue-greys and blacks as well as a range of browns. Paying attention to these differences will give your drawing depth and form, as they reveal the shaded areas within the feathers. Beware of using pure black for the very darkest areas, however, as it is a very harsh and unforgiving colour, whereas using a combination of indigo and a very dark brown will give you a softer, more sympathetic result.

Take plenty of time to build up the texture. Get it right and you'll almost feel as if you could ruffle the feathers with your fingertips. Use short pencil strokes that follow the direction in which the feathers grow. The highlights are not very obvious in the reference photograph, so you need to work out where they would appear: as any light source is likely to be above the subject, they are normally in the upper part of the eye. Note also that the owl's head is turned slightly to one side, so we can see more of one eye than the other.

The important thing in a drawing like this is to keep referring to your reference photograph to ascertain the lights and darks. Stand back from your drawing regularly and assess it as a whole. It's easy to get caught up in detail rather than see the overall effect.

Materials
- Smooth, heavy drawing paper
- 2B pencil
- Coloured pencils: primrose yellow, olive green, gold or mid yellow, gunmetal or charcoal grey, blue-grey, indigo, chocolate brown, sepia
- Tracing paper
- Pencil sharpener
- Kneaded eraser

The subject
You'd have to be very lucky to get so close to such a magnificent bird in the wild. This owl was photographed at an owl sanctuary. Whatever you think about zoos and wildlife parks, they do provide an opportunity to admire and draw specimens that might otherwise be difficult to see.

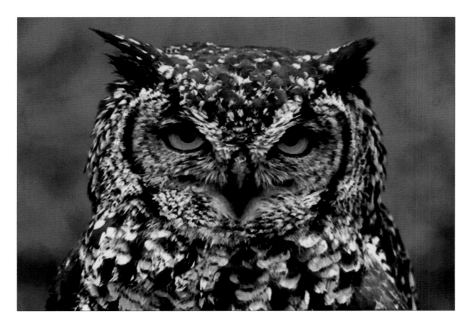

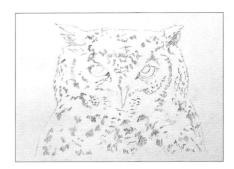

1 Using a 2B pencil, lightly sketch the subject. Map out the blocks of dark-coloured feathers across the bird's head and body with light, gentle strokes.

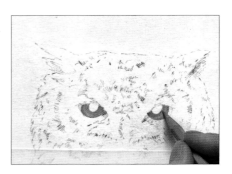

2 Using a primrose yellow pencil, colour in the iris of the eye and put tiny strokes of olive green over the darkest part (the part immediately below the pupil) to darken the yellow. Go over the iris again with gold or a mid-yellow pencil.

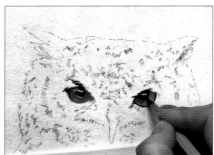

3 Colour in the pupils of the eyes, using a gunmetal or charcoal grey pencil and leaving a highlight in each pupil untouched. Go over the pupil again with a blue-grey pencil. Using an indigo pencil, put down the first indication of the feathers that grow around the eyes.

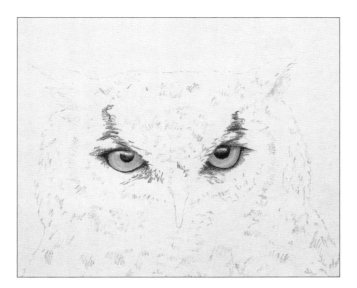

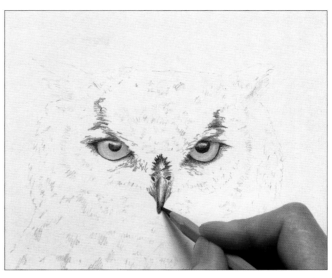

4 Go over the pupil again with indigo and the iris with mid-yellow. Note how these successive layers build up, creating a smooth, almost glossy surface colour. Outline the eyes with an indigo pencil and put in some of the feather detail around the eyes with the same colour.

5 Put in the beak with a blue-grey pencil, leaving the bright highlight untouched. Go over the darkest part with a chocolate brown pencil. Use tiny pencil strokes for the feathers that overlap the top of the beak. Take care not to make the beak too dark or it will overpower the whole image.

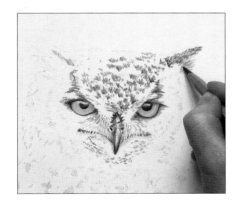

6 Using a sepia pencil, put in the dark feathers on the owl's face and head. Use little, jagged scribbling strokes that follow the direction in which the feathers grow so that you begin to get some realistic-looking texture into the feathers. Look at the relative length of the feathers, too: those around the ears are longer, so make long pencil strokes, using the side of the pencil rather than the tip.

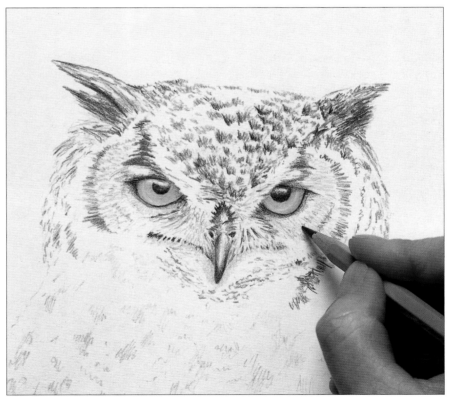

Tip: The pencil point will wear down very quickly. Roll it around in your fingers as you work, so that it doesn't blunt into a wedge shape. Sharpen all your pencils regularly.

7 At this point you need to define the outline of the bird without creating a rigid line. Use short, wispy, horizontal strokes around the edge of the face and vertical strokes for the body behind, as the difference in direction helps to define the form, and leave some gaps around the outline for the white feathers. Continue mapping out the dark areas of feathers on the face, using blue-grey and sepia pencils as before.

▶

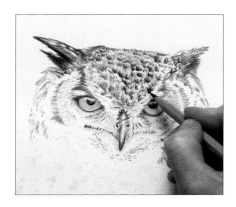

8 Continue working around the top of the head, using jagged, scribbling strokes as in Step 6 and alternating between charcoal grey and sepia pencils as appropriate. For the very darkest feathers, use chocolate brown. This immediately gives the feathers more depth and we can begin to see the different layers.

9 Darken the side of the face with sharp, jagged strokes of indigo, so that it stands out more clearly from the body. Some areas within the face are still completely empty of pencil marks. Using the side of the pencil, make light strokes for the feathers in this area. Although the feathers are largely white, you need to introduce some tones of pale grey here as there are shadows within them.

10 Build up the colours on the owl's face using the same pencils as before – indigo and chocolate brown for the very darkest areas, and blue-grey and charcoal grey elsewhere. The area around the eyes is particularly important: build up the dark feathers here so that you see the eyeball as a rounded form rather than as a flat circle on the surface of the face. Begin mapping out the darkest blocks of feathers on the body, using the side of a chocolate brown pencil. The feathers are bigger here than on the face, so you can be less precise about their placement and shape.

Assessment time

The drawing is progressing well, but more detailing is needed on the side of the head and the body. Work slowly and deliberately: it is amazing how much texture you can create by building up the layers of pencil work.

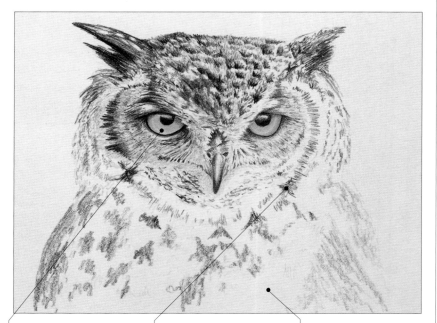

Our attention is drawn to the eyes, but the vivid yellow needs to be still more vibrant.

The face is in danger of merging into the body and needs to stand out more clearly.

Only the main blocks of feathers have been put in on the body. More detail and texture are required.

11 Go over the irises again with another layer of primrose yellow and olive green to intensify the colour and create a smooth, glossy surface that contrasts well with the soft ruffles of the feathers. Reinforce the dark feathers on the owl's face with indigo and chocolate brown. Repeat the process on the body, using the side of the pencil rather than the tip to create broader marks. (The clumps of feathers are larger here, so you can be less precise with your marks.)

12 Darken the beak with indigo, so that it stands out from the feathers, taking care not to obliterate the highlights. Use long, smooth pencil strokes to create the hard, bony texture. Reassess the feathers on the face, and add more definition if necessary.

The finished drawing
This drawing is a perfect demonstration of how successive layers of coloured pencil marks can create detailed textures and depth of colour. The key is patience: if you rush a drawing like this, you will not achieve such subtlety and detailing. Contrasts of texture – the hard, shiny beak versus the soft, ruffled feathers and the shiny, moist eyes – are vital.

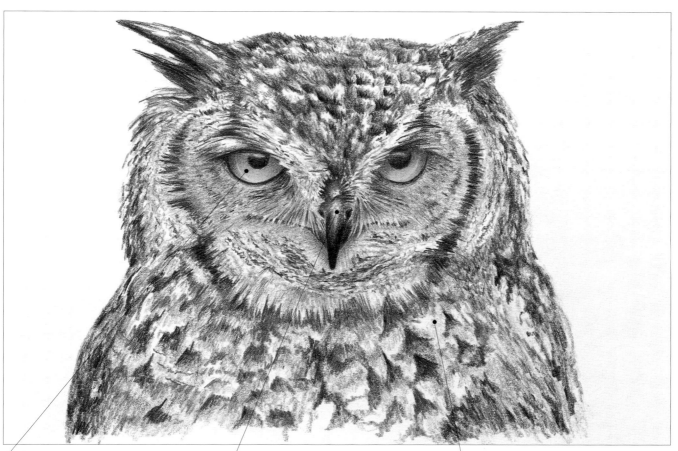

Note the intensity of colour created by gradually building up successive layers of different colours.

The highlight on the beak helps to indicate its curving shape, hard, bony texture and slightly shiny surface.

The face stands out well from the body, thanks to the jagged pencil marks used for the feathers in this area.

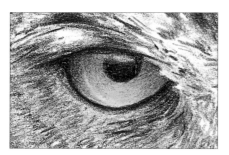

Flamingo in watercolour

This project offers you the opportunity to practise building up layers of colour and to use your brush in a controlled way. You need to assess the tones quite carefully when you are painting a subject that is mostly just one colour. It may help to half close your eyes, as this makes it easier to see where the lightest and darkest areas are.

It is often a good idea to keep the background soft and blurred by using wet-into-wet washes when you are painting a textured subject like this, as the detail of the subject stands out more from its surroundings.

The subject
This shot was taken in a nature reserve as reference for the feather colours. Wildlife parks and nature reserves are good places to take photos of animals and birds that you might not be able to get close to in the wild.

Materials
- *HB pencil*
- *Hot-pressed watercolour board or smooth paper*
- *Watercolour paints: viridian, Payne's grey, cadmium red, ultramarine blue, ivory black, cadmium yellow*
- *Gouache paints: permanent white*
- *Brushes: large round, medium round, fine round, small flat, very fine*
- *Masking (frisket) film*
- *Scalpel or craft (utility) knife*
- *Tissue paper*

Preliminary sketches
Try out several compositions to decide which one works best before you make your initial underdrawing.

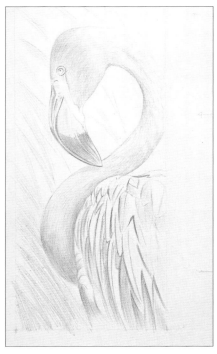

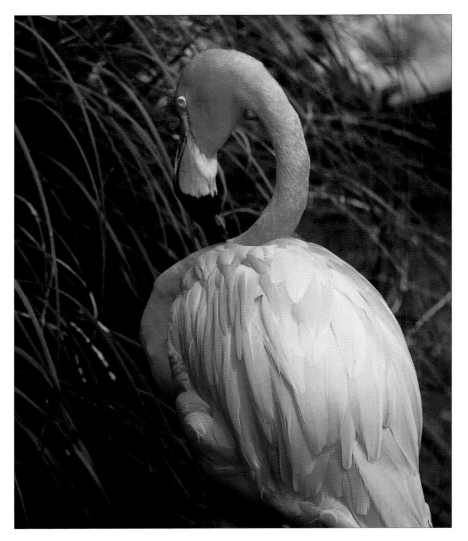

1 Using an HB pencil, trace your reference sketch on to hot-pressed watercolour board or smooth paper. Place masking (frisket) film over the whole picture area. Using a sharp scalpel or craft (utility) knife, carefully cut around the outline of the flamingo and the oval shape which is formed by the curve of the bird's neck. Peel back the masking film from the background, leaving the flamingo covered.

2 Take a piece of tissue paper and gently rub it over the film to make sure it is stuck down firmly and smoothly. It is essential that the background wash can't slip under the mask and on to the flamingo's body.

3 Mix a pale, watery wash of viridian. Using a large round brush, brush it over the background in long diagonal strokes, stopping about halfway down the paper.

4 Mix a pale wash of Payne's grey. While the first wash is still damp, working from the bottom of the painting upwards, brush the Payne's grey over the background, stopping at the point where it overlaps the viridian a little.

▶

5 Using a medium round brush and holding the brush almost vertically, brush long strokes of Payne's grey over the damp wash to suggest the foreground grasses. The paint will blur slightly, creating the effect of an out-of-focus background. Leave to dry.

6 Remove the masking film from the flamingo. Mix a pale, watery wash of cadmium red. Using a medium round brush with a fine point, carefully brush the mixture over the flamingo's head and neck, leaving the bill and a small highlight area on the top of the head unpainted. Make sure none of the paint spills over on to the background.

7 Strengthen the colour on the bird's head and neck by applying a second layer of cadmium red. Paint the pale pink wash on to the central part of the face.

8 Using the first wash of pale cadmium red, move on to the body, making broad strokes that follow the direction of the wing feathers. Leave the highlight areas unpainted. Add a wash of Payne's grey to the bill. Leave to dry.

Assessment time

The overall base colours of the painting have been established and we are beginning to see a contrast between the blurred, wet-into-wet background and the sharper, wet-on-dry brushstrokes used on the bird, which will be reinforced as the painting progresses. Much of the rest of the painting will be devoted to building up tones and feather texture on the flamingo.

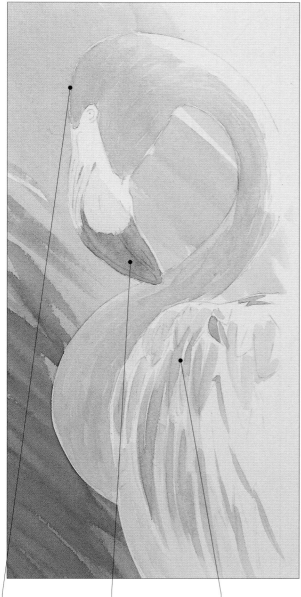

Note the use of complementary colours – red on the bird and green on the background.

The bill has been given a pale wash of Payne's grey.

The strokes follow the direction of the feathers.

9 Mix a stronger wash of cadmium red and, using a very small, almost dry, round brush, start building up the colour on the head, making tiny, evenly spaced brushstrokes to create the feeling of individual feathers. Using a small flat brush with the bristles splayed out, start working down the neck, again making tiny brushstrokes.

10 Continue painting the flamingo's neck, making sure that your strokes follow the direction in which the feathers grow. Using a fine round brush, paint over the main wing feathers again. Leave to dry.

▶

11 Mix a very pale pink from pale cadmium red with a little permanent white gouache and, using a fine round brush, carefully paint the area around the eye. Mix a mid-toned wash of Payne's grey and, using a fine round brush, paint the detailing on the bird's bill. Leave to dry.

12 Continue building up detail on the bill. Add a little ultramarine blue to the Payne's grey mixture and paint the shadow cast by the beak and the shadowed area on the outer edge of the bird's body. Leave to dry.

13 Mix a wash of ivory black and paint the bill, leaving spaces between your brushstrokes in order to give some texture and show how light reflects off the shiny bill. Add a dot of pale cadmium yellow for the eye.

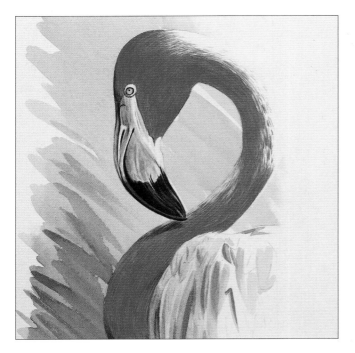

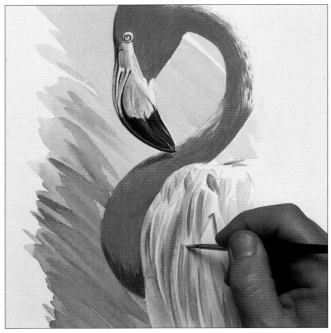

14 Mix cadmium red with a little cadmium yellow and, using a very fine round brush, dot this mixture on to the bird's neck, just beyond the point where the initial cadmium red washes end, so that there isn't such a sharp transition from red to white. Use a fine round brush to add detail in ivory black to the eye.

15 The body looks very pale compared to the head and neck so, using a fine round brush and cadmium red, continue to build up tone on the body with tiny brushstrokes that follow the direction of the feathers. Touch permanent white gouache into the white spaces on the bird's body, leaving white paper on the right-hand side so that the image appears to fade out on the lightest side.

The finished painting

This is a beautiful example of the effectiveness of building up layers of the same colour to achieve the desired density of tone. The lovely soft texture is achieved through countless tiny brushstrokes that follow the direction of the feathers.

The shape of the painting leads the viewer's eye in a sweeping curve from the bottom right-hand corner to the focal point – the bird's head.

Softly feathered brushstrokes soften the transition from red to white.

Paying careful attention to where the highlights fall has helped to make the bill look three-dimensional.

Note how gouache gives you much more control over the exact placement and size of highlights than simply leaving the paper unpainted, as you can paint over underlying colour with a very fine brush.

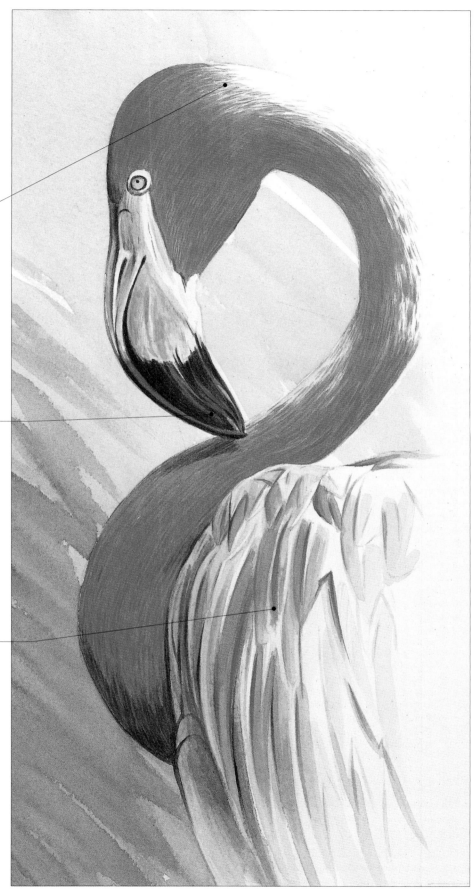

Flying pelicans in acrylics

If you're serious about being a wildlife artist, there's no substitute for observing and sketching animals and birds in the field and learning as much as you can about their shapes, textures, behaviour and habitat. However, many artists also work from photographs, often taking elements from several images in order to create their painting. This demonstration was done using three separate photographs as reference, in order to portray the wings at different stages of flight.

One of the main challenges of this painting is that you have to contend with several different greys. Not only are some of the feathers grey in colour, but the white feathers also contain grey tones in the shaded areas. Although

you might be tempted to put in the feather detail right from the start, you must get the basic tones right to begin with. If you do not, then no amount of textural detailing will make your painting look right. Establish the tones first, then gradually add more detail and texture.

In this demonstration, the artist applied a very thin layer of white acrylic paint over the paper, left it to dry, and then lightly sanded the paper before painting the birds. This gives a very smooth surface on which to paint although the pencil underdrawing is still visible. However, this is entirely optional and you may work on a conventional, unprimed watercolour paper if you prefer.

The artist who painted this demonstration opted for a smooth coverage of paint in the background so as not to detract from the birds, with no visible brush marks, but you could include details such as clouds in the sky.

Materials
- *2H or HB pencil*
- *HP pre-stretched watercolour paper*
- *Gum strip*
- *Masking fluid and old brush*
- *Fine sandpaper (optional)*
- *Acrylic paints: titanium white, yellow ochre, ultramarine, cerulean blue, burnt umber, cadmium yellow, cadmium red*
- *Brushes: fan-shaped hog brush, soft badger brush, fine round*

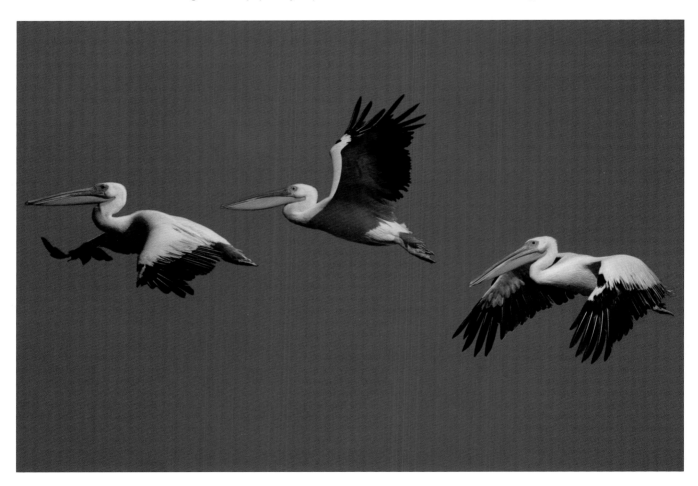

The subject
In his painting the artist wanted to show how the birds' wings move in flight. He combined three digital photos of birds showing different flight movements on the computer and tidied up the background to get a uniform colour in the sky. As the original sky was a dull grey, he decided to lighten and brighten it in the painting.

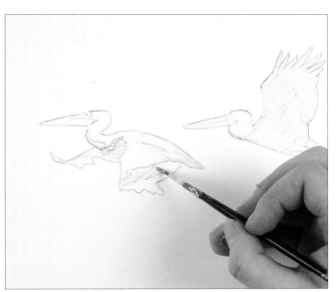

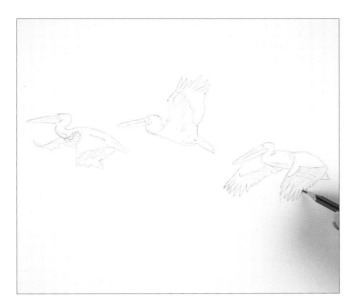

1 Pre-stretch your watercolour paper and tape it to a drawing board with gum strip, to prevent cockling. Using a 2H or HB pencil, sketch the birds.

2 Using an old brush, paint over all the birds with masking fluid and leave to dry. The masking fluid must be completely dry before you move on to the next stage.

3 Mix a blue-grey sky colour from white and small amounts of yellow ochre, ultramarine and cerulean blue. The paint should be the consistency of pouring cream. Wet the paper, using a brush dipped in clean water; acrylic paints dry very quickly, but the damp paper prevents any hard lines from forming. Using a fan-shaped hog brush, brush the sky colour over the whole painting, including the masked-out birds, making sure you work it well into the fibres of the paper.

4 Go over the painting once more, applying your brushstrokes vertically instead of horizontally this time, to ensure a good, even coverage. Using a clean hog brush, gently brush over the painting to remove any excess paint, then use a badger brush to get rid of any brushstrokes. Leave to dry.

 Tip: Mix plenty of paint. Acrylic paints dry very quickly, and if you have to stop halfway through applying the initial wash to mix more paint, you'll get hard lines in the sky.

 Tip: Remember to thoroughly clean the badger brush immediately after use so that it retains its softness.

▶

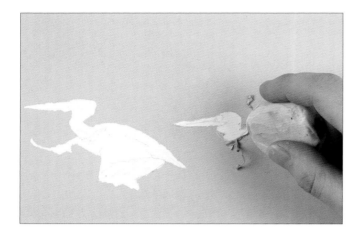

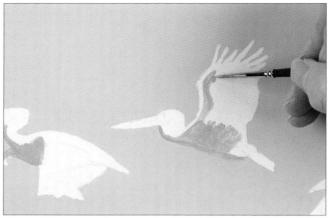

5 Using an eraser or your fingers, gently peel off the masking fluid from the birds. You may find that you need to use the tip of a craft (utility) knife to lift up the edge of the fluid to begin with.

Tip: Have some of the background colour to hand in a sealed container, in case some of the background paint peels off along with the masking fluid and you need to touch it up around the edges of the birds.

6 If you wish, apply a very thin layer of white paint over the birds, leave it to dry, then gently sand it to create a completely smooth, primed surface similar to illustration board that can hold lots of crisp detailing. Then begin putting in the mid tones, as this will make it easier to assess whether you need to go darker or lighter on the other areas of the birds. Mix a neutral grey from white, yellow ochre, burnt umber and ultramarine. Using a fine round brush, block in the mid-toned feathers and shadow areas.

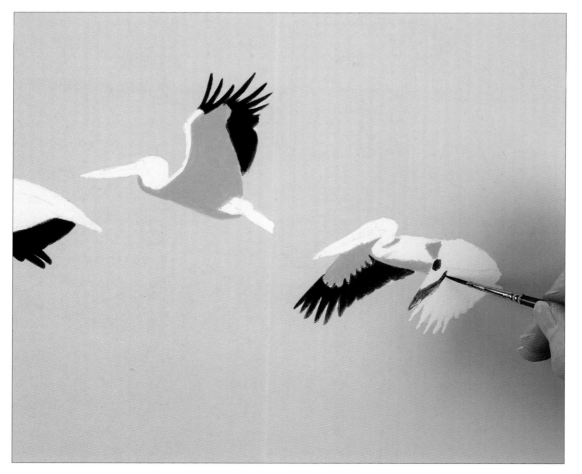

7 Mix a dark blue-black from burnt umber and ultramarine. Using a fine round brush, begin putting the black on the wings. At this stage, do not try to put in any texture; you should simply be aiming to get the right tone.

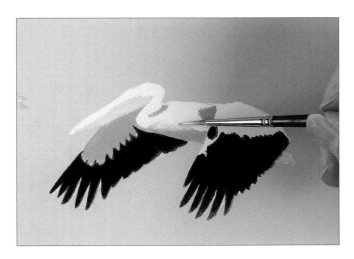

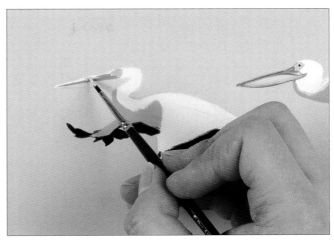

8 Mix a warm yellow from cadmium yellow, yellow ochre and white and then block in the beaks. Add a little cadmium red to the mix and paint the feet. There is also a yellow-grey tone on the birds' chests. Touch this in very lightly; you will paint over it later in grey, but it will provide a warm undertone.

9 Paint the area around the eyes in an orangey-pink mix of cadmium red, white and yellow ochre. Using the neutral grey from Step 6, paint the grey of the beaks.

Assessment time
Once you've established all the basic shapes and tones, you can begin to think about putting in some textural detail and making the birds look more three-dimensional. As always, careful assessment of the tones is the key. Look at the reference photo and you will see that there are different areas of the light and mid tones; you need to be aware of these in order to give the birds form and make them look three-dimensional.

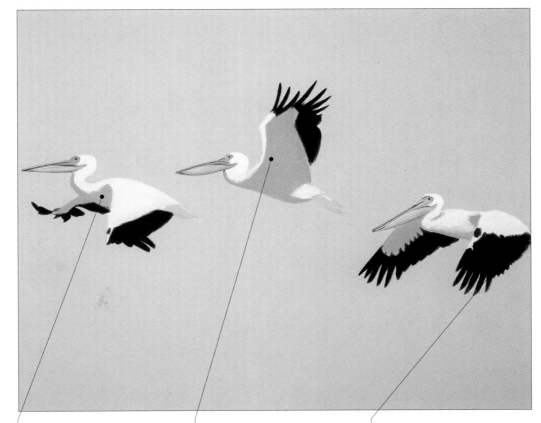

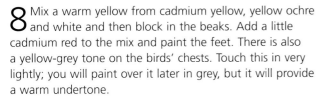

The basic light, mid and dark tones have been put in as flat blocks of colour, but the birds do not yet look fully rounded and three-dimensional.

Some shading is required within the wing to hint at the muscles and bones beneath the surface.

So far, the large primary and secondary feathers have been painted as solid blocks of tone; some texture needs to be put in here.

▶

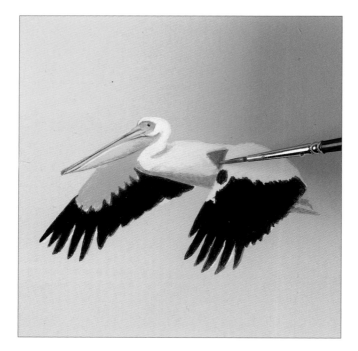

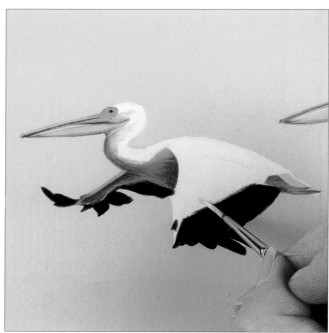

10 Add a little burnt umber and yellow ochre to the mid-toned grey mix from Step 6 to warm it up a little and paint the shadows on the birds' wings. Assess the tones carefully: some of the initial grey that you applied in Step 6 needs to remain visible.

11 Go a shade darker still, adding a tiny bit of burnt umber, ultramarine and yellow ochre to the mix. You are gradually developing more form and texture on the birds. Touch up the white of the wings with a very pale, warm grey shadow to make the birds' bodies look more rounded.

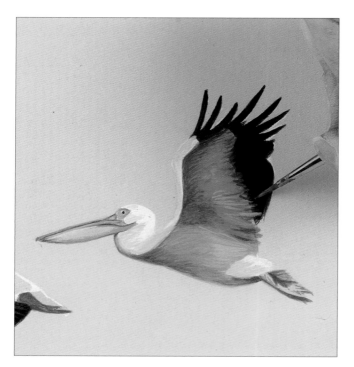

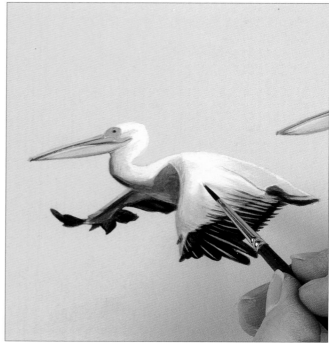

12 Carefully draw the main primary and secondary wing feathers, using the grey mix of white, burnt umber, yellow ochre and ultramarine to show where the feather veins are. The wings are no longer just blocks of solid colour: we are beginning to see some real texture here.

13 Continue putting in the veins on the feathers. Darken the wing tips with the blue-black mix of burnt umber and ultramarine from Step 7. Finally, apply pure white to the very brightest feathers on the wings and heads so that they stand out from the mid tones.

The finished painting

This deceptively simple-looking painting captures the way the birds fly beautifully. The colour palette is limited, but the tiny touches of burnt umber and yellow ochre in the grey mid tones adds warmth to what might otherwise be a rather cold image. The tonal differences in the greys and shadow areas are very subtle, but they make the painting more lifelike. The sky, too, is a warm blue and complements the orangey-yellow of the birds' beaks and feet.

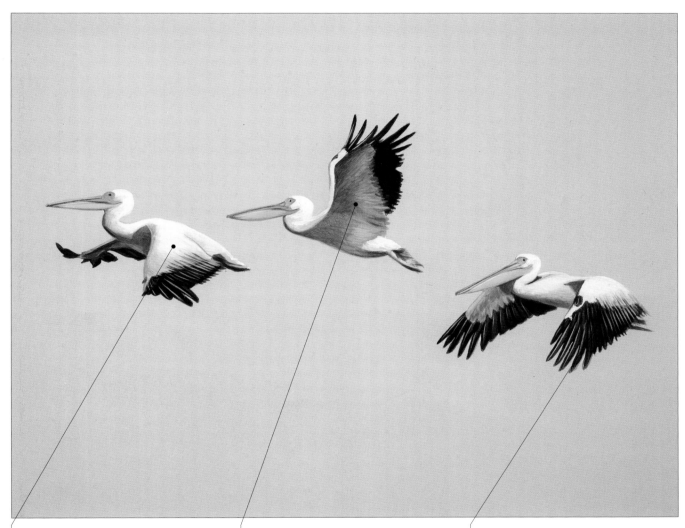

Note that the white feathers are not completely white: the use of very pale greys indicates shaded areas and implies the curve of the birds' bodies and wings.

Putting a little burnt umber and yellow ochre into the greys gives tonal variety and adds warmth to the image.

The feather detailing is painted using a very fine brush and adds all-important texture.

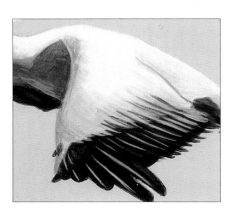

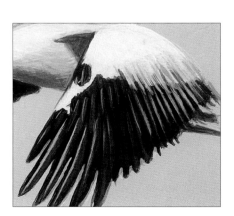

Parrot in pastels

This demonstration uses both soft pastels and pastel pencils. Soft pastels and pastel pencils can be blended both physically (using your fingertips or a torchon) and optically (by applying a thin layer of one colour over another). Both approaches are used here. Soft pastels blend better than pastel pencils, but the colours can be very strong. Try blending colours on a scrap piece of paper before you commit to using them on your drawing.

The feathers of this bird are very vibrantly coloured – almost iridescent in places. It's hard to capture iridescence in any drawing or painting medium, but soft pastels offer more scope than most. When colours are laid down close together and on top of one another, they combine optically on the paper and seem almost to shimmer.

Note that the feather textures vary: the feathers on the chest, for example, are smaller and softer than those on the wings. For the softer feathers, apply small dots and dashes of pastel and overlay other colours on top or very close by. For the larger wing feathers, use linear marks to delineate the individual feathers and blend the colours physically on the paper, so that the coverage is smooth. Build up the colours and textures gradually – and remember to look at the shaded spaces between the blocks of feathers, as well as at the feathers themselves.

On first glance, the background in this scene appears to be very dark, but it contains many different colours – some of them very bright. You'll find that half closing your eyes makes it easier to see the background as blocks of colour or tone. Take care not to overblend the pastel marks, however, or you'll end up with a murky mess. Wipe your fingers regularly, and use different fingers for light and dark areas so that the colours remain separate.

With soft pastels, it's all too easy to smudge what you've already done and 'muddy' the colours. A useful tip is to place a piece of clean paper over the part you are not working on to protect it from being smudged.

Materials
- *Charcoal-grey pastel paper*
- *Pastel pencils: light blue, mid blue, brown, pinkish red, orange, yellow, aquamarine, bright green, dark green, purple, reddish brown, salmon pink, peach, pink-brown, fuchsia pink, sage green, olive green*
- *Soft pastels: bright blue, bright green, dark green, peach, pink, purple, lilac, blue-green*

The subject
Here, the bird's head is turned so that it is looking directly at us, and this really brings the subject to life. The most striking thing, of course, is the brilliantly coloured plumage. Study the colours and the relative shapes and sizes of the different blocks of feathers carefully and establish where the shaded areas are, as this will help to make the bird look three-dimensional.

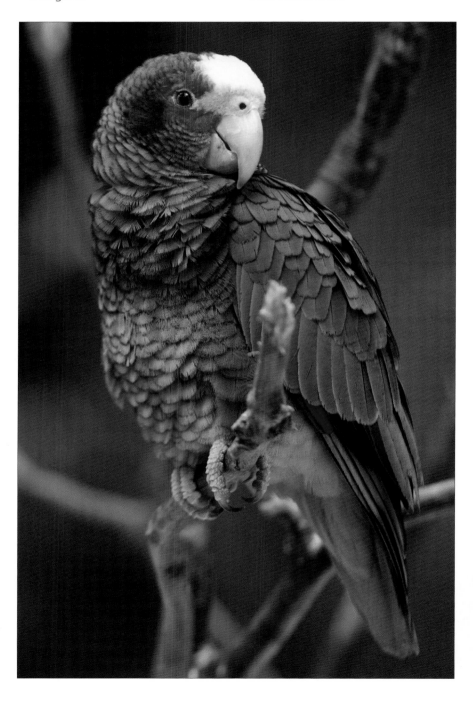

1 Using a light blue pastel pencil, roughly sketch the main shapes of the bird and background branches. Blue is one of the mid tones in the subject: it will be used in both the foreground and the background, so using this colour for the initial sketch will help to unify the drawing. A mid tone is also easy to work over: if the initial sketch were done in black, this would tend to 'grey' any other colours worked over it.

2 Loosely scribble colour into the background, using bright and light blue, bright and dark green, peach, reddish brown, pink, purple, lilac and ultramarine soft pastels. Begin blending the marks with your fingertips.

Tip: You don't need to be too specific about which colours you use where, as the background is mostly a dark, out-of-focus blur: just put down the colours you perceive coming through.

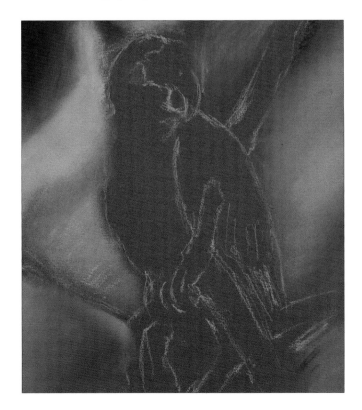

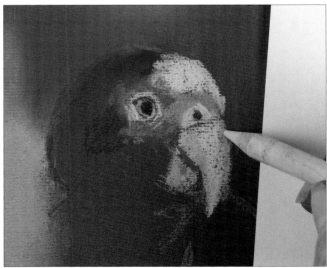

3 Continue blending the background, adding whatever colours you feel are appropriate.

4 Using a mid blue pastel pencil, scribble in the blue patches in the bird's head feathers. The top of the head and parts of the beak are very bright: put these parts in with a white pastel pencil. Colour in the eye with brown, with white around, and use the same brown for the nostril. Apply a pinkish red, orange and yellow to the head and beak.

▶

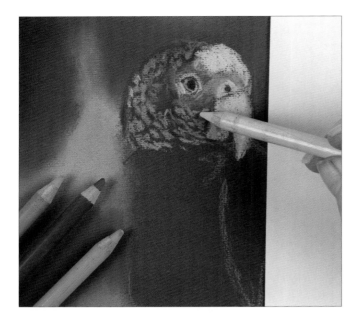

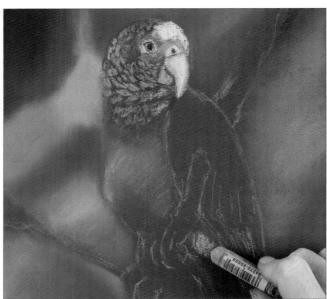

5 Using bright green, dark green, aquamarine and pale blue pastel pencils, scribble in blocks of different greens for the feathers on the head, overlaying colours to create optical mixes and leaving the grey paper colour showing through in between to create some sense of the shadows. For the very brightest greens, add a little yellow on top.

6 Lightly hatch over the bird's chest with pale blue pastel pencil, then apply a little blue-green soft pastel, with bright green on top, and gently blend the colours together with your fingers. Use bright green pastel, overlaid with touches of yellow where necessary, on the wing and the underside of the tail feathers.

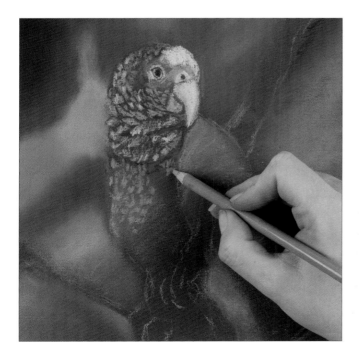

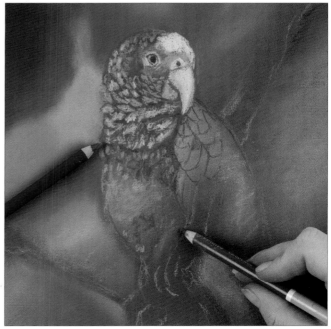

7 Scribble in blocks of greens on the chest, just as you did on the head, overlaying yellow soft pastel for the lighter greens and bright blue for the bluer greens. Already, you are beginning to develop the iridescence of the feathers, as the colours intermingle optically. Scribble red-brown pastel pencil between the blocks of green for the dark areas between the feathers.

8 Put in the spaces between the long wing feathers using a mid blue pastel pencil. Scribble blue into the spaces between the chest feathers, then go over the blue with a reddish-brown pencil to create the shadows.

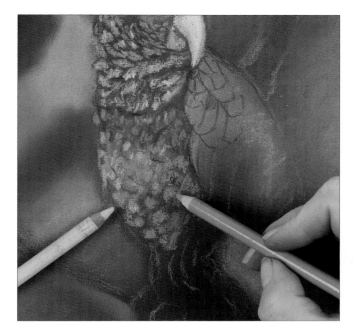

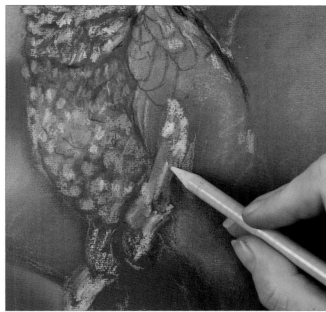

9 Continue applying blocks of bright green, aquamarine and yellow to the chest feathers as before, overlaying the colours where necessary to create lively optical mixes and blending them with your fingers. Don't worry too much about getting the colours exactly right at this stage, as you can refine them later; simply try to see the bird as blocks of light and dark feathers.

10 Block in the branch on which the bird is perched, using purple and brown pastel pencils for the darkest parts and salmon pink, peach and pink-brown for the lighter areas. If you need warmer browns in parts of the branch, overlay a little orange on the paler colours. Even though you have not yet put in any textural detail, the use of light and dark tones is already making the branch appear rounded and three-dimensional.

11 Draw in the highlighted edges of the large individual wing feathers using a yellow pastel pencil, and map out the darker shadow areas between the wing feathers in mid blue. Remember that you're still mapping out shapes and blocks of tone at this stage, and not attempting any fine textural detailing yet.

12 Block in the wing feathers with mid green and aquamarine, blending the marks but taking care not to lose the highlighted yellow edges. There are some flashes of very bright blue, light blue, fuchsia pink and bright green on the tail feathers. Put these in with soft pastels or pastel pencils. These echo the colours on the head.

13 Intensify the colours on the upper part of the wing by overlaying bright green, yellow, aquamarine and white. Lower down the wing, where it is more in shadow, use more muted sage and olive greens. You may find that you need to reinforce the yellow highlight lines that you added in Step 11.

▶

Assessment time

Building up the colours in the feathers has to be a slow, gradual process if you are to create the right optical mixes on the paper, but in the final stages of the drawing you can make sure the textures are right, too. Here, the colours of the chest feathers are correct, but the blocks of feathers appear to merge together; this is because the shadows between the feathers have not been put in strongly enough. To complete the drawing, you need to add the branches and any missing patches of background colour; at the same time, check whether or not you need to adjust the background colours now that the bird is complete.

The eye looks dull and lifeless; adding a white highlight will solve this.

The chest feathers look soft in texture, but all seem to merge together.

Adding the branches will make the setting look more realistic – but make sure you get the warm and cool tones right, so that the branches look rounded and three-dimensional.

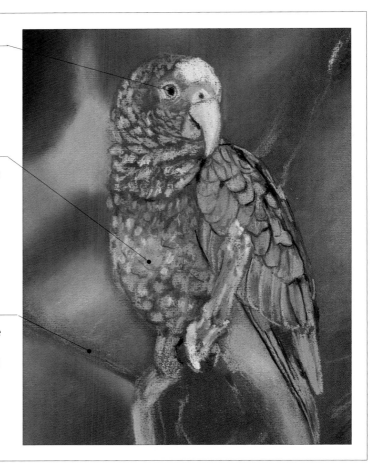

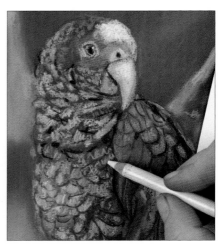

14 Block in the shapes of the background branches using lilac, purple and white soft pastels (for the brighter parts) and brown for the shaded undersides, then fingerblend the marks to smooth them out. Using the same colours as before, adjust the background as necessary to fill in the spaces between the branches and strengthen the colours.

15 Using brown and black pastel pencil, put in the dark, shaded areas on the long tail feathers. Darken the underside of the tail feathers where necessary by adding touches of brown and orange.

16 Using a white pastel pencil, dot in a highlight in the eye and on the chest. If necessary, dot more bright green on to the chest, with yellow on top for the brightest greens, to build up the tones and texture. Add touches of bright blue between the feathers, too; this helps to separate the blocks of feathers and contributes to both the texture and the iridescent effect.

The finished drawing
This is a colourful drawing that captures the bird's plumage beautifully without getting bogged down in detail. The pastels have been physically blended on the paper to create smooth patches of colour on the large wing feathers. They have also been optically blended, both by overlaying colours and by laying down small blocks of colour very close together so that they play against one another and create a lively, shimmering effect. The background, too, is a lively mix of all kinds of different colours, creating the effect of out-of-focus foliage or flowers that allows the bird to stand out in all its glory.

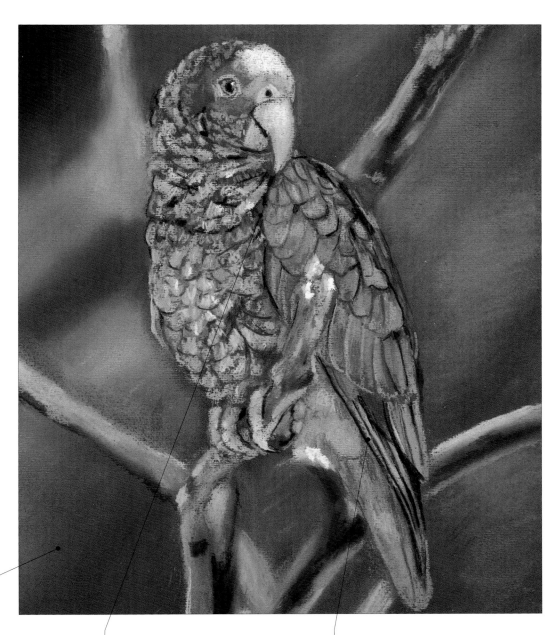

The background colours suggest out-of-focus foliage or flowers: the detail is not important, as the purpose of the background is to provide a foil for the bird.

Note the different textures on the feathers – soft, downy feathers on the chest and longer, stronger feathers on the wing.

Note the contrast between the bold linear work on the large wing feathers and the softly blended colour on the underside of the tail.

Geese in watercolour

Your main challenge in this painting is to paint white birds without using white-coloured paint, using only the white of the paper for the brightest areas. You might expect that such a light, delicate subject would require a very pale palette of colours but, the way to make the birds look really white is to make the surrounding areas dark, so that they stand out. Assess the tones carefully: you may be surprised at how dark the background really is.

The colours of the water are built up gradually in light washes and layers (glazes). Remember that, as watercolour is a transparent medium, any colours that you add will always be modified to some extent by the colours underneath. Don't worry too much about recreating the colours of the scene exactly: it is more important that the colours work well together to create a harmonious whole than to slavishly imitate nature.

Note that in the background, the water takes much of its colour from the surrounding trees. Even though the artist has chosen not to include them in the painting, their effect on the water must still be obvious.

Use as large a brush as you feel comfortable with, as it will enable you to make bold, confident brushstrokes. If you use a small a brush, you might get carried away with the tiny details instead of seeing the broader picture; as a result, your painting will become tight and laboured. You can always switch to a smaller brush for putting in details such as the eyes of the geese, if necessary, but a good-quality large or medium brush that comes to a fine point should do the job perfectly well.

Materials
- *Heavy watercolour paper*
- *4B pencil*
- *Watercolour paints: yellow ochre, Indian red, cerulean, ultramarine, light red, cobalt, cadmium yellow, alizarin crimson*
- *Brushes: large or medium round*

Thumbnail sketch
Experiment with the composition to focus attention on the most important parts. Here the artist left out the background trees, so that the birds could occupy more of the picture space. He also decided to omit the fifth goose, which is straggling some way behind the rest, in order to tighten the composition.

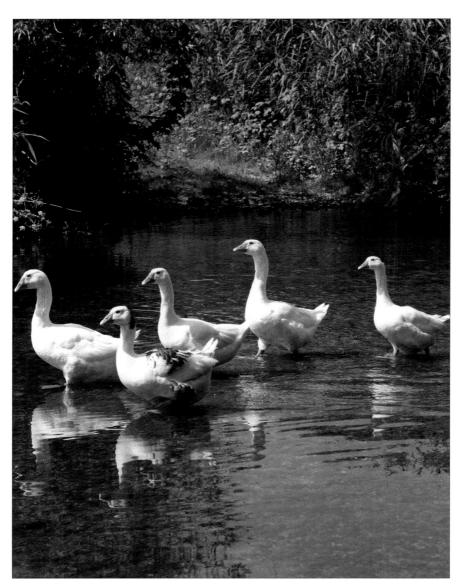

The subject
The deceptively simple-looking scene of a gaggle of geese crossing a shallow stream requires careful planning: in watercolour, the first step is always to decide which areas of the paper need to be left untouched, as the very brightest parts of the image.

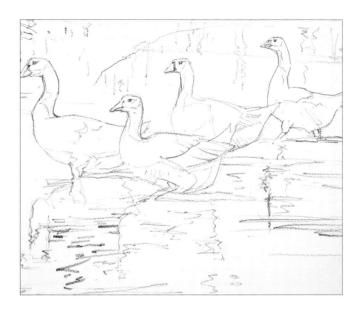

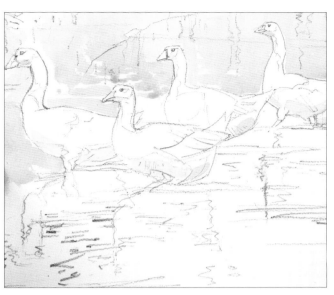

1 Using a soft (4B) pencil, sketch the scene. The advantage of using a soft pencil is that it is easy to erase the marks if you make a mistake. Here, the artist made his pencil marks quite dark so that some would remain visible in the finished painting, adding texture and linear detailing.

2 Mix a pale, sandy orange from yellow ochre and Indian red. Using a large round brush, carefully wash it over the background, leaving gaps for any really bright patches such as the flowers on the left-hand side. Brush a little of the same colour on to the underside of the birds' bellies, as some colour is reflected up from the stream bed.

> **Tip**: Don't attempt to put in every ripple; instead, look at the overall pattern that they make and use them to help you map out the light and dark areas within the water.

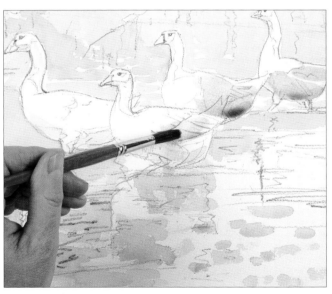

4 Mix a very pale blue-grey from cerulean, ultramarine and a little Indian red. Carefully touch in the shaded areas of the geese's wing feathers.

3 Continue putting in the background colour, remembering to leave the white of the paper for the geese's reflections. Add more Indian red to the mix as you work your way down the paper, to make the mix warmer and imply that this area is closer to the viewer. Use short dabs and dashes of the brush to create the effect of the ripples in the water.

> **Tip**: Note that the shaded parts of the wing feathers are lighter at the top: use more cerulean in the mix for these parts and add more ultramarine as you work down. Dab off excess paint with kitchen paper if necessary.

▶

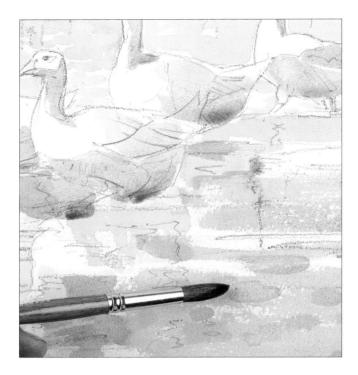

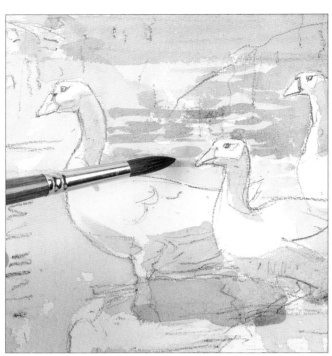

5 Overlay the same colour on the water on the right-hand side of the image, dragging the brush across the paper very lightly to get a slightly mottled, broken effect like sunlight sparkling on the water. Use horizontal brushstrokes to echo the direction of the ripples in the water.

6 Continue overlaying the blue-grey mix in the background behind the geese. Note how the colour is modified by the yellow ochre/Indian red mix beneath. Leave some of the underlying sandy orange colour showing through as you work down the picture. Leave to dry.

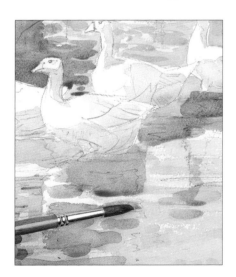

7 Mix a rich, brown-red from light red and a little ultramarine, and brush in the browns in the water.

Tip: Use the side of the brush, rather than the tip, to make horizontal marks for the patches of earth in the stream bed.

8 Using the same blue-grey mix as before, strengthen the shadows on the underbellies of the birds and in their reflections. Immediately the birds begin to look more rounded. You may need to repeat this process several times before you achieve the right density of tone.

9 Using the blue-grey mix, put in the shadows cast on the water by the bankside vegetation. Use the same colour for the long shadows cast on the water by the geese. Hold the brush almost horizontally so that your brushstrokes are the same shape as the rippled reflections.

Assessment time
The pale blue-grey shadows on the wings give a good sense of the form of the birds, but they do not yet stand out sufficiently against the background, which needs to be much darker. The water is so shallow that we can clearly see the bed of the stream, with its lovely, rich-coloured stones. We are beginning to build up the colour, but at present the water is too pale and there is no real feel of the sparkling sunlight.

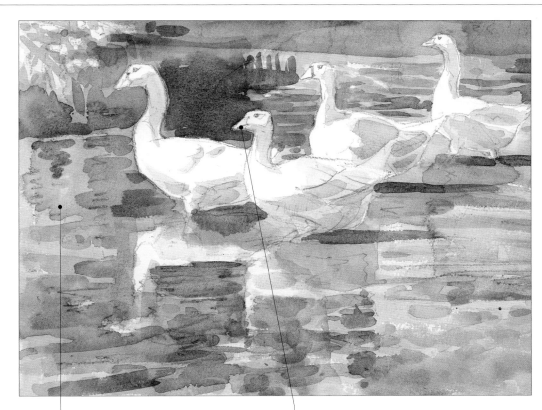

The background and water need to be made darker, in order for the brilliant white of the birds to really stand out.

Painting in small details such as the eyes and beaks will really bring the birds to life.

10 Using light red, touch in the orange of the geese's beaks and feet, leaving the tops of the beaks white where the sun hits them. (You may need to strengthen the colour later.) Stroke the same colour into the water, wherever you see darker browns.

11 Mix a bright, olivey green from yellow ochre, light red and a little cobalt. Brush it over the background shadow and into the water, into the reflection of the bankside vegetation. Note how the green is modified by the underlying colours.

12 Gently touch the green colour from Step 11 very lightly on to the underbellies of the geese, where the colour is reflected up from the water.

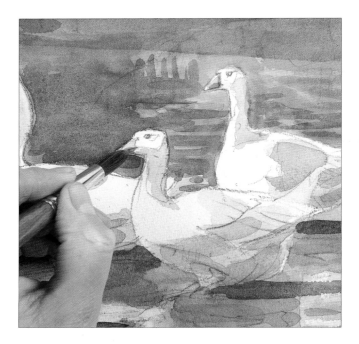

13 Mix a dark orange-red from light red and a tiny amount of ultramarine and, using only the very tip of the brush, carefully touch in the shadows on the underside of the beaks.

14 Mix a blue-black from ultramarine and Indian red and put in the eyes. Use the same colour to strengthen the shadows cast on the water in the background and along the side of the bank.

Tip: Pure black is rarely found in nature and a ready-made black can have a deadening effect in watercolour. It is better to mix your own black colour. Remember that blacks are usually either cold (containing more blue) or warm (containing more red/brown).

15 Use the same ultramarine and Indian red colour mix and continue to add dark ripples to the water in the foreground.

16 Mix a bright orange from cadmium yellow and light red, and strengthen the colour of the beaks. Strengthen the shadows cast by the geese's bodies with a mix of ultramarine and a tiny amount of alizarin crimson. Brush the same colour over the bottom right corner, to brighten the water in this area.

The finished painting

The geese have been simply but sympathetically painted, with the white of the paper standing for the very brightest parts, and the shadows on their wings and bellies created by applying pale layers of blue-grey to achieve the right density. The rich red-brown earth and pebbles on the stream bed impart a warm glow to the scene that enhances the feeling of warm sunlight. Short horizontal brushstrokes capture the rippling water, with layer upon layer of pale glazes creating a subtle interplay of tones and colours. Although the bankside vegetation is only hinted at, it provides a tranquil rural setting.

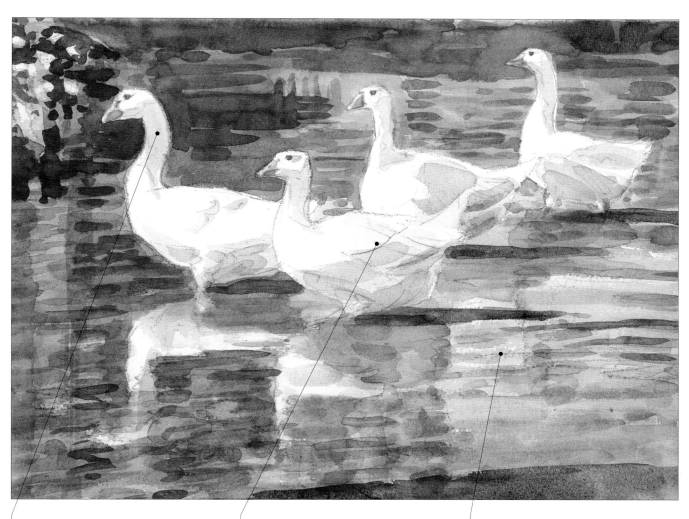

The dark background allows the lovely curving shapes of the geese's necks to stand out clearly.

Note how some of the original pencil marks remain visible, providing subtle linear detailing that would have been difficult to achieve in watercolour alone.

Note how the ripples distort the shape of the reflections.

Puffin in watercolour

For this demonstration, the artist used just six colours – and two of those (cadmium yellow and scarlet) in only very small areas of the painting. Beginners often make the mistake of trying to find a ready-mixed paint for every hue that they need. If you restrict yourself to just a few colours it helps you to think about the colours you're using, and you will quickly learn just how many mixes you are able to achieve by using colours in different combinations and proportions.

The puffin's wing feathers are basically black – but when the wings are opened out, as here, light appears to stream through them. This kind of subject is an absolute joy for a watercolourist. You can leave patches of the paper completely untouched, or covered by the very thinnest of glazes, for the very brightest patches, and gradually build up layer upon layer of colour in the mid- and dark-toned areas until you get the density of tone that you need. Remember that watercolour paint always looks a little paler when dry than it does when wet – so don't worry if the initial wash is a bit dark.

Vary your techniques to exploit the potential of the medium to the full. Working wet into wet allows you to create soft and diffuse blurs of colour that are perfect for the background sky, foreground vegetation and shadows on the bird's chest, while drybrush work in the softer feathers adds subtle but very effective textural detailing.

Materials
- *Good-quality watercolour paper*
- *6B pencil*
- *Watercolour paints: alizarin crimson, ultramarine, viridian, raw umber, cadmium yellow, scarlet*
- *Brushes: medium round, small round*

The subject
The cliff rising up behind the puffin gives the composition a strong diagonal line, which is counterbalanced by the angle of the wings. From this side-on viewpoint, all the detail of the wings and head can be clearly seen.

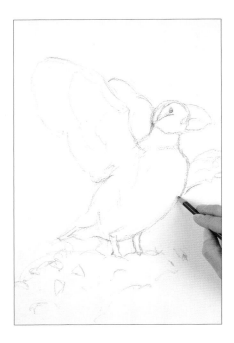

1 Using a 6B or other soft pencil, lightly sketch the bird and the line of the cliff on which it is standing. Try to reduce the bird's body, head and wings to simple geometric shapes – ovals and spheres. Define the areas of black and white on the body with a faint pencil line so that you've got a guide to where to apply the paint.

Tip: Ignore the detail at this stage – just concentrate on getting the overall shapes right.

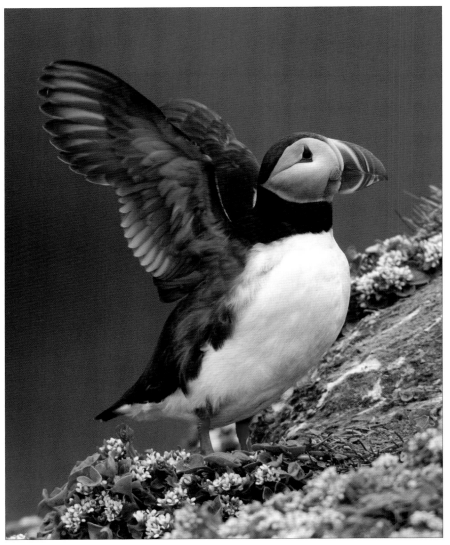

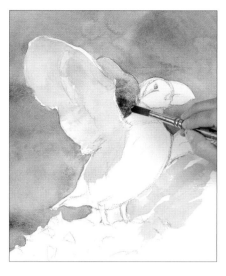

2 For the background, mix a cool dark purple-black from alizarin crimson, viridian and ultramarine, and a warm dark purple-black from alizarin crimson and viridian. Using a medium round brush, apply dilute washes of these colours around the bird, judging for yourself whether a warm or a cool tone is required. Use the negative shapes – the space around the bird – to help define the bird's shape.

3 Add a little raw umber to the purple-black mix from Step 2. Brush this on to the exposed rock just to the right of the puffin. Add a little ultramarine to the mix and, using a diluted wash, block in the underside of the right wing. Mix ultramarine with a tiny bit of alizarin crimson and block in the left wing, which is much darker in tone. This tonal variation will separate the wings visually from each other.

4 Darken the colour that you used for the left wing in the previous step and block in the neck and the top of the head. This is virtually the darkest tone on the bird, so once you've established it you will find it easier to judge the mid and light tones.

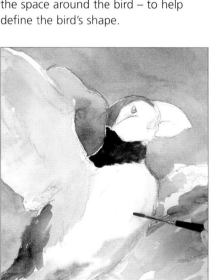

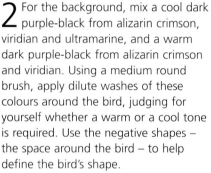

5 Use the same dark purple-black for the tail feathers. Wet the bird's chest with clean water. Using a fine round brush and a dilute version of the purple used for the bird's right wing, put in the warm colour on the underbelly. The paint will blur and spread. Using a small round brush and very dilute ultramarine, put in the darker tones within the white feathers.

6 Mix a warm green from cadmium yellow and ultramarine. Using an almost dry brush, so that you can create some textural marks, dab the colour on to the rocks, leaving some gaps white. Dot in some of the warm purple-black from Step 2 where necessary, keeping your marks loose and free. Again, let the colours mingle wet into wet.

7 Apply a dilute purple over the shadowed areas on the bird's head.

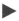

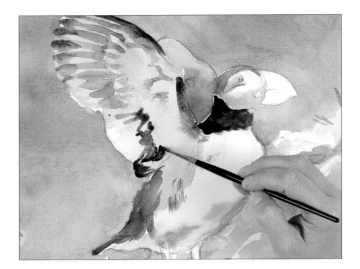

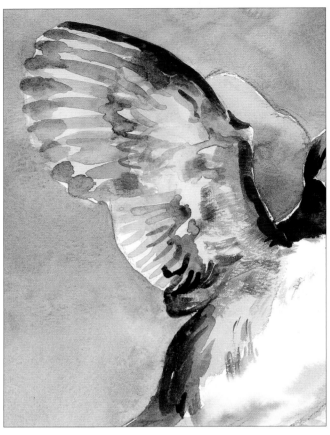

8 Add raw umber to the cool purple-black mix from Step 2. Using a small round brush, brush it around the edge of the near wing, as shown, so that the two wings are visually separated. Using the same colour, put in the long, dark flight feathers on the near wing, leaving gaps in between to create the effect of light shining through. Put in the smaller feathers at the base of the wing, using fine, curving brushstrokes.

 Tip:The paper should still be damp from the initial wash of colour, so the paint will blur and 'feather' a little – perfect for creating the texture of feathers! If the paper has dried too much, carefully brush over the painted flight feathers with clean water to soften the edges of the paint marks.

9 Continue adding texture to the wings, using an almost dry brush and feathering your strokes outwards. Apply another layer of colour to the back and tail feathers, to deepen the colour.

10 Mix a bright red from scarlet and a little alizarin crimson. Using a small brush carefully put in the red of the beak, eye, nostril and legs.

Tip: Add more alizarin to the mix to paint the back leg. It is further away and slightly in shadow.

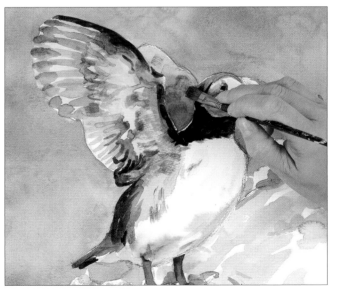

11 Add more ultramarine to the cool purple-black mix from Step 2 and put in the dark detailing on the head and beak. Using the same mix and a dry, flat brush, drag the colour over the far wing to create more texture.

The finished painting

This is a simple yet effective watercolour study of one of nature's more comical-looking birds. The painting demonstrates the versatility and subtlety of watercolour, with delicate wet-into-wet applications being used to build up tone without leaving any harsh edges and carefully controlled brush marks being used to delineate the individual flight feathers. The colour palette is limited (even the sky in the background is made up of the differing proportions of the colours used on the bird), and the overall effect is harmonious.

The line of the cliff top rises up through the image in a sharp diagonal line, which adds interest to the composition. Although both the background and cliff are painted very sketchily, they provide enough information to give us a clue to the puffin's natural habitat.

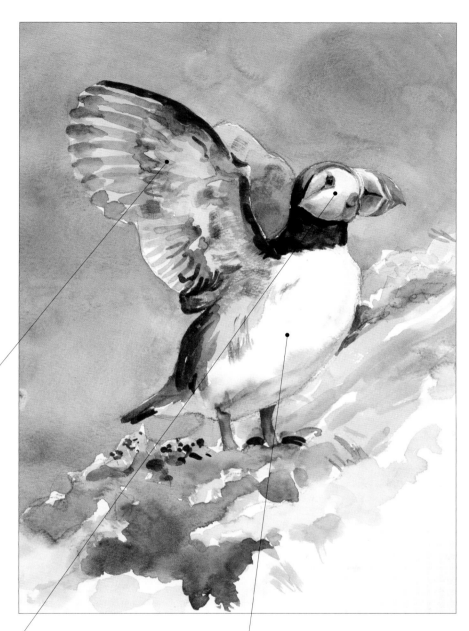

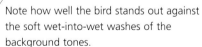

The large flight feathers are painted in bold brushstrokes on slightly damp paper, so they spread out and the edges appear diffuse. Note how the white paper implies light shining through the outspread wings.

Note how well the bird stands out against the soft wet-into-wet washes of the background tones.

Drybrush marks hint at the soft, downy texture of the chest feathers, while wet-into-wet soft blends create the shaded areas on the underside of the chest.

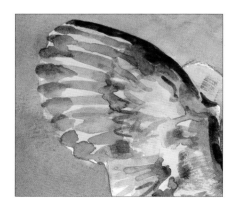

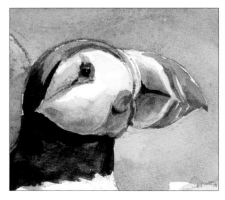

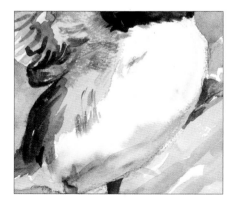

Swimming fish in water-soluble pencils

This colourful project combines elements of both drawing and painting. In the early stages, water-soluble pencils are used in a linear fashion as drawing tools; later, they are washed over with clean water, so that the pigment spreads on the support just like watercolour paint. You can also apply dry water-soluble pencil over wet washes to deepen the colour, either by using the pencils directly or by brushing water over the tip of the pencil so that the brush picks up a little pigment. The benefit of this technique is that you don't create hard edges.

As you'll be applying water to the paper, use watercolour paper, which is absorbent enough not to tear under the weight of the water. When you start applying water, work on one part of the image at a time – first the fish, then the water – so that the colours don't all blur together.

One of the most attractive aspects of this project is the sense of movement in the water. Observe how the ripples catch the light as this will help you to convey the movement. Use curved pencil strokes for the ripples and look at how the water breaks around the fish.

Materials
- *Watercolour paper*
- *Water-soluble pencils: orange, bright yellow, dark blue, olive green, yellow ochre, warm brown, reddish brown, red, blue-green*
- *Masking fluid and old dip pen*
- *Paintbrush*
- *Kitchen paper*

The subject
The colouring on the fish is spectacular – strong, saturated reds, yellows and oranges. Note how the shape of the fish is slightly distorted by the ripples in the water. The ripples themselves catch the light from above, which creates a glorious sense of movement and shimmering light.

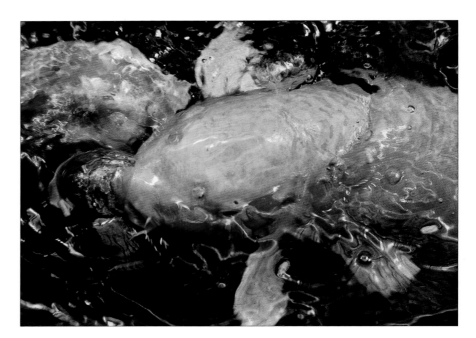

1 Using an orange water-soluble pencil, lightly sketch the outline of the fish, making a clear distinction between the top of the larger fish's head, which is just poking out of the water, and the rest of the body. Draw a few of the largest ripples in the water, too.

2 Using masking fluid and an old dip pen, mask out the white highlights on the water and the fish. Leave to dry.

Tip: You can speed up the drying process by using a hairdryer.

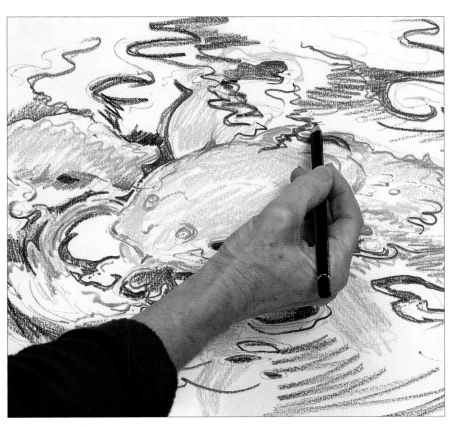

3 Lightly scribble bright yellow over all except the white parts of the fish. Apply orange to the reddest areas, pressing quite hard on the pencil.

4 Now start putting some colour into the water, using dark blue with a few touches of olive green for the very darkest parts.

5 Colour in the submerged fins of the large fish using a yellow ochre pencil and go over the reddest part of both with a warm brown. Continue adding colour to the water, using the same colours as before and making curved strokes that follow the shape of the ripples.

Assessment time

You've now put down virtually all the linear detail that you need. Once you start applying water, however, there's a risk that you might lose some of the detail: it's important, for example, to retain some of the ripples in the water – so decide in advance where you want the pigment to spread and, if the colours run into areas where you don't want them to go, be ready to mop them up with a piece of absorbent kitchen paper.

Although the shape of the fish is clear, it's hard to tell which parts are submerged and which are above the water.

Confident, flowing linear marks capture the ripples in the water – and at least some of these marks should be visible in the finished drawing.

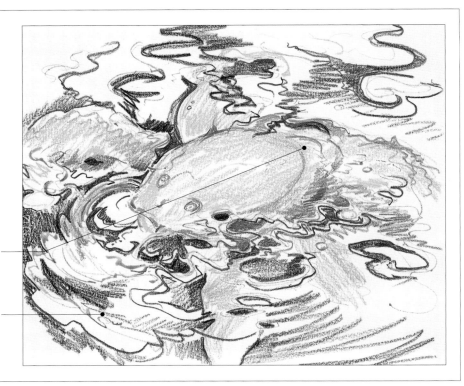

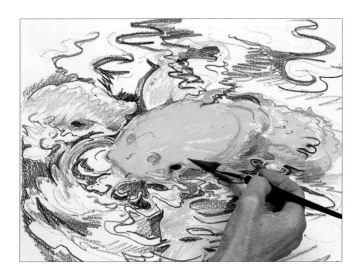

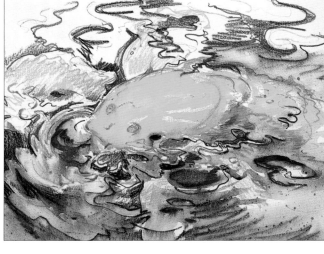

6 Dip a paintbrush in water and gently brush over the large fish. Note how intense and vibrant the colour becomes.

7 Brush clean water over the painted water, following the lines of the ripples, leaving some highlighted ripples white.

Tip: You may find it best to lay the drawing flat at this stage, so that the water doesn't run down it.

Tip: If the water runs where you don't want it to go, simply blot it off with absorbent kitchen paper.

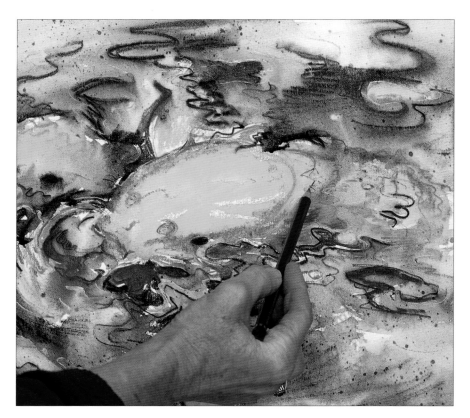

9 Dip a red pencil in water and darken the red of the fish where necessary. Reinforce the outlines of the fish with a blue pencil. Leave to dry.

8 Brush clean water over the small fish. Allow the support to dry slightly, but not completely, and go over the reddest parts of the fish with a reddish brown pencil. The colour will intensify. It will also blur and spread, so you won't get any hard edges. The blurred orangey-red will look as if it is under water – so it will become clearer which parts of the large fish are jutting up above the water's surface.

10 Rub off the masking fluid. Scribble blue-green into the darkest parts of the water, pressing quite hard with the pencil to create the necessary depth of colour.

The finished drawing

Capturing a sense of movement, this drawing demonstrates the potential and versatility of water-soluble pencils and combines linear detailing with lovely, fluid washes that intensify the colours and blend them together on the support.

Masking fluid can be used to keep the highlights white.

Curved pencil strokes create a sense of movement in the water.

The transition from one colour to the next is almost imperceptible.

Dolphin in acrylics

With their high intelligence and inquisitive nature dolphins are, for many people, one of the most fascinating and appealing of all animal species. This demonstration gives you the chance not only to capture a good likeness of this beautiful creature, but to practise painting the effect of light on water.

If you're lucky enough to see live dolphins, do not rely entirely on photographs for your reference material. Sketching a leaping dolphin might seem rather daunting at first, but start by asking yourself a few simple questions. How high above the water surface does the dolphin leap? At what angle is the body in relation to the water? If you spend time studying them, you'll soon see some patterns recurring. Look, too, at the light. How intense is it? Is the sun high in the sky, hitting the top of the animal, or lower, illuminating the animal from the side? And what about the water? Where are the highlights and shadows, and how many different colours can you see within the water?

The dolphin's body is fairly uniform in colour, so the key to making this painting work is assessing the tonal values carefully in order to make the animal look three-dimensional. One of the joys of working in acrylics is that the paint is opaque – so if you get it slightly wrong you can simply paint over what you've already done.

You can have fun experimenting with different ways of capturing the splashes of water. Here, the artist spattered on white paint in the final stages – but you could spatter on masking fluid right at the start, to preserve the white of the paper.

Materials
- *Good-quality watercolour paper*
- *2B pencil*
- *Acrylic paints: cerulean blue, violet, titanium white, bright green, ultramarine, burnt sienna*
- *Brushes: medium round, small flat, small round*
- *Painting knife*

1 Using a 2B pencil, sketch the scene, putting in some of the ripples in the water as well as the dolphin. Check carefully to make sure the proportions of the dolphin and the curve of its back are correct. Here the dolphin's eye has been positioned 'on the third' – a classic compositional device.

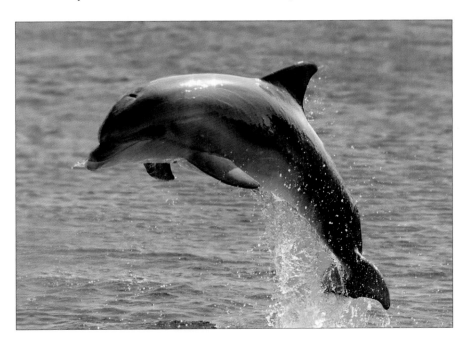

The subject
This scene has a wonderful feeling of light, with the sunlight sparkling on the sea. The dolphin is leaping right out of the water, its beautifully arced back creating a lovely dynamic shape. The splashes of water give a great sense of motion. Here, the artist decided to make a portrait-format painting in order to emphasize the height of the dolphin's leap.

2 Mix a bright blue from cerulean, violet and white. Using a medium round brush, dab it on the water area quite thickly, varying the proportions of the colours in the mix and using short horizontal strokes to create the effect of ripples in the sea. Add in some bright green, allowing it to blend into the blue mix. Leave gaps for the bright highlights on the water.

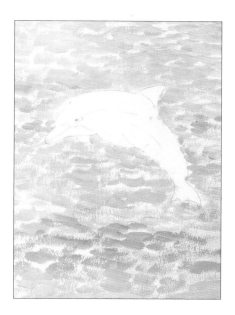

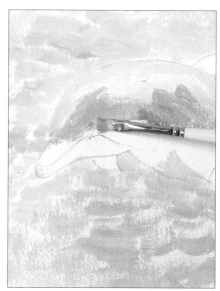

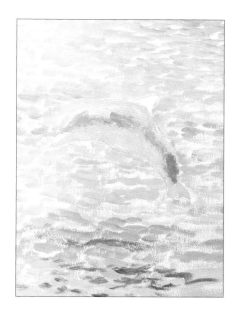

3 Continue with the blue-green mixes, working carefully around the outline of the dolphin, until all the sea area has been roughly put in. This is similar to the approach used by the Pointillist painters; when viewed from a distance, the colours will appear to combine together to create shimmering mixes.

4 Mix a light violet from violet and white. Using a small flat brush, put in the light tones on the top of the dolphin's back. Add ultramarine to the mix and put in the mid tones. Once you've established the mid tones, you'll find it easier to judge how light or dark the rest of the animal needs to be.

5 Continue developing the form on the dolphin, using almost pure violet for the darkest tones on the centre of the back and a mix of cerulean and white for the lightest tones.

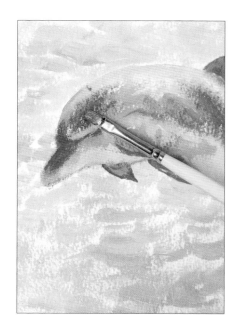

6 Add burnt sienna to the dark mix on the nose, fins and centre of the back. This adds warmth to the colour as well as darkening it. Keep the paint quite thick. Use an almost dry brush, with very little paint, and drag the brush lightly across the paper to create a slightly broken, mottled texture.

7 Keep assessing the light and dark tones as you work. Note how the sun catches the top of the dolphin's body: use a very pale mix of violet and white here and make sure that the edge of the body is sharply defined, so that it stands out from the water.

8 Using the tip of a small round brush, carefully paint the details of the nose and eye in pure violet.

▶

Assessment time

It is only by correctly placing the light and dark tones that you can make the animal look really rounded and three-dimensional – and one of the most common mistakes is to make both the darkest and the lightest tones too close to the mid tones. However, acrylic paint is opaque, so you can just paint over what you've already done if you need to make minor adjustments. Here, the dark tones are dark enough – but the top of the dolphin's body needs to be a bit lighter to create the impression of strong sunlight hitting the body.

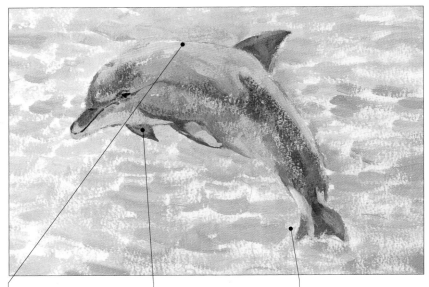

This area is too close in tone to the mid tones: it needs to be lighter.

The dark tones work well: they help convey the rounded form of the animal as it turns away from the light.

Adding splashes of water as the dolphin emerges from the sea will really help to create a sense of movement in the painting.

9 Again using the small round brush, redefine the outline of the dolphin by putting some dark blue-violet into the water immediately behind it, so that the light colours on the dolphin's back really stand out. Apply dilute white to the very brightest areas along the top of the dolphin's back, using clean water to blend the paint into the previous colours so that you do not get any harsh transitions from one tone to the next.

10 Mix violet with lots of white to make a very pale blue-white. Using the small flat brush again, brush this mix on in long, vertical strokes for the water streaming off the underside of the dolphin's body.

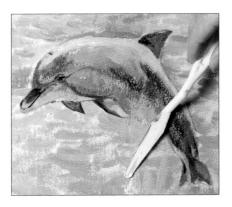

11 Repeat the previous step, but this time use a palette knife instead of a brush, and make the paint much thicker so that the streams of water are more pronounced.

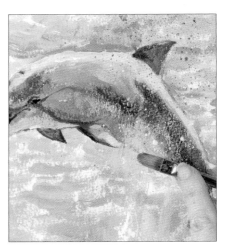

12 Spatter violet paint over the water behind the dolphin and thin white paint over the dolphin's body, where it emerges from the water.

Tip: Tap gently, and do not overload the brush with paint – otherwise you may find that the droplets of spattered paint are too large.

The finished painting

This is a very lively and atmospheric painting that is full of movement. Note that if you divide the picture space into three, both horizontally and vertically, the dolphin's nose and tail fall more or less on the intersection of the thirds – a classic compositional device. The colour palette is limited – mostly blue-violet, blue and green, which gives a lovely, restful colour harmony – but the tones have been extremely well observed, giving good modelling on the dolphin. Short, horizontal strokes of the brush have been used to create the gently rippling sea, with spattering and longer brushstrokes adding the texture of the splashes of water.

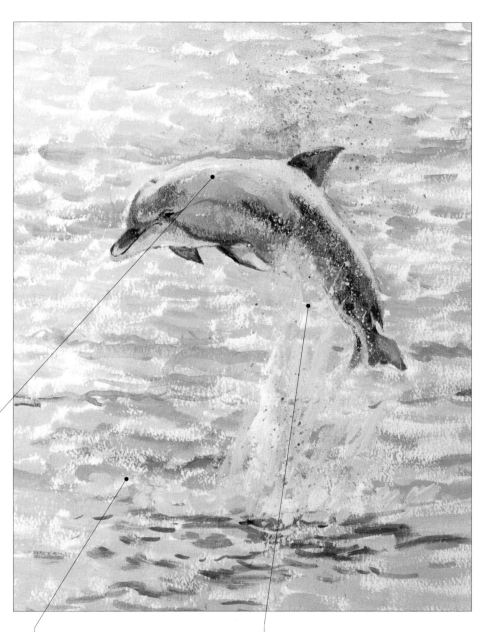

Drybrush work on the dolphin's body allows the texture of the paper to show through and creates a lovely mottled effect on the dolphin's skin.

Although the sea has been loosely and spontaneously painted, note how many different colours there are in the water, with gaps left for the bright highlights.

Spattering and long strokes of thicker paint are used to convey the splashes of water.

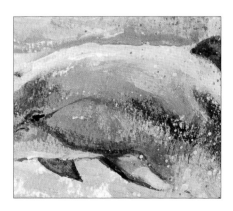

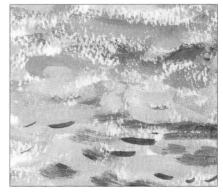

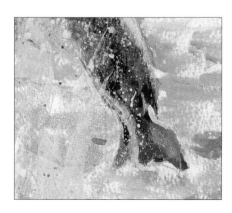

Tropical fish in acrylic inks

Your main challenge in this project is to recreate the wonderfully vibrant colours of the fish. Acrylic inks (used here) are one option: simply mix them on a palette, as you would with watercolour or acrylic paints, to create the colours you need. You could also try combining acrylic paints with a pearlescent or an iridescent medium. Pearlescent mediums create a shimmering effect, while iridescent mediums contain tiny flakes of mica that, when mixed with paint, appear to change colour depending on the direction of the light. These mediums are particularly effective with transparent colours.

Note that many of the markings on the fish are not solid, unbroken lines. If you paint them as solid lines, you run the risk of creating an image that is more like a cartoon character, or a

design for stained glass. Instead, use the tip of your brush to dab on tiny dots and dashes of ink and create a much more lifelike effect.

The coral in the background of this image adds a lovely texture behind the fish. You can put in as much or as little of it as you wish, but remember that the fish is the most important part of the painting and should remain the focus: the coral is behind the fish, so paint it in less detail. Let the inks do a lot of the work for you. Drop the coral colours on to wet paper, so that they blur and spread, and try tilting your drawing board to create interesting runs of colour. When the background has dried, you can then decide if you want to add more linear detailing and texture to the coral – but do not allow it to dominate the painting.

Materials
- *Good-quality watercolour paper*
- *2B pencil*
- *Masking fluid*
- *Ruling drawing pen, dip pen or brush*
- *Acrylic inks: crimson, phthalocyanine blue, pearlescent blue, burnt sienna, bright green, yellow-gold, bright red, pearlescent violet, pearlescent crimson*
- *Brushes: rigger, large round*

The subject
A side-on viewpoint allows us to see the shape and markings of this tropical fish, while the deep blue of the sea sets off the fish's vibrant colours. Note that the fish is angled slightly upwards, which makes for a more dynamic composition. The coral provides a natural-looking setting without detracting from the main subject.

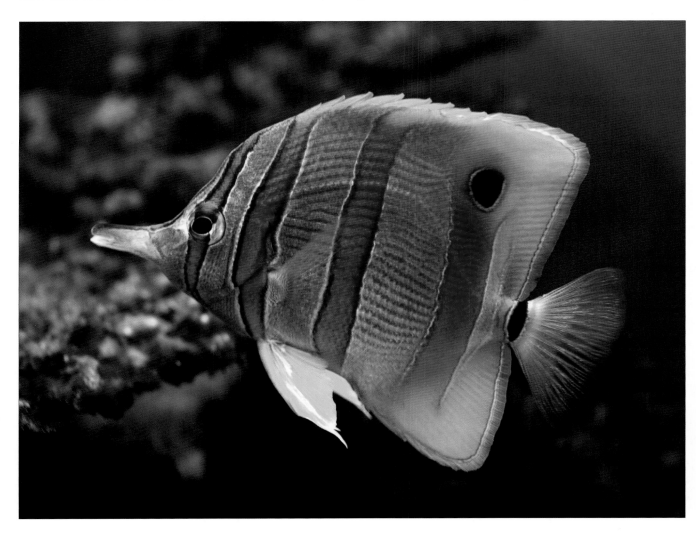

1 Using a 2B pencil, sketch the fish, putting in the main markings.

Tip: It's a good idea to mark the tips of the fish's nose and tail lightly on the paper before you start, to ensure that you can fit everything in.

2 Using a ruling drawing pen, a dip pen or an old brush dipped in masking fluid, mask out the very light markings on the fish. Leave to dry.

Tip: The masking fluid must be completely dry before you go on to the next stage.

3 Mix a deep purple-black from pearlescent crimson and phthalocyanine blue acrylic inks. Using a rigger brush, put in the very dark lines on the edges of the fish's striped markings. The colour is darkest near the fish's head: add more water to lighten the colour as you work down the body.

4 Add more phthalocyanine blue to the mix and put in the blue lines and circular markings near the tail. Don't worry about the mixes varying slightly in tone: if the fish's markings were all painted a uniform, solid colour, the image would look more like a cartoon than a painting.

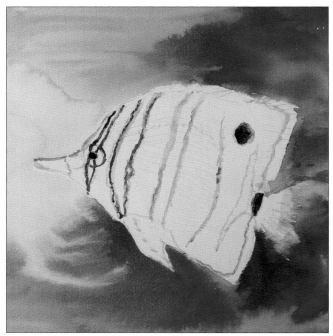

5 Wet the background with clean water, taking care not to go over the fish. Using the dropper from the ink bottle, drop on pearlescent blue and phthalocyanine blue inks, then brush the colours together with a large round brush, lifting off ink in places to get some tonal variation in the water. Leave the coral reef on the left of the image untouched.

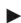

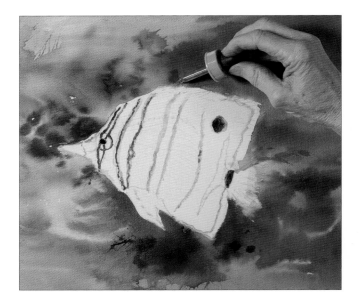

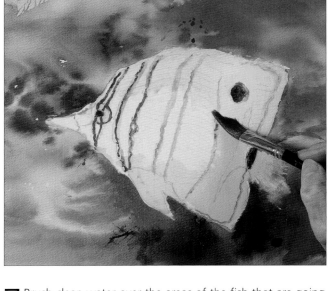

6 Dot burnt sienna ink on to the coral area, touching the pipette directly on to the paper to get little blobs of colour that spread outwards, wet into wet. Repeat with bright green ink, again allowing it to spread naturally.

7 Brush clean water over the areas of the fish that are going to be orange or yellow. Using a medium round brush, brush yellow-gold ink over these areas. The ink will spread over the damp paper of its own accord and, by working wet into wet, you will avoid getting any obvious brush marks.

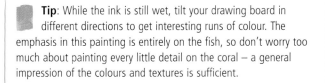

Tip: While the ink is still wet, tilt your drawing board in different directions to get interesting runs of colour. The emphasis in this painting is entirely on the fish, so don't worry too much about painting every little detail on the coral – a general impression of the colours and textures is sufficient.

Tip: It doesn't matter if you go over the inks you laid down in Steps 3 and 4: once the ink has dried, it should not lift off.

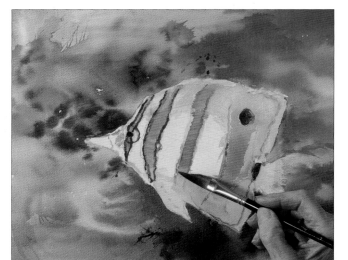

8 Mix a bright orange from yellow-gold and bright red inks. Brush in the orange parts, applying two or more layers for the really dark orange parts. In some areas, the orange is a deep, burnt orange – add more red to the mix for this. Brush on a second layer of colour in short, horizontal strokes so that you begin to develop some of the striped markings.

9 Deepen the orange/red markings by applying another layer of colour. Mix a deep violet from pearlescent violet and a little pearlescent crimson and paint the violet vertical stripes. Add more crimson to the mix and, holding the brush almost vertically and allowing only the tip to touch the paper, put in the horizontal markings that run across each stripe.

Assessment time

In the final stages, concentrate on boosting the depth of colour on the fish where necessary and on refining the markings on the fish's body, so that you create more texture. You also need to make sure that the fish stands out from the background; in places, the fish almost merges into both the coral and the surrounding sea. The area of sea just below the coral, to the left of the fish, is distractingly bright.

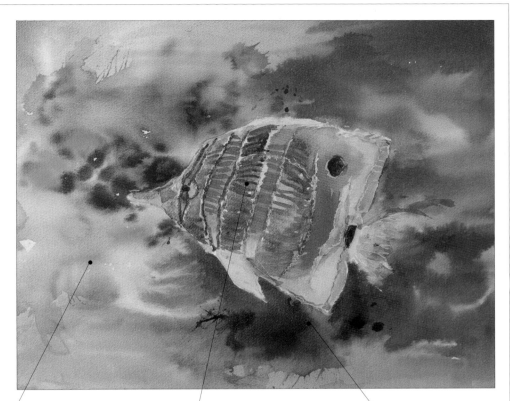

The coral is rather indistinct and formless and needs to come forwards in the image.

The markings can be reinforced a little more strongly.

Darkening the sea around the fish will allow it to stand out more clearly.

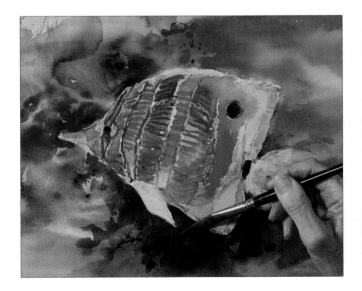

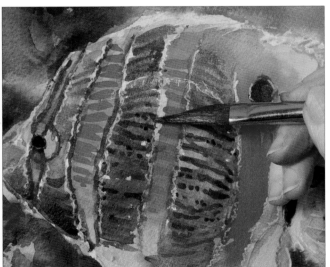

10 Wet the background with clean water, brushing carefully around the fish. Dot the deep violet colour from Step 9 into the coral, wet into wet, allowing it to spread to create more texture and colour. Carefully apply dark blues and purples underneath the fish, cutting right in around the edge to define its shape more clearly and allow it to stand out from the background.

11 Using the pearlescent crimson and phthalocyanine blue mix from Step 3 and the tip of the brush, go over the horizontal markings again, making tiny dots of colour. Textural details such as this are another way of ensuring that the fish stands out from the background.

▶

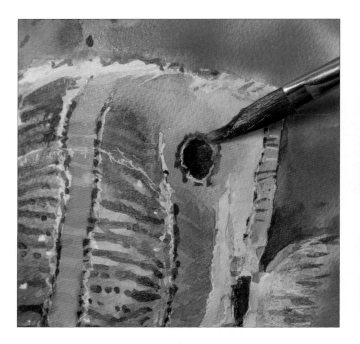

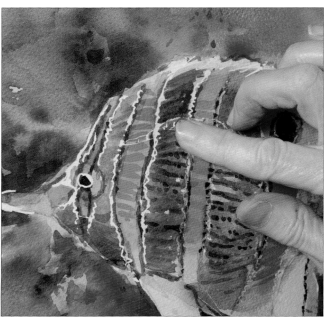

12 Use the same colour and 'dotting' technique to redefine the vertical bands that you painted in Step 3. Cut in around the 'frilly' edges at the top of the fish with dark blue, so that the shape of the yellow fronds is more clearly defined. Darken the tiny band of orange around the eye-like marking near the tail. Leave to dry.

13 Using your fingertips, carefully rub off all the masking fluid that you applied in Step 2 to reveal the very lightest markings on the fish.

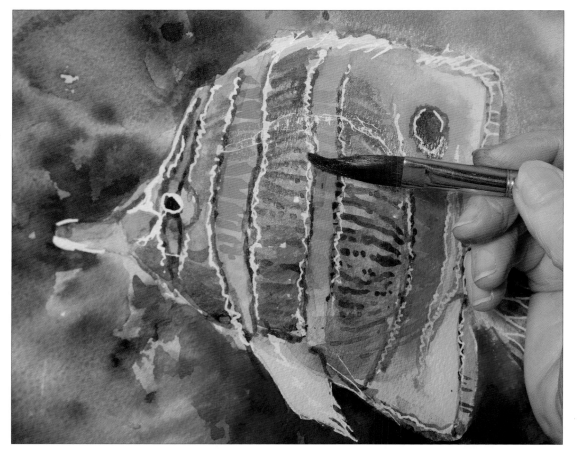

14 Some of the white now looks too stark. Brush over it with very dilute pearlescent blue or violet, as necessary, leaving only the very brightest markings as white paper.

The finished painting

This lively painting exploits the wet-into-wet technique to the full, with wonderfully atmospheric blurs of colour in the sea and coral. The layers of colour on the fish have been built up gradually, with delicate wet-on-dry brushstrokes being used for many of the markings. The deep blue of the sea sets off the vibrant yellow and orange stripes beautifully.

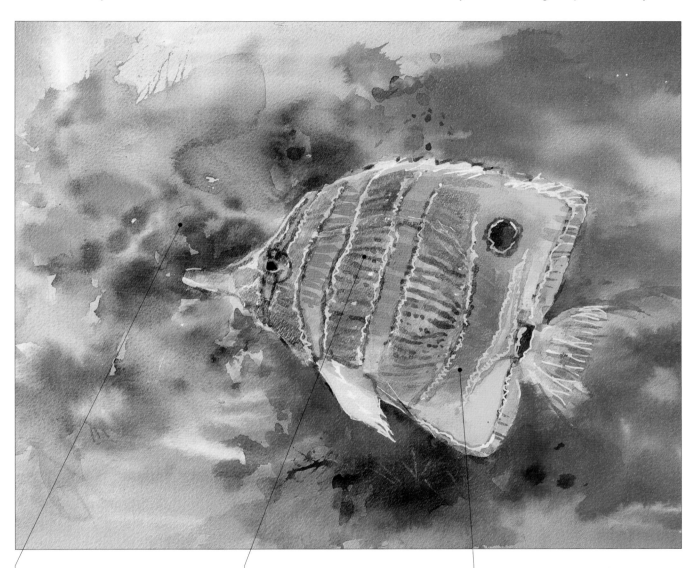

The colours have blurred and spread, wet into wet, creating interesting shapes and textures without detracting from the main subject.

The markings have been painted using tiny dots and carefully controlled horizontal brushstrokes, creating delicate but important textural detail on the fish.

The complementary colours – orange/deep blue and yellow/violet – really sing out and help to give the subject a feeling of great energy.

Tropical butterfly in oils

Both butterflies and moths belong to the scientific order Lepidoptera, which means 'scale-wing' in Latin, and most butterfly wings are covered with tiny, individually coloured scales arranged in partially overlapping rows, like tiles on a roof. Butterfly houses give you the chance to see all kinds of exotic, brilliantly coloured and patterned species. This peacock pansy butterfly (*Nymphalidae precis almana*) is indigenous to Nepal and neighbouring regions and is characterized by the eyespots on the wings, which act as a deterrent to potential predators.

The artist selected a smooth-surfaced board for this study in oils, for two good reasons: first, he wanted this to be a detailed painting and a smooth surface allows you to put in small details without the paint spreading and sinking into the support; second, he did not want the texture of the support to show through in the final painting.

To speed up the drying time so you can complete the painting in one session, add a drying agent such as drying linseed oil.

As each scale on the wing is differently coloured, you will find infinitely subtle gradations of tone. One way of conveying both the texture of the wings and the subtlety of the colour shifts is to stipple the paint on, using the tip of the brush, to create optical colour mixes in the same way that the Pointillist painters such as Georges Seurat (1859–91) did. However, although some inks and liquid watercolours can come close, it is difficult to match the intensity of iridescent colours with even the brightest of pigments.

Materials
- *Smooth-surfaced board*
- *HB pencil*
- *Oil paints: chrome yellow, cadmium orange, geranium lake, brilliant pink, titanium white, ultramarine blue, turquoise blue deep*
- *Turpentine (white spirit)*
- *Drying linseed oil*
- *Brushes: selection of fine rounds, filbert*

The subject
With its dramatic eyespots and brilliant colouring, this peacock pansy butterfly makes an appealing subject for a painting. However, the artist decided not to include all the flowers, as he felt they detracted from the butterfly. It is perfectly permissible to leave out certain elements of a scene in order to make your painting more dramatic.

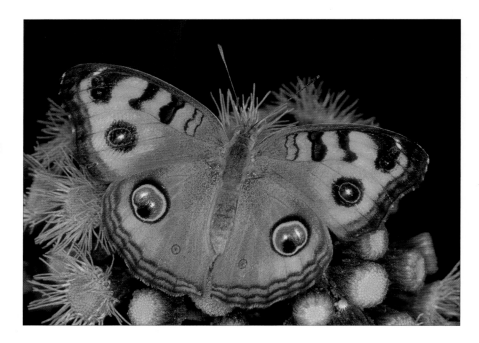

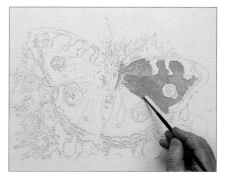

1 Lightly sketch the butterfly in HB pencil. It is entirely up to you how much detail you put into your underdrawing, but including the veins and the fringe-like pattern around the outer edge of the wings will make it easier for you to keep track of where you are in the painting.

2 Using a fine round brush and alternating between chrome yellow and cadmium orange, start putting in the basic colour of the wings. Thin the paint with turpentine (white spirit) and mix it with drying linseed oil so that it is the consistency of single (light) cream.

Tip: Use a different brush for each colour, so that you do not have to keep stopping to clean brushes.

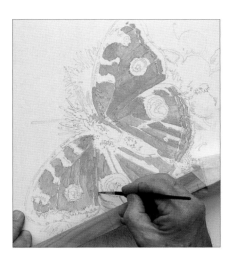

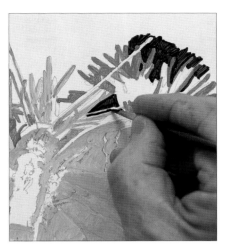

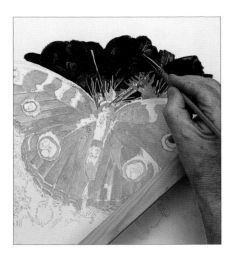

3 Continue until all the yellow is complete, looking closely at your subject to see the different tones. You may need to turn the support around and use a mahl stick to keep your hand clear of wet paint. If you do not have a mahl stick, you can improvize one by taping rags around one end of a thin piece of wood or dowelling, as the artist did here.

4 Mix a range of bright pinks from geranium lake, brilliant pink and titanium white and start painting the flowers on which the butterfly is resting. Mix a dark, purplish blue from ultramarine blue and geranium lake and start putting in the background, taking care not to get any colour on the butterfly. Again, use a mahl stick, if necessary, to keep your hand clear of any wet paint.

5 Continue painting the background, carefully cutting in around the flower tendrils.

Tip: When you are clear of the butterfly and flowers, switch to a larger brush to enable yourself to cover the background more quickly.

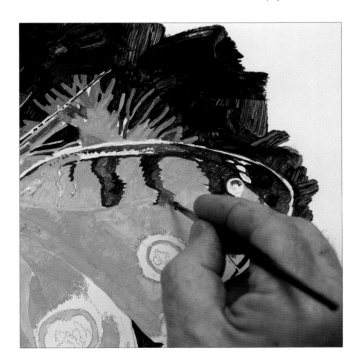

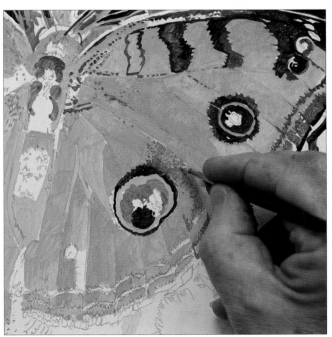

6 Using the same colours that you used for the flowers and background, start putting in some of the dark detail on the butterfly, using short brushstrokes to convey the texture of the scales on the wings.

7 Paint the 'eyes', using cadmium orange and the purple/pink mixture from Step 4, and stipple the colour on with the tip of the brush to create an optical colour mix. Note that there are bluish-purple patches next to the two largest eyes: add more white and ultramarine blue to the mixture for these areas. Paint the 'fringe' around the outer edge of the wings in oranges and pinks, as appropriate.

Assessment time

The main elements of the painting are in place. All that remains is to add more fine detailing to the butterfly and complete the surrounding flowers and background, working carefully and methodically. Although the artist had originally intended to include the flowers to the right of the butterfly, at this point he decided that they would detract too much from the painting of the insect.

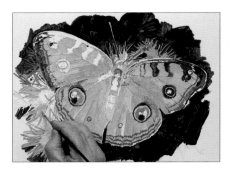

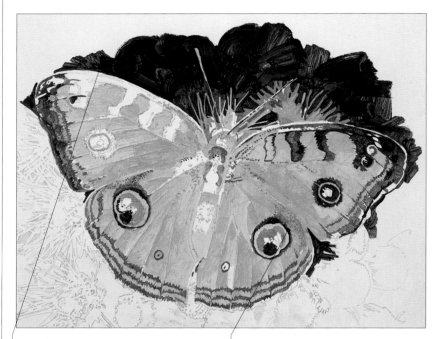

The dark background acts as a foil to the butterfly. Keeping its edges irregular adds to the informality of the study.

The detail is beginning to take shape; features like this are best put in during the final stages, when the underlying colours and shapes have been established.

8 Using a fine brush and the same pinks and purples as before, paint the flowers on the left-hand side, gradually working down the painting. Paint as much of one colour as you can while you have it on your brush. When you have finished the flowers, paint the dark background.

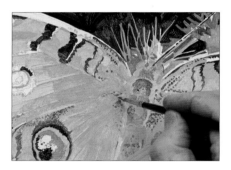

9 Paint the body of the butterfly, blending the colours on the support so that the brushstrokes are not visible.

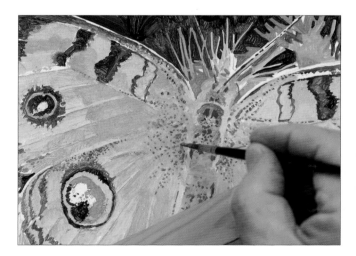

10 Continue painting the dots of colour on each side of the body. Although the dots are clustered more densely near the body, the same colours also run along some of the veins. Finish painting the 'eyes' on the left-hand side of the butterfly, using the same colours as before.

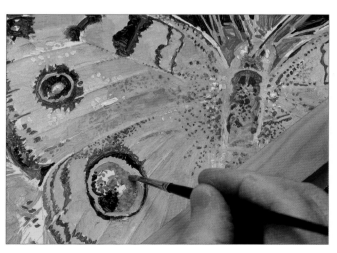

11 Mix a bright blue from turquoise deep blue and white and dot it into the whites of the 'eyes'. The patterning is now beginning to stand out strongly. Reinforce the orange areas around the two largest eyes with cadmium orange, deepening the colour with geranium lake where necessary.

The finished painting

Although this was never intended as a photorealistic painting, Pointillist-style dots of colour help to capture the iridescent quality of the wings – something that cannot be achieved easily in paint. Much of the painting consists of a single layer of paint, which is appropriate for the thin and delicate structure of the insect. Note the clever use of different lengths of brushstroke to create texture: longer, blended strokes are used for the furry body, while short strokes and tiny stipples convey the individual scales on the wings. The artist has also used some artistic license in reducing the number of flowers so that the butterfly is more clearly defined against the dramatic, dark background.

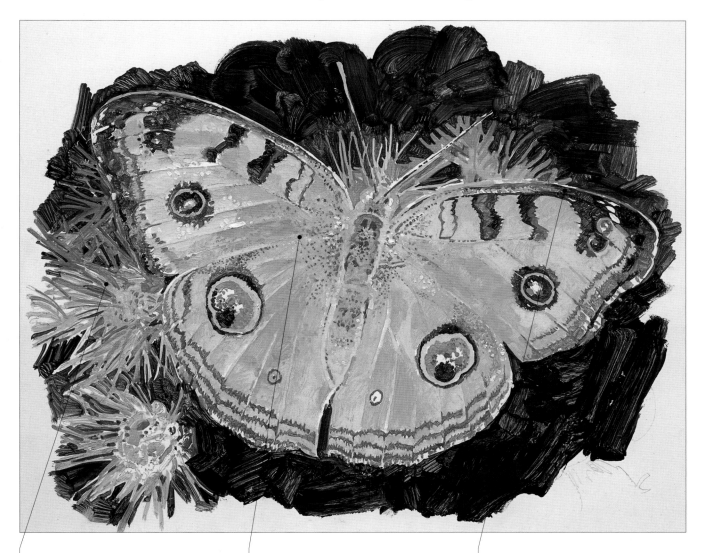

The flowers are loosely painted but echo some of the colours in the butterfly.

Different lengths of brushstroke create different textures.

The butterfly stands out clearly against the dark background.

Dragonfly in watercolour

Dragonflies can often be seen in summer on or near garden ponds or waterways and with their spectacular, jewel-like colours, they are a delight to watch and sketch. They can fly at incredible speed, so your only real chance of sketching them is when they are at rest. This gives you the perfect opportunity to study their anatomy closely, as most dragonflies at rest hold their wings out horizontally (unlike damselflies, which hold their wings together or just slightly open when at rest). You will see that they have four semi-transparent wings, which broaden near the base at the point where they attach to the body, and two large eyes, which take up most of the head.

If you're painting from a close-up photo, beware of putting in too much detail on the dragonfly, even though it is clearly visible in your reference. It is difficult to see this much detail with the naked eye, so if you include it in your painting it will look unrealistic.

You might choose to fill your picture space with the dragonfly, in which case you will probably be painting it several times larger than life size. If you choose to include more of the surroundings, think about the scale and make sure that the insect and the surroundings are in proportion to each other. Position the insect in the foreground of your painting, so that you can paint the detail. The further away the insect is, naturally, the less detail you will be able to discern, so if you have a detailed insect in the middle distance of your painting, you will destroy the sense of scale and distance. By placing the dragonfly in the foreground you can also, to some extent, free yourself from the problem of it being in scale with the background. In the demonstration shown here, if the dragonfly was on one of the lily pads, it would be very small if painted to the correct scale.

Look, too, for interesting lines and shapes in the surroundings that will bring another visual element to your painting. Here, the artist made a feature of the vertical stems in the background, which contrast with the rounded shapes of the lily pads and make for a more dynamic composition.

Materials
- *Heavy watercolour paper*
- *4B pencil*
- *Watercolour paints: yellow ochre, Indian red, cadmium yellow deep, cerulean, cobalt blue, ultramarine, lemon yellow, light red*
- *Brushes: large or medium round, rigger*

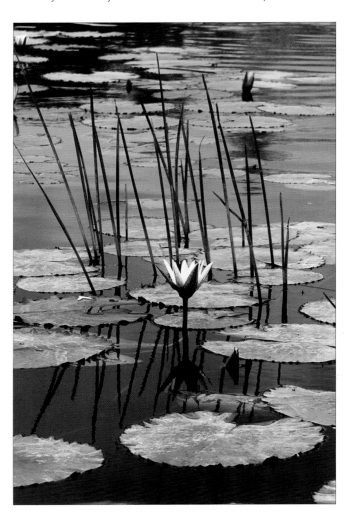

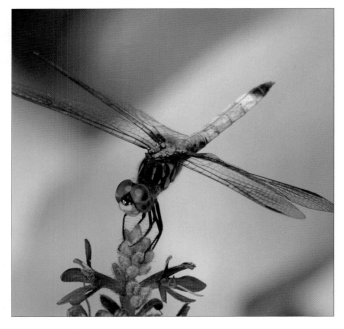

The subject
To create this painting, the artist worked from two photos – a close-up shot of a dragonfly (above) and a photo of waterlilies on a lake (left). Although the dragonfly is a fascinating subject in its own right, he wanted to place it in a recognizable setting rather than simply replicate the blurred, out-of-focus background of the reference photo. He elected to place the dragonfly in the foreground of the image, with the round shapes of the waterlily pads and the vertical lines of the grasses behind providing added interest.

Thumbnail sketch

Simple thumbnail sketches are always a good way of working out the composition of your painting and are essential when you're combining two or more references. Here, the artist opted for a version in which the dragonfly is in the foreground so that attention is concentrated on it, and the lily flower is off-centred some distance behind it.

1 Using a 4B pencil, sketch the subject. Pay particular attention to where the reflections start: note how the water distorts the shape of the reflections so that the edges of the grass stems appear to ripple slightly.

2 Mix a yellowy orange from yellow ochre and a touch of Indian red. Using a large or medium round brush, loosely wash in the underlying yellow colour of the lily pads and the submerged foliage.

4 Mix the deep blue of the water from cobalt blue, ultramarine and a little yellow ochre. Loosely brush this colour on.

3 Mix a pale green from cadmium yellow deep and cerulean. Loosely establish the light blue-greens of both the lily pads and water.

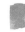 **Tip:** Don't worry if you paint over the grass stems. These are very dark in colour, so any blue paint will be easy to cover at a later stage.

▶

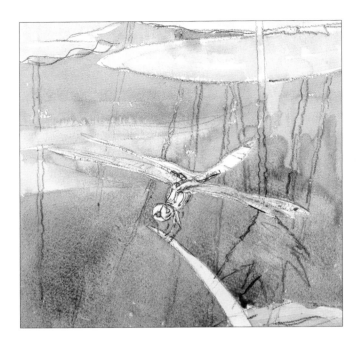

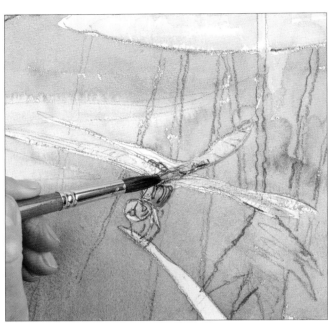

5 Make the colour stronger as you work down the paper. The closer it is to the viewer, the darker the water should look. The dragonfly's wings are semi-transparent, so you can see some of the water through them: drag the brush lightly across the wings, barely touching the surface, to create this effect. Leave to dry.

6 Mix a very light blue-green from cerulean and a tiny bit of lemon yellow and paint the dragonfly's head and body. Lightly brush cobalt blue over the dragonfly's thorax.

7 Mix a dark reddish brown from light red and ultramarine and put in the dark grass stems and their reflections.

Tip: Use a wiggly line for the stem reflections, as their shape is distorted by the water.

8 Mix a bright green from cerulean and lemon yellow. Brush this colour mix over the lily pads, allowing some of the initial yellow colour applied in Step 2 to show through. Keep the lily pads fairly light in colour, in contrast to the rich, dark blues of the water.

Assessment time

All the elements of the image are now in place, but the image is too pale overall. Concentrate on strengthening the tones – but remember that watercolour always looks slightly lighter when dry than when wet. Build up the layers gradually until you achieve the density of tone that you want. You also need to make the dragonfly stand out more from the background; the way to do this is to make the background much darker.

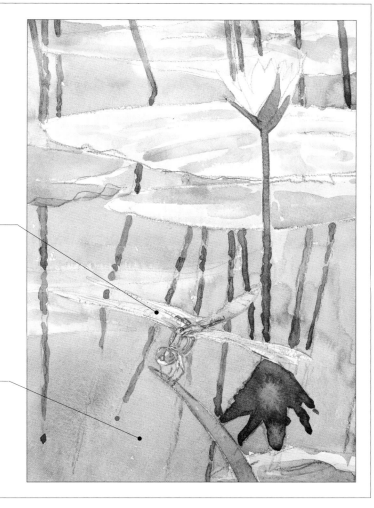

The dragonfly is merging into the background and needs to stand out more clearly.

The water is too pale, and needs to be a much more rich blue colour in the foreground area.

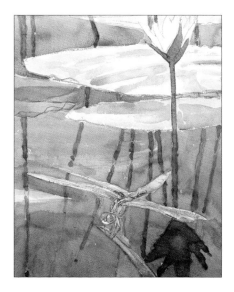

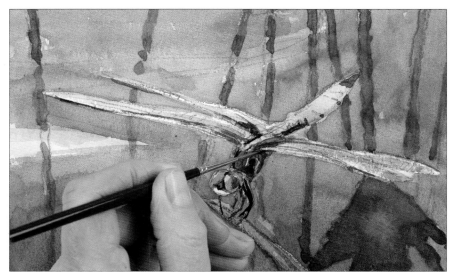

9 Deepen the watercolour with a rich mix of cobalt and a tiny amount of lemon yellow. Brush some of the colour over any areas of the lily pads that are partially submerged.

10 Mix a dark purple-black from ultramarine and Indian red. Using a rigger brush (or any thin brush that comes to a fine point), put in the detailing on the dragonfly – the dark colours on the underside of the thorax and along the edges of the delicate lace-like wings. Use an almost dry brush and very little paint so that you can control exactly where you place these very fine lines.

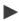

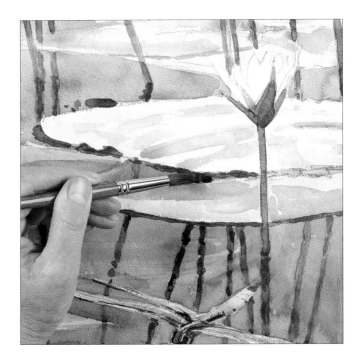

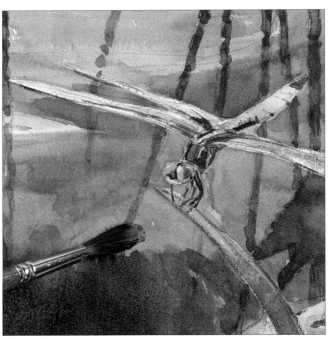

11 Darken the reflections of the grass stems a little, using the same light red and ultramarine mix as before. Mix a dark blue-green from ultramarine and yellow ochre and put in the slight shadows under the edges of the lily pads so that they look more three-dimensional.

12 Using the cobalt blue and lemon yellow mix from Step 9, darken the area immediately around the dragonfly so that the subject stands out from the background more. Brush the same colour over the bottom left corner of the image, where the water is more densely shaded.

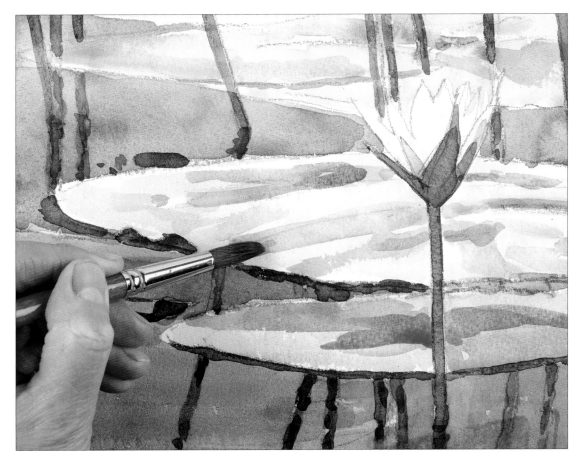

13 Mix a bright blue-green from lemon yellow, cerulean and a little ultramarine, and darken the foremost lily pad so that it comes forward in the painting a little more.

The finished painting

This painting has a lovely feeling of spontaneity that is perfectly in keeping with the subject; one feels that the dragonfly has alighted only momentarily and might take off again at any moment. The lily pads and stems have been painted fairly loosely, but their lines and shapes counterbalance the horizontal lines of the insect's wings. The restricted colour palette – predominantly soft blues and greens – is harmonious and restful to look at. The colours in the water have been built up gradually in thin layers, with each layer modifying the previous one; as a result, the water contains many subtle variations that are far more effective than a flat application of one tone or colour could ever be.

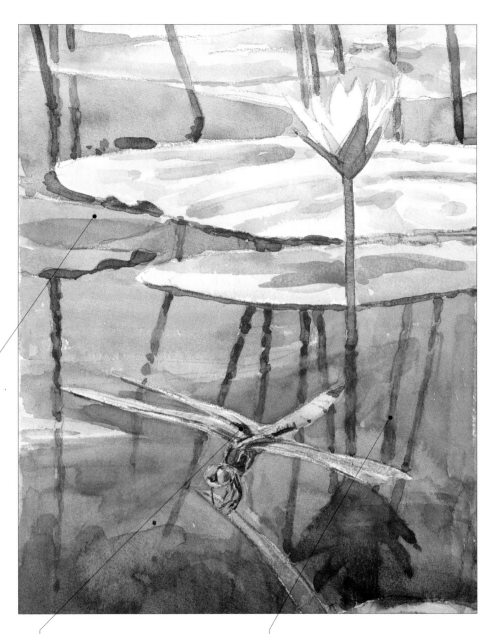

Note how a slight shadow under the lily pads immediately makes them look three-dimensional.

The dragonfly's wings are semi-transparent, so some colour can be seen through them; nonetheless, they stand out well against the darker blue of the water.

Note how the reflections are painted in slightly wobbly lines, to show how the water distorts them.

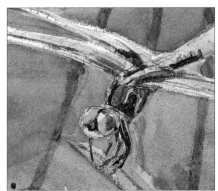

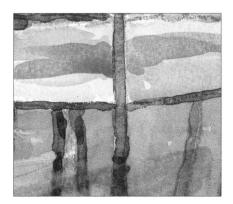

Beetle in acrylics

One of the difficulties that wildlife artists face is that specimens in the field may be set against an unsympathetic or distracting background. If that's the case, then why not use a bit of artistic licence and combine several references to create your own painting?

Your references may be in the form of sketches made in the field, or photographs that you have taken yourself or found in books or on the Internet. Whatever the source, remember to think about the relative scale of the different elements – particularly when you're painting things that are very different in size.

It's also important to make sure that the lighting is consistent. If the sunlight in your sketch or photograph of the habitat comes from the left, the shadows will fall on the right; and if the light illuminating your wildlife subject is from the right, then the shadows will fall on the left. If you follow your references exactly and put in both sets of shadows, they will cross over one another and your drawing or painting will look unrealistic. Decide which direction you want the light to come from in your painting and work out how dense the shadows need to be.

Finally, check that the species you're painting would actually be found in that habitat or on that particular plant. Check the seasonality, too: if you're painting a butterfly on a flower, for example, make sure that both would be found at the same time of year.

Materials
- *HB pencil*
- *HP pre-stretched watercolour paper*
- *Gum strip*
- *Masking fluid and old brush*
- *Acrylic paints: titanium white, yellow ochre, permanent green light, burnt sienna, raw umber, cadmium yellow, ultramarine, burnt umber, permanent rose, cadmium red, phthalocyanine green*
- *Brushes: fan-shaped hog brush, soft badger brush, selection of round brushes*
- *Craft (utility) knife (optional)*

The subject and the setting
For this painting of a rose chafer beetle (*Cetonia aurata*), the artist worked from photographs of a beetle taken in a natural history museum (below) and a thistle – one of the plants on which this particular beetle feeds – growing in the wild (above).

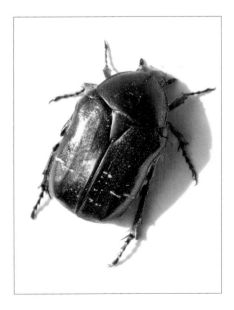

1 Using an HB pencil, sketch the beetle and plant, putting in some light shading for the darkest areas, then paint over the beetle and thistle with masking fluid and leave to dry. Wet the paper, using a brush dipped in clean water. Mix a pale green from titanium white, yellow ochre and permanent green light. Brush this colour over the whole painting, including the masked-out areas, working it well into the fibres of the paper.

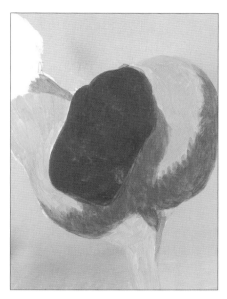

2 Dot pale yellow (white/yellow ochre mix) and dark brown (burnt sienna/raw umber) randomly over the green. Blend the colours together with a fan brush, then go over the marks lightly with a soft badger brush to get rid of any brush marks. Leave to dry.

3 Carefully peel off the masking fluid. Mix a bright but dark green from permanent green light and yellow ochre and block in the beetle. Add cadmium yellow and white to the mix to make a bright, light green and block in the green of the thistle heads.

4 Add ultramarine and a little burnt umber to the bright green mix and begin putting in the shaded areas on the thistle heads. Go over this again with the same mix to solidify and intensify the colour.

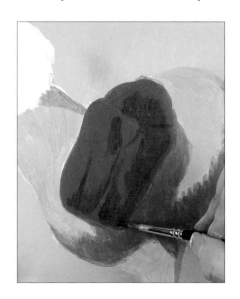

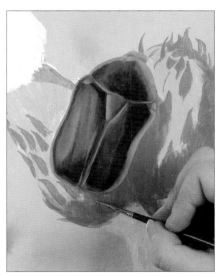

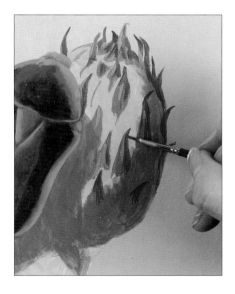

5 Mix a gold or bronze colour for the beetle from yellow ochre, burnt sienna and cadmium yellow. Block in the gold colour of the beetle quite roughly, keeping the paint thin so that some of the underlying green is still visible in places. Darken the mix by adding burnt umber and ultramarine, then paint in the edges of the elytra (the wing casings) and the darker parts of the wings.

6 Mix a rich, golden brown from burnt sienna and yellow ochre and paint the highlights on the elytra. Mix a dark, purple-pink from permanent rose, white, ultramarine and a little burnt umber and put in the mid-toned patches on the thistle heads.

7 Mix a bright pink from white and permanent rose and paint the petals of the flower head, leaving the brightest parts untouched. Add a little burnt sienna and put in the darker tones. Mix a dark purple-red from burnt umber, permanent rose, cadmium red and ultramarine and darken the shaded sides of the 'scales' on the thistle stems so that they begin to look more three-dimensional.

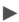

Assessment time

Although the different tones of gold and green on the beetle's shell help to make it look rounded, at this stage there is no real sense of the hard, shiny surface of the shell – some bright highlights are needed in order to convey this. The flower heads are taking shape well, but still look somewhat flat and one-dimensional.

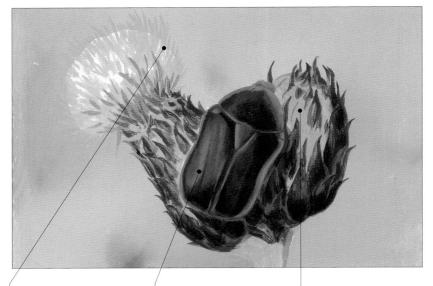

The flower head lacks form and textural detail.

The beetle is too uniform in colour – there are no highlights to indicate light reflecting off the hard carapace.

The underlying green colour of the thistle head is distractingly bright.

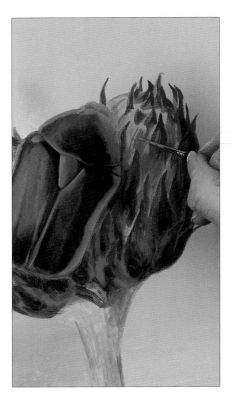

8 Mix a rich, golden brown from burnt sienna and yellow ochre and paint the highlights on the elytra. Mix a dark, purple-pink from permanent rose, white, ultramarine and a little burnt umber and put in the mid-toned patches on the thistle heads.

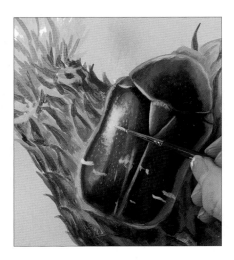

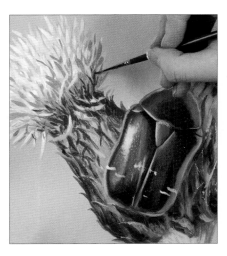

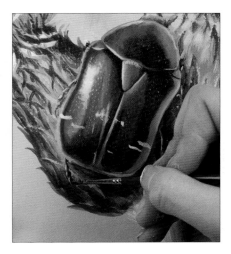

9 Add lots of white to the light green mix from Step 3 and put in the bright highlights on the beetle's shell. These highlights help to establish the curve of the beetle's body and make it look more rounded and three-dimensional.

10 Add lots of white to the bright pink mix from Step 7 and gently stroke it into the flower head to give it more form. Mix a cool purple from permanent rose, white, ultramarine and a tiny bit of burnt umber and put in the shadow colour in the flower head.

11 Mix a very thin dark green from burnt umber, ultramarine, phthalo green and permanent green light and glaze it over the shadow cast on the plant by the beetle. Use the same colour to put in the segments of the legs.

The finished painting

This is a deceptively simple-looking painting, with only two pictorial elements – the beetle and the plant. Nonetheless, the composition has been carefully thought out: the beetle and left-hand flower head are angled to point diagonally away from one another, thus introducing an element of visual tension to what, at first glance, is a very static scene.

The background is soft and muted, but painted in natural colours. The colours are complementary: the pinks and purples enhance and balance the greens. The different tones of green and gold within the beetle have been well observed, creating a good sense of form, while the bright, crisp highlights on the beetle's shell convey its hard, shiny surface.

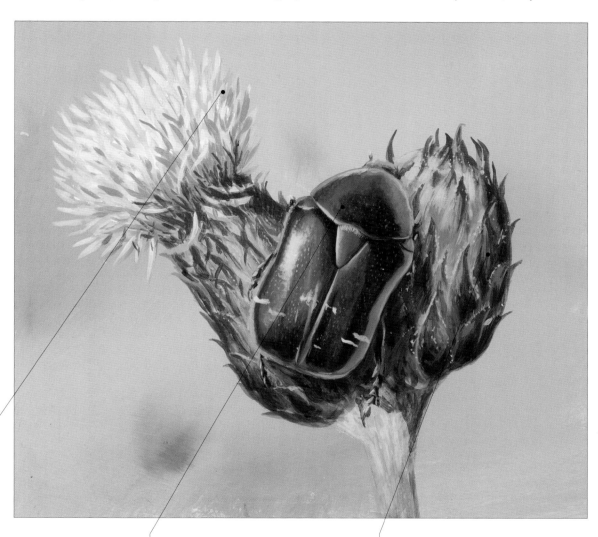

Note the use of different tones of pink on the petals. This helps to make them look rounded and three-dimensional.

The highlights on the beetle's shell are crisp and sharp, indicating that the surface is hard and shiny.

Note the use of cool purple for the shadow areas within the thistle head. This is important in creating a sense of form.

Bee in pastels

Both soft pastels and pastel pencils were used in this demonstration, with the soft pastels being used predominantly for the out-of-focus background elements and the pastel pencils for areas that require finer detail.

To create the soft background effect, the artist has simply blended the soft pastels with her fingers to create a very smooth surface with no obvious pastel marks. When blending, work on sections that are similar in colour first – all the pinks, and then all the greens. If you try to put down all the background colours and then blend the whole thing, you'll end up with a very muddy-looking result. And remember that you don't have to fill in every gap between the flowers; the paper is already a useful leafy-green colour, so use it to your advantage.

At first glance, both the bee and foreground flowers might seem like rather complicated subjects. The key, as always, is to try to see them as blocks of colour rather than as specific things. Start by putting down light layers, simply to establish the position on the paper, and then gradually build up to the correct density of colour, adding textural detail as you go.

There are so many tiny flowers in this particular scene that it's easy to lose track of where you are in the drawing. As the bee is the main subject, use it as a point of reference. Note, for example, where a particular flower aligns with the base of the wings or the edge of a yellow stripe and then take an imaginary line across from the bee to where the flower starts, so that you can be sure of positioning it accurately.

Materials
- *Mid-green pastel paper*
- *Pastel pencils: charcoal grey, yellow, white, fuchsia pink, peach, dark green, bright green, turquoise blue, purple, black, orange-yellow, pink-brown, lemon yellow, flesh colour*
- *Soft pastels: violet, pale pink, ultramarine blue, pale sky blue, brown, purple, white*
- *Cotton bud (cotton swab) or torchon*

The subject
There is an incredible amount of detail in this reference photo, from the tiny hairs on the bee's body to the individual flower petals. Don't lose sight of the fact that the bee is the main subject of the drawing: although they are important, the flowers should always be of secondary interest.

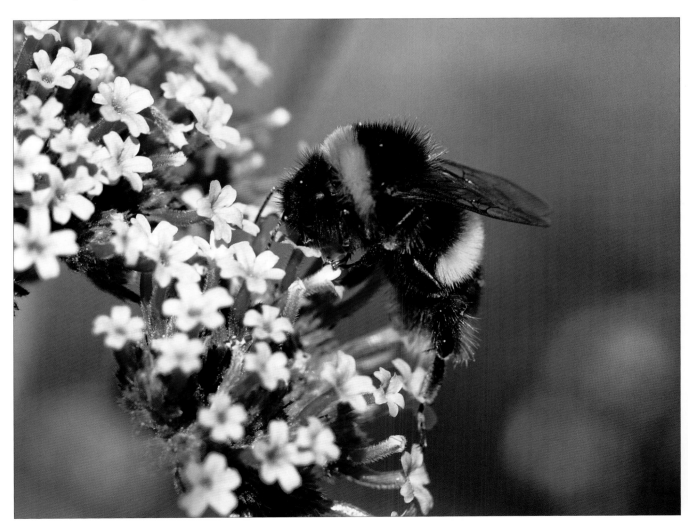

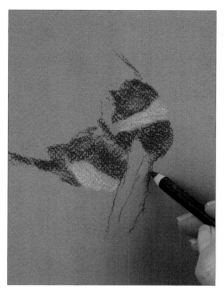

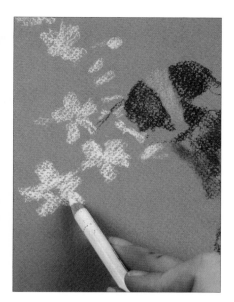

1 Using a charcoal grey pastel pencil, block in the dark markings of the bee's body. Do not press too heavily on the pencil: in this early stage, you are simply establishing the positions of the bands of colour, not attempting to create the right density of tone.

2 Block in the yellow markings, using a yellow pastel pencil. Establish the position of the transparent wings using the charcoal grey pencil.

 Tip: Turn the paper around to prevent smudging when you draw the wings.

3 Using a white pastel pencil, begin mapping out the main flowers. As with the bee, you're not attempting to get the right tone at this stage, you're trying simply to establish the positions and shapes; try to see the flowers as blocks of colour rather than as individual blooms. Make loose, scribbly marks that you can work over again later.

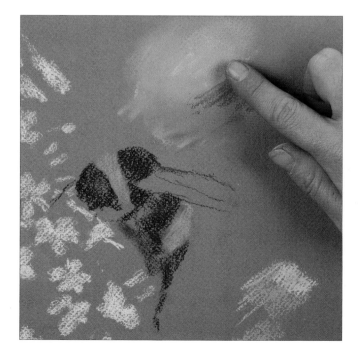

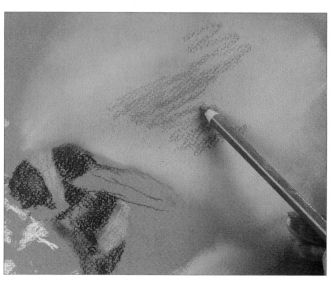

5 Using fuchsia pink and peach pastel pencils, scribble more colour over the out-of-focus flowers, then blend the marks with your fingers.

4 Using a violet soft pastel, scribble in the out-of-focus pink flowers in the background, then blend the marks with your fingertips. Add pale pink, ultramarine blue and pale blue soft pastel on top, as appropriate, and then blend the marks again with your fingers to get a smooth coverage.

Tip: Note that the colours tend to be warmer (pinks and peach) in the centre of the flowers with slightly cooler colours (blues and violet) towards the edges of the flowers.

▶

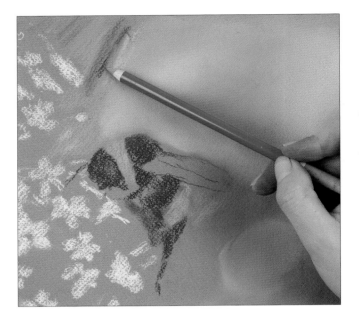

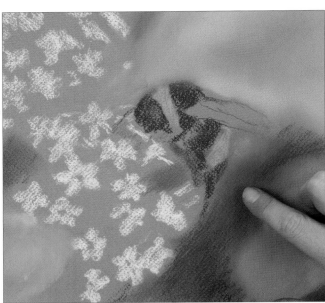

6 Loosely put in the shapes of the leaves behind the flowers, using dark green and bright green pastel pencils. Apply a little turquoise blue pastel pencil along the edge of the out-of-focus flowers to create a slight shadow and the impression of depth, then blend the marks with your fingers.

7 Continue working on the background, adding brown and purple soft pastel just below the bee, where the background is much darker. Take the blended background right up to the edge of the bee: you'll draw over it later to define the detail on the bee.

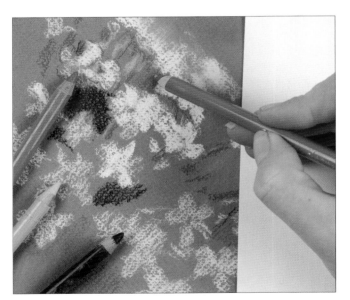

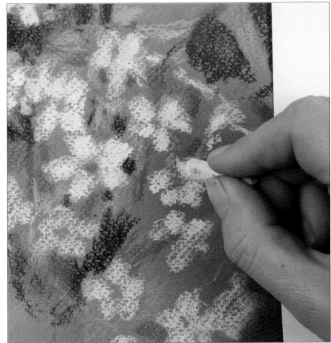

8 Using fuchsia pink, peach and purple pastel pencils, scribble in the pinks and purples of the flowers. Try to see the flowers as blocks of colour, rather than as individual blooms. Roughly block in the spaces between the flowers using a black pastel pencil; overlay purple on the brown for the very darkest patches.

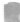 **Tip**: Lay a piece of clean paper over your drawing to prevent smudging what you've already done.

9 Using pink and peach pastel pencils, put in the flower stalks. Dot in bright yellow between the flowers, for the lighter bits of foliage. Now that you're building up colour on the flowers, you may find that you need to strengthen the whites that you put down initially. Use a white soft pastel for this, rather than a pastel pencil, as a pencil will not give you a bright enough white.

Assessment time

Apart from the bee's wings, all the main elements have been mapped in and the drawing is beginning to take shape. However, the bee, in particular, lacks form and detailing.

You also need to take time to assess the tonal balance of the drawing as a whole at this point: now that the pinks and purples of the flowers have been put in, the out-of-focus background of the early stages seems quite cold in comparison.

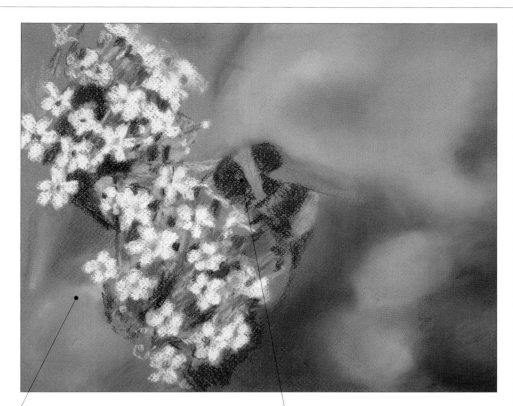

Set against the pinks of the flowers, this area of the background now seems too cool and blue.

Now that you've established the position and shape of the bee, you can concentrate on building up the depth of colour required and on developing the texture of the tiny hairs.

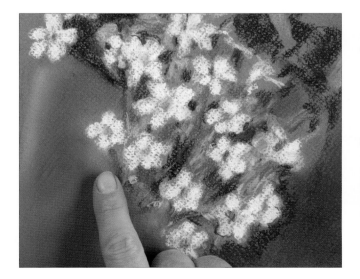

10 Darken the background, using the same colours as before, and gently blend the marks with your fingertips. Drawing is always a gradual process of assessment and refinement: if you had made the background very dark to begin with, you would not be able to apply lighter colours on top.

11 Using a black pastel pencil, go over the black parts of the bee again to instensify them, using a scribbling motion for the densest areas and fine lines for the tiny hairs. Some of the yellow areas of the bee are in shadow: use an orange-yellow pastel pencil for these, making short vertical scribbles to build up the texture and tone.

12 If you look carefully, you will see that there are tiny flecks of other colours in the bee's hairs – yellow, orange and a pink-brown in the black areas. Put them in using tiny pencil strokes. These subtle optical colour mixes add depth and enhance the overall effect.

> **Tip**: Roll the pencils around in your fingers as you work so that they do not blunt into a wedge shape.

13 Some pale colours can be seen through the transparent wings – lemon yellow, orange-yellow and peach. Put these in quite lightly, using pastel pencils. Note that the colours that can be seen through the wings will appear slightly more muted than those elsewhere in the background; the effect is rather like looking at something through a sheet of plastic. Use a lemon yellow pencil for the very brightest areas of yellow, scribbling quite hard to get the necessary depth of tone. Put some tiny flecks of black into the yellow for the spaces between the hairs.

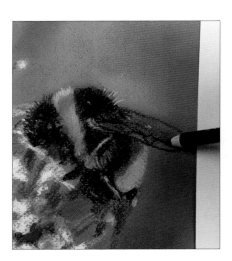

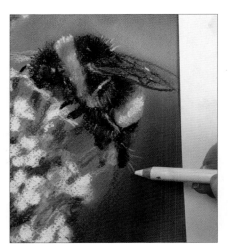

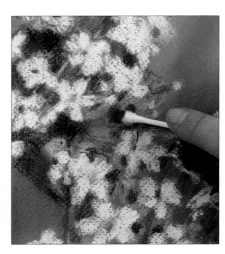

14 Draw in the veining on the wings using a black or very dark purple pastel pencil. These lines need to be very precise, so make sure that your pencil is sharpened to a fine point before you start.

15 There are some very bright, backlit hairs around the edges of the bee. Put these in with white and flesh-coloured pastel pencils.

> **Tip**: Wipe the white pencil tip on scrap paper to clean off any other colours that it may have picked up.

16 Add the flowers immediately below the bee, using the same colours as before. (It would be extremely difficult to put these flowers in at an earlier stage without running the risk of smudging them when you work on the bee.) Blend the dark background colours in the small spaces between the flowers using a cotton bud or torchon.

The finished drawing

In this skilful pastel drawing the emphasis is very firmly on the bee, with the foreground flowers being treated more loosely so that the bee really stands out. As in the reference photograph, the background is a series of impressionistic blurs of vivid colour, which gives the drawing a strong and contemporary feel. Any textural detail is reserved mainly for the bee itself, with tiny flicks of sharp-tipped pastel pencil being used to create the impression of individual hairs. Within the body of the bee, layer upon layer of pastel has been built up to create an intricate optical mix of different colours. The result is a delightful interpretation of an everyday garden subject.

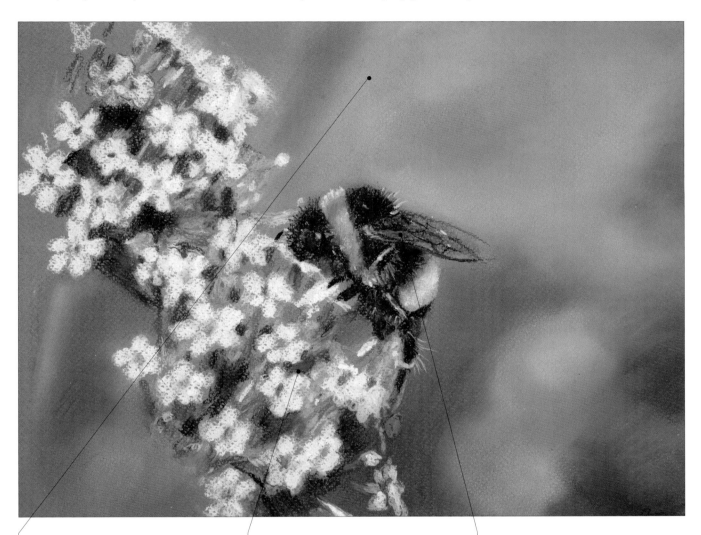

The background has been smoothly blended so that no trace of the original pastel strokes remains.

The flowers have been worked loosely and lightly so that they do not overpower the main subject.

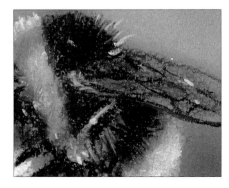

Note the contrast in texture between the tightly packed hairs on the bee's body and the delicate tracery of the wings.

Butterfly in coloured pencil

This drawing was done using a close-up photograph as reference. When photographs are taken using a close-up or macro lens, the depth of field – the part of the image that is in sharp focus – is only a few centimetres. This means that the background is blurred, throwing attention on to the main subject. Here, the background foliage is reduced to blobs of colour; the artist chose to incorporate them into the composition as a semi-abstract graphic device, which gives the drawing a very contemporary feel.

Coloured pencils come in a huge range of colours but, even so, you may find that you do not always have the exact colour or tone that you need and that you have to create your own colour mixes. The most important thing to remember when working with coloured pencils is that the colours cannot be physically combined in the way that two paint colours can be

mixed together on a palette. The only way to mix two or more coloured pencil colours together is to layer them and allow the mixing to happen optically, on the paper. You can apply a light colour over a dark one, or vice versa; the resulting mix will differ depending on which colour is applied first.

It can be very difficult to work out which colours you need to use, particularly for beginners, so if you're unsure, test out your colour combinations on a piece of scrap paper first. Once you've decided on your colours, it's a good idea to scribble the names and sample patches on to a piece of paper, so that if you take a long break between drawing sessions, you'll remember which colours you were using.

Work very lightly; in the early stages, the colour should be barely perceptible. To increase the depth of colour and tone, it's much better to build up

several layers than to apply a single layer too heavily, which could risk damaging the paper.

The demonstration was done on smooth white illustration board. As in watercolour painting, the colour of the support is used for any whites in the subject (in this case, the white markings on the butterfly's wings) and the very brightest highlights. Work out first where the whites are going to be and leave space for them.

Materials
- *Tracing paper*
- *Smooth illustration board*
- *HB pencil*
- *Coloured pencils: cadmium yellow lemon, lemon, orange yellow, burnt ochre, burnt sienna, black soft, sap green, juniper green, apple green, light carmine, alizarin crimson, Payne's grey*
- *Kneaded eraser*

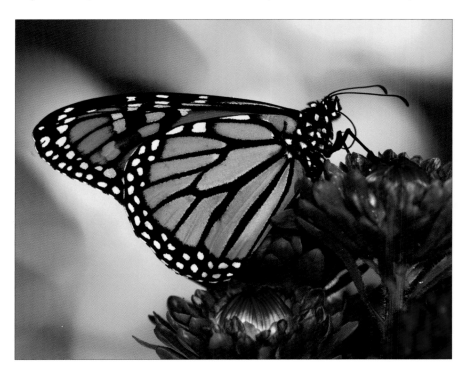

The subject
Because the depth of field – the area of the photo that is in sharp focus – is so shallow, the background is just an impressionistic blur of colour, allowing the butterfly to stand out clearly; even the antennae and proboscis are clearly visible, while the beautiful wing markings look almost like stained glass. The foreground flowers provide a setting for the butterfly without detracting from it.

1 Using an HB pencil, trace or draw the outline of the butterfly's wings and the flower tops on illustration board. At this stage, do not put in the legs or antennae. Using cadmium yellow lemon and lemon, apply two very light coats over the background of the green areas. Vary the pressure to create lighter and darker areas, but keep the strokes small and smooth.

2 Still using the HB pencil, trace or draw in the orange wing markings. Correct any mistakes by dabbing off the pigment with a kneaded eraser. (Work gently; if you rub, you may damage the paper.)

Tip: Mould the kneaded eraser to a very fine point, so that you can lift out small areas. When the tip of the eraser becomes too dirty to use, simply pull that part off and discard it.

3 Using the side of the pencil, block in the orange areas in with a very light base coat colour of lemon yellow, then go over it again in orange yellow. Concentrate pressure where the colours are most intense and blend the pencil strokes softly outwards.

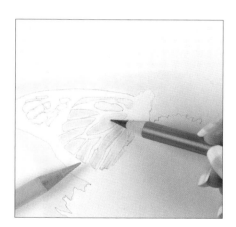

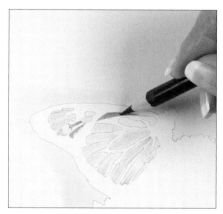

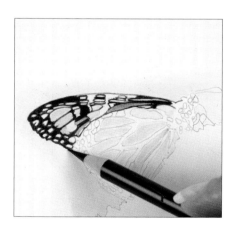

4 Use burnt ochre to pick out stronger, darker areas of colour, trying to capture the delicate gradations of tone. Create highlights within the markings by going over the base colour in more cadmium yellow lemon. Continue to build up the depth of colour in the markings, alternating between orange yellow and burnt ochre and using very light, tiny straight strokes. The yellow highlights then appear brighter.

5 For the markings at the top of the wing use the same process of building up the colour, but apply more burnt ochre. For the richer and darker markings, use a very light application of burnt sienna. Gradually build up the burnt ochre to darken and enrich these areas further if necessary.

Tip: Practise blending the three colours on scrap paper to achieve the right intensity and effect.

6 Draw in the white spots on the wings and body very lightly, using an HB pencil, then go around these markings in black soft coloured pencil, firmly, keeping the pencil well sharpened. Block in the black, noting that the edges of the black areas blend into the colours rather than being a sharp, crisp line.

▶

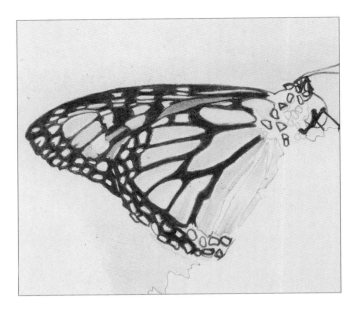

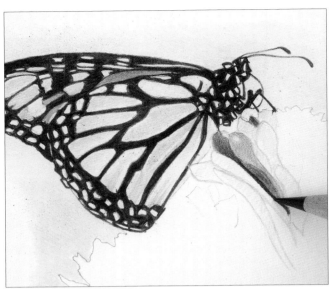

7 Finish the spots and go over the HB lines with black soft on the legs, body, antennae and proboscis.

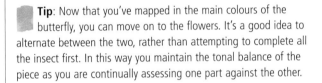

Tip: Now that you've mapped in the main colours of the butterfly, you can move on to the flowers. It's a good idea to alternate between the two, rather than attempting to complete all the insect first. In this way you maintain the tonal balance of the piece as you are continually assessing one part against the other.

8 Trace or draw in the flowers and foliage very lightly, using an HB pencil. Go over the HB foliage lines in sap green and apply soft touches of yellow to the tips of the leaves. Pinpoint areas of deeper colour in juniper green to help you map out the area. Apply a very light undercoat of yellow all over the foliage. Go over this in apple green, and then sap green. Fill in the darker areas in juniper green. For the very dark areas of shade, use black soft.

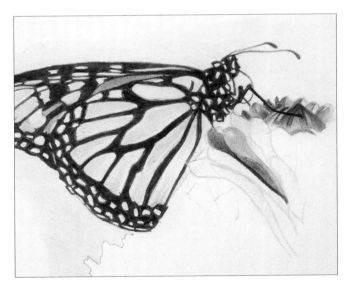

9 For the flower, apply a light layer of light carmine, then go over it in alizarin crimson. Using black soft, start at the tip and draw fine light lines down the petals, blending softly into the alizarin crimson as the colour darkens further down the flower head. Go back over with light carmine. Sketch the leaves behind the flower in sap green over the background yellow, then go over lightly with sap green and juniper green. Use black soft to put in the butterfly's foot on the flower.

10 Fill in the rest of the leaves using a very light layer of yellow and building up the greens as before, leaving the lighter colours showing where there are highlights. Work up the darks now, to enable you to get the balance of the other colours right. Use Payne's grey and then black soft in the deeply shaded areas. In areas with little definition, build up blocks of colour and finish by applying a layer of very light black soft.

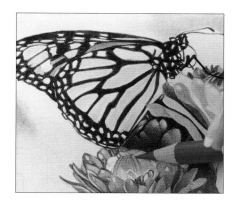

11 Lightly draw a rectangle around the picture area, using an HB pencil, so that you are absolutely clear where the edges of the picture lie. Block in the out-of-focus green background behind the butterfly in a very light layer of sap green, fading it out into the yellow where necessary. Begin adding juniper green for the bluer, darker areas, alternating and blending it with lemon.

12 Block in the leaves of the flowers with a light layer of cadmium yellow lemon, then apply the base colour of apple green followed by sap green, leaving the yellow undercolour showing for the very lightest areas. Use juniper green for the darker areas and the shadows.

13 Continue working on the leaves, using the same colours as in the previous two steps. Complete the pink flowers, using light carmine as the base colour with alizarin crimson on top for the veining on the petals. Leave the white of the illustration board showing through where necessary for the light, bright petal tips.

Assessment time

All the elements – butterfly, foreground flowers and background – are lightly in place; now you can concentrate on building up the correct density of colour and tone, using the same colours as before. It's very important to keep sight of the drawing as a whole and assess each part in relation to the rest: if you try to complete either the butterfly or the background in isolation from each other, the chances are that you will get the tonal balance wrong.

At this stage the artist has mapped out the main blocks of colour in the background, but the area is still far too pale. The foreground flowers look rather flat and insubstantial, and require more linear detail; the shadows, in particular, need to be made much darker.

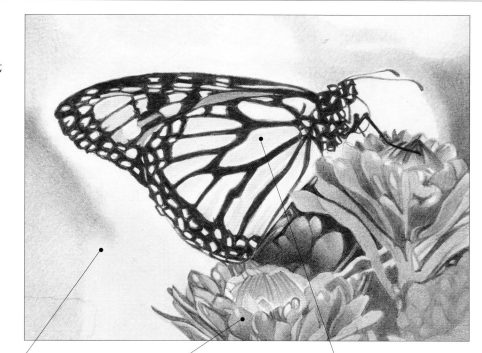

The background is pale and distractingly bright.

The flowers and leaves in the foreground look very flat; increasing the contrast between the light and dark areas will make them look more three-dimensional.

The wing markings need several more layers in order to build up the right depth of colour.

▶

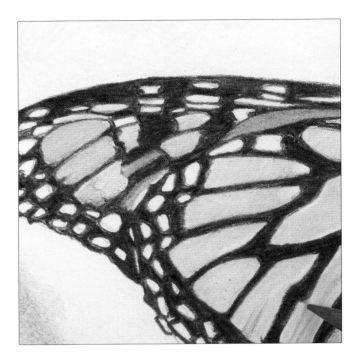

14 Darken the colour on the wings. On the far wing, which is darker than the near wing, apply a light layer of burnt ochre.

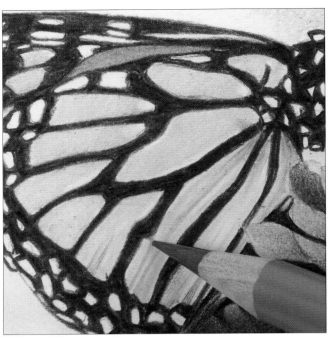

15 On the near wing, apply a fine layer of orange yellow over all the coloured markings, then use burnt ochre for the finer markings within the coloured segments.

16 Darken the green background where necessary, using juniper green, which is a cooler, bluer green than the other greens.

Tip: You will probably find it easier to work on the top left corner if you turn the drawing upside down. Protect the rest of the drawing by laying a sheet of clean paper over it if necessary, so that your drawing hand does not smudge the layers of colour that you have already laid down.

17 Darken the black wing markings where necessary. Note that the markings are not rigid, hard-edged lines: the multitude of tiny scales on the wings means that the edges are slightly fuzzy, so break up these lines slightly by 'flicking' the black pencil out into the adjoining areas. Alternating between juniper green and black soft, put in the dark shadow areas on the leaves.

The finished drawing

This drawing demonstrates the precision and subtlety that can be achieved using coloured pencil. It captures the butterfly in fine detail, with delicately applied layers of colour creating subtle tonal variations within the subject and tiny pencil strokes picking out the slightly fuzzy edges of the individual scales on the wings. The foreground is drawn in a stylised way to create a general impression of the leaves and flowers, although it still has depth, while the background is an impressionistic blur of similar-toned colours that allows the butterfly to stand out in all its glory.

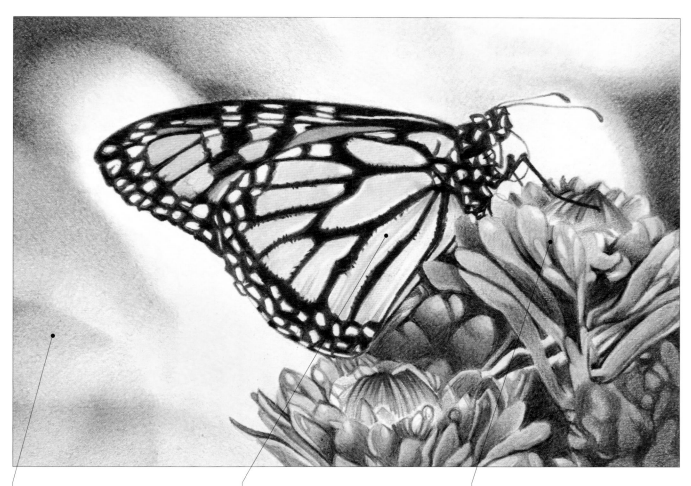

The background is made up of several layers of yellows and greens, lightly applied so that the colours mix optically on the paper.

Fine strokes made using the fine point of the pencil convey the subtlety of the wing markings.

The contrast between the light and dark areas makes the flowers and leaves look really three-dimensional.

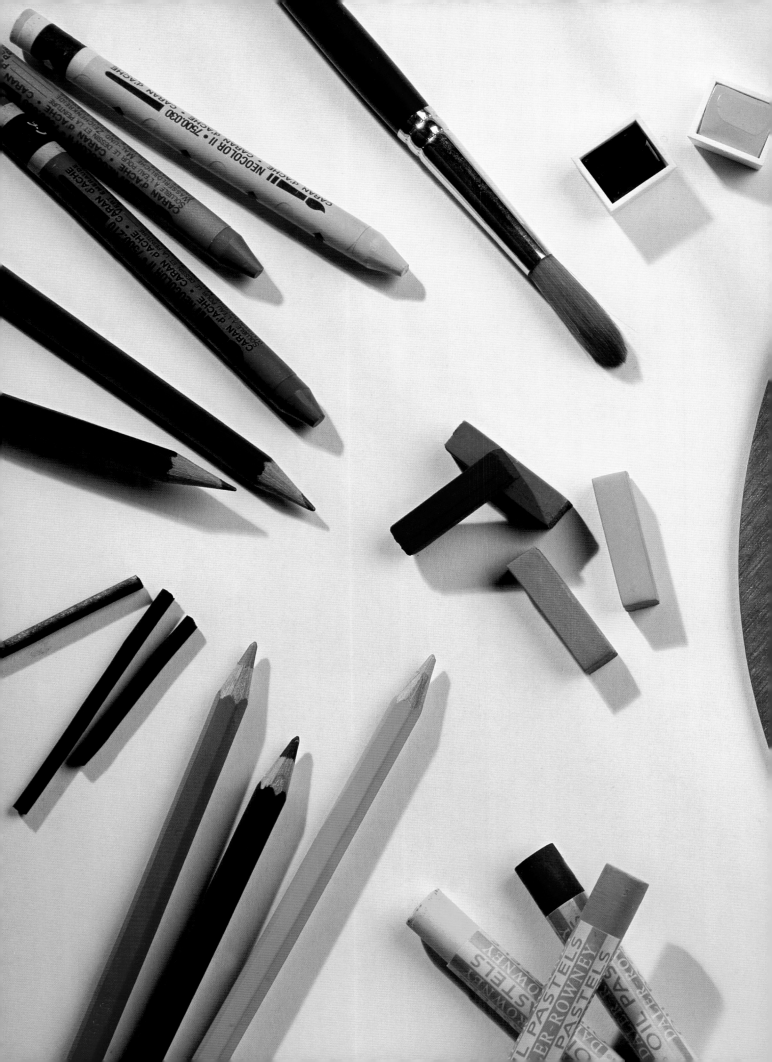

Materials

Most artists have one medium in which they prefer to work. For some, it's the translucency of watercolour that captures their imagination, while others love the linear detailing that can be achieved with pen and ink. Or perhaps it's the versatility of soft pastels that appeals, or the soft, buttery consistency of oil paints. You might use easily portable pencils, charcoal or coloured pastels for quick sketches of birds, fish and insects in their natural habitat, and another quick-drying medium, such as acrylics, for more detailed studies back at home, in your own studio. The important thing is to become familiar with what your chosen materials can do, so this chapter sets out the characteristics of all the main drawing and painting media. And if you're already experienced in one medium, then why not use the information given here to try out something different? Experimenting with a range of different materials is a great way to create exciting new visual effects.

Monochrome media

For sketching and underdrawing, as well as for striking studies in contrast and line, there are many different monochrome media, all of which offer different qualities to your artwork. A good selection is the foundation of your personal art store, and it is worth exploring many media, including different brands, to find the ones you like working with.

Pencils

The grading letters and numbers on a pencil relate to its hardness. 9H is the hardest, down to HB and F (for fine) and then up to 9B, which is the softest. The higher the proportion of clay to graphite, the harder the pencil. A choice of five grades – say, a 2H, HB, 2B, 4B and 6B – is fine for most purposes.

Soft pencils give a very dense, black mark, while hard pencils give a grey one. The differences can be seen below – these marks were made by appying the same pressure to different grades of pencil. If you require a darker mark, do not try to apply more pressure, but switch to a softer pencil.

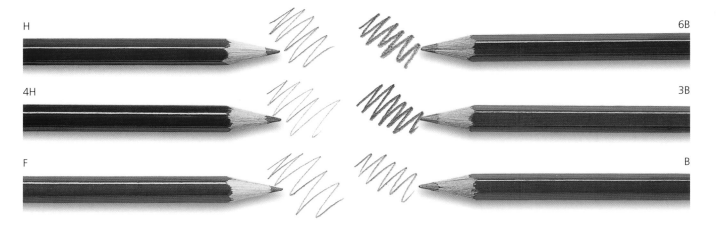

Water-soluble graphite pencils

There are also water-soluble graphite pencils, which are made with a binder that dissolves in water. Available in a range of grades, they can be used dry, dipped in water or worked into with a brush and water to create a range of watercolour-like effects. Water-soluble graphite pencils are an ideal tool for sketching on location, as they allow you to combine linear marks with tonal washes. Use the tip for fine details and the side of the pencil for area coverage.

Water-soluble graphite pencils

Graphite sticks

Solid sticks of graphite come in various sizes and grades. Some resemble conventional pencils, while others are shorter and thicker. You can also buy irregular-shaped chunks and fine graphite powder, as well as thinner strips of graphite in varying degrees of hardness that fit into a barrel with a clutch mechanism to feed them through.

Graphite sticks are capable of making a wider range of marks than conventional graphite pencils.

For example, you can use the point or edge of a stick to make a thin mark, or stroke the whole side of the stick over the paper to make a broader mark.

Charcoal

The other monochromatic drawing material popular with artists is charcoal. It comes in different lengths and in thin, medium, thick and extra-thick sticks. You can also buy chunks that are ideal for expressive drawings. Stick charcoal is very brittle and powdery, but is great for broad areas of tone.

Compressed charcoal is made from charcoal dust mixed with a binder and fine clay and pressed into shape. Sticks and pencils are available. Unlike stick charcoal, charcoal pencils are ideal for detailed, linear work. As with other powdery media, drawings made in charcoal should be sprayed with fixative to hold the pigment in place and prevent smudging during and after working on the piece.

Thick and thin charcoal sticks

Pen and ink

With so many types of pens and colours of ink available, not to mention the possibility of combining linear work with broad washes of colour, this is an extremely versatile medium and one that is well worth exploring. Begin by making a light pencil underdrawing of your subject, then draw over with pen – but beware of simply inking over your pencil lines, as this can look rather flat and dead. When you have gained enough confidence, your aim should be to put in the minimum of lines in pencil, enough to simply ensure you have the proportions and angles right, and then do the majority of the work in pen.

Rollerball, fibre-tip and sketching pens

Rollerball and fibre-tip pens are ideal for sketching out ideas, although finished drawings made using these pens can have a rather mechanical feel to them, as the line does not vary in width. This can sometimes work well as an effect. By working quickly with a rollerball you can make a very light line by delivering less ink to the nib. Fibre-tip and marker pens come in a range of tip widths, from super-fine to calligraphic-style tips, and also in a wide range of colours. Sketching pens and fountain pens enable you to use ink on location without having to carry bottles of ink.

Dip pens and nibs

A dip pen does not have a reservoir of ink; as the name suggests, it is simply dipped into the ink to make marks. Drawings made with a dip pen have a

Nibs and dip pens

unique quality, as the nib can make a line of varying width depending on how much pressure you apply. You can also turn the pen over and use the back of the nib to make broader marks. As you have to keep reloading with ink, it is difficult to make a long, continuous line – but for many subjects the rather scratchy, broken lines are very attractive.

When you first use a new nib it can be reluctant to accept ink. To solve this, rub it with a little saliva.

Sketching pen

Fibre-tip pen

Rollerball pen

Bamboo, reed and quill pens

The nib of a bamboo pen delivers a 'dry', rather coarse line. Reed and quill pens are flexible and give a subtle line that varies in thickness. The nibs break easily, but can be recut with a knife.

Quill and bamboo pens

Inks

The two types of ink used by artists are waterproof and water-soluble. The former can be diluted with water, but are permanent once dry, so line work can be worked over with washes without any fear of it being removed.

They often contain shellac, and thick applications dry with a sheen. The best-known is Indian ink, actually from China. It makes great line drawings, and is deep black but can be diluted to give a beautiful range of warm greys.

Water-soluble inks can be reworked once dry, and work can be lightened and corrections made. Do not overlook watercolours and soluble liquid acrylics – both can be used like ink but come in a wider range of colours.

Waterproof ink

Water-soluble ink

Liquid acrylic

Coloured drawing media

Containing a coloured pigment and clay held together with a binder, coloured pencils are impregnated with wax so that the colour holds to the support with no need for a fixative. They are especially useful for making coloured drawings on location, as they are a very stable medium and are not prone to smudging. Mixing takes place optically on the surface of the support rather than by physical blending, and all brands are inter-mixable, although certain brands can be more easily erased than others; so always try out one or two individual pencils from a range before you buy a large set. Choose hard pencils for linear work and soft ones for large, loosely applied areas of colour.

Box of pencils ▲
Artists who work in coloured pencil tend to accumulate a vast range in different shades – the variance between one tone and its neighbour often being very slight. This is chiefly because you cannot physically mix coloured pencil marks to create a new shade (unlike watercolour or acrylic paints). So, if you want lots of different greens in a landscape, you will need a different pencil for each one.

Water-soluble pencils

Most coloured-pencil manufacturers also produce a range of water-soluble pencils, which can be used to make conventional pencil drawings and blended with water to create watercolour-like effects. In recent years, solid pigment sticks that resemble pastels have been introduced that are also water-soluble and can be used in conjunction with conventional coloured pencils or on their own.

Wet and dry ▼
Water-soluble pencils can be used dry, the same way as conventional pencils.

Conté crayons and pencils

The best way to use Conté crayons is to snap off a section and use the side of the crayon to block in large areas, and a tip or edge for linear marks.

The pigment in Conté crayons is relatively powdery, so, like soft pastels and charcoal, it can be blended by rubbing with a finger, rag or torchon. Conté crayon drawings benefit from being given a coat of fixative to prevent smudging. However, Conté crayons are harder and more oily than soft pastels, so you can lay one colour over another, letting the under-colour show through.

Conté is also available in pencils, which contain wax and need no fixing (setting); the other benefit is that the tip can be sharpened to a point.

Conté crayons ▼
These small, square-profile sticks are available in boxed sets of traditional colours. Drawings made using these traditional colours are reminiscent of the wonderful chalk drawings of old masters such as Michelangelo or Leonardo da Vinci.

Conté pencils ▼
As they can be sharpened to a point, Conté pencils are ideal for drawings that require precision and detail.

Pastels

Working in pastels is often described as painting rather than drawing, as the techniques used are often similar to those used in painting. Pastels are made by mixing pigment with a weak binder, and the more binder used the harder the pastel will be. Pastels are fun to work with and ideal for making colour sketches as well as producing vivid, dynamic artwork.

Soft pastels

As soft pastels contain relatively little binder, they are prone to crumbling. For this reason they sometimes have a paper wrapper to help keep them in one piece. Even so, dust still comes off, and can easily contaminate other colours nearby. The best option is to arrange your pastels by colour type and store them in boxes.

Pastels are mixed on the support either by physically blending them or by allowing colours to mix optically. The less you blend, the fresher the image looks. For this reason, pastels are manufactured in a range of hundreds of tints and shades.

As pastels are powdery, use textured paper to hold the pigment in place. You can make use of the texture of the paper in your work. Spray soft pastel drawings with fixative to prevent smudging. You can fix (set) work in progress, too – but colours may darken.

Pastel pencils

A delight to use, the colours of pastel pencils are strong, yet the pencil shape makes them ideal for drawing lines. If treated carefully, they do not break – although they are more fragile than graphite or coloured pencils. The pastel strip can be sharpened to a point, making pastel pencils ideal for

Hard pastels

One advantage of hard pastels is that, in use, they do not shed as much pigment as soft pastels, therefore they will not clog the texture of the paper as quickly. For this reason, they are often used in the initial stages of a work that is completed using soft pastels. Hard pastels can be blended together by rubbing, but not as easily or as seamlessly as soft pastels.

Hard pastels

Box of soft pastels ▼
When you buy a set of pastels, they come packaged in a compartmentalized box so that they do not rub against each other and become dirtied.

describing detail in drawings that have been made using conventional hard or soft pastels.

Available in a comprehensive range of colours, pastel pencils are clean to use and are ideal for linear work. Ideally, store them in a jar with the tips upward to prevent breakage.

Oil pastels

Made by combining fats and waxes with pigment, oil pastels are totally different to pigmented soft and hard pastels and should not be mixed with them. Oil pastels can be used on unprimed drawing paper and they never completely dry.

Oil-pastel sticks are quite fat and therefore not really suitable for detailed work or fine, subtle blending. For bold, confident strokes, however, they are absolutely perfect.

Oil-pastel marks have something of the thick, buttery quality of oil paints. The pastels are highly pigmented and available in a good range of colours. If they are used on oil-painting paper, they can be worked in using a solvent such as white spirit (paint thinner), applied with a brush or rag. You can also smooth out oil-pastel marks with wet fingers. Oil and water are not compatible, and a damp finger will not pick up colour.

Oil pastels can be blended optically on the support by scribbling one colour over another. You can also create textural effects by scratching into the pastel marks with a sharp implement – a technique known as sgraffito.

Less crumbly than soft pastels, and harder in texture, oil pastels are round sticks and come in various sizes.

Pastel pencils

A box of oil pastels

Watercolour paint

One of the most popular media, watercolour paint comes in pans, which are the familiar compressed blocks of colour that need to be brushed with water to release the colour; or tubes of moist paint. The same finely powdered pigments bound with gum arabic solution are used to make both types. The pigments provide the colour, while the gum arabic allows the paint to adhere to the paper, even when diluted.

It is a matter of personal preference whether you use pans or tubes. The advantage of pans is that they can be slotted into a paintbox, making them easily portable, and this is something to consider if you often paint on location. Tubes, on the other hand, are often better if you are working in your studio and need to make a large amount of colour for a wash. With tubes, you need to remember to replace the caps immediately, otherwise the paint will harden and become unusable. Pans of dry paint can be rehydrated.

Tubes (above) and pans (right) of watercolour

Grades of paint

There are two grades of watercolour paint: artists' and students' quality. Artists' quality paints are the more expensive, because they contain a high proportion of good-quality pigments. Students' quality paints contain less pure pigment and more fillers.

If you come across the word 'hue' in a paint name, it indicates that the paint contains cheaper alternatives instead of the real pigment. Generally speaking, you get what you pay for: artists' quality paints tend to produce more subtle mixtures of colours. The other thing that you need to think about when buying paints is their

permanence. The label or the manufacturer's catalogue should give you the permanency rating. In the United Kingdom, the permanency ratings are class AA (extremely permanent), class A (durable), class B (moderate) and class C (fugitive). The ASTM (American Society for Testing and Materials) codes for light-fastness are ASTM I (excellent), ASTM II (very good) and ASTM III (not sufficiently light-fast). Some pigments, such as alizarin crimson and viridian, stain more than others: they penetrate the fibres of the paper and cannot be removed.

Working with watercolour paint

Different pigments have different characteristics. Although we always think of watercolour as being transparent, you should be aware that some pigments are actually slightly opaque and will impart a degree of opacity to any colours with which they are mixed. These so-called opaque pigments include all the cadmium colours and cerulean blue. The only way to learn about the paints' characteristics is to use them, singly and in combination with other colours.

Judging colours

It is not always possible to judge the colour of paints by looking at the pans in your palette, as they often look dark. In fact, it is very easy to dip your brush into the wrong pan, so always check before you put brush to paper.

Even when you have mixed a wash in your palette, do not rely on the colour, as watercolour paint always looks lighter when it is dry. The only way to be sure what colour or tone you have mixed is to apply it to paper and let it dry. It is always best to build up tones gradually until you get the effect you want. The more you practise, the better you will get at anticipating results.

Appearances can be deceptive ▼
These two pans look very dark, almost black. In fact, one is Payne's grey and the other a bright ultramarine blue.

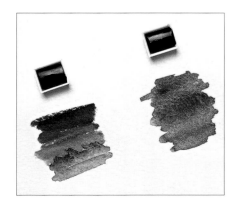

Test your colours ▼
Keep a piece of scrap paper next to you as you work so that you can test your colour mixes before you apply them.

Gouache paint

Made using the same pigments and binders found in watercolour, gouache is a water-soluble paint. The addition of *blanc fixe* – a precipitated chalk – gives the paint its opacity. Because gouache is opaque you can paint light colours over darker ones – unlike traditional watercolour, where the paint's inherent transparency means that light colours will not cover any darker shades that lie underneath.

Recently some manufacturers have begun to introduce paint made from acrylic emulsions and starch. The best-quality gouache contains a high proportion of coloured pigment. Artists' gouache tends to be made using permanent pigments that are light-fast. The 'designers' range uses less permanent pigments, as designers' work is intended to last for a short time.

Working with gouache paint

All of the equipment and techniques used with watercolour can be used with gouache. Like watercolour, gouache can be painted on white paper or board; due to its opacity and covering power it can also be used on a coloured or toned ground and over gesso-primed board or canvas. Gouache is typically used on smoother surfaces than might be advised for traditional watercolour, as the texture of the support is less of a creative consideration.

If they are not used regularly, certain gouache colours are prone to drying up over time. Gouache is water-soluble so can be rehydrated when dry, but dried-up tubes can be difficult to use. On the support, you can remedy any cracking of the dried paint by re-wetting it. During your work on the painting, you need assured brushwork when applying new paint over previous layers to avoid muddying the colours. Certain dye-based colours are particularly strong and, if used beneath other layers of paint, can have a tendency to bleed. With practice, this is easy to cope with.

Tubes of gouache paint

Bold brushwork ▲
Gouache remains soluble when it is dry, so if you are applying one colour over another, your brushwork needs to be confident: a clean stroke, as here, will not pick up paint from the first layer.

Muddied colours ▲
If you scrub paint over an underlying colour, you will pick up paint from the first layer and muddy the colour of the second layer, as here. To avoid this effect, see bold brushwork, left.

Change in colour when dry ▼
Gouache paint looks slightly darker when dry than it does when wet, so it is good practice to test your mixes on a piece of scrap paper – although, with practice, you will quickly learn to make allowances for this.

Wet gouache paint Dry gouache paint

Wet into wet ▲
Like transparent watercolour paint, gouache paint can be worked wet into wet (as here) or wet on dry.

Removing dry paint ▲
Dry paint can be re-wetted and removed by blotting with an absorbent paper towel.

Oil paint

There are two types of traditional oil paint – professional, or artists', grade and the less expensive students' quality. The difference is that artists' paint uses finely ground, high-quality pigments, which are bound in the best oils and contain very little filler, while students' paints use less expensive pigments and contain greater quantities of filler to bulk out the paint. The filler is usually *blanc fixe* or aluminium hydrate, both with a very low tinting strength.

Students' quality paint is often very good and is, in fact, used by students, amateur painters and professionals.

Tubes or cans? ▼
Oil paint is sold in tubes containing anything from 15ml to 275ml (1 tbsp to 9fl oz). If you tend to use a large quantity of a particular colour – for toning grounds, for example – you can buy paint in cans containing up to 5 litres (8¾ pints).

Drawing with oils ▶
Oil bars consist of paint with added wax and drying agents. The wax stiffens the paint, enabling it to be rolled into what resembles a giant pastel.

Water-mixable oil paint

Linseed and safflower oils that have been modified to be soluble in water are included in water-mixable oil paint. Once the paint has dried and the oils have oxidized, it is as permanent and stable as conventional oil paint. Some water-mixable paint can also be used with conventional oil paint, although its mixability is gradually compromised with the more traditional paint that is added.

Working with oil paint

However you use oil paint, it is most important to work on correctly prepared supports and always to work 'fat over lean'. 'Fat' paint, which contains oils, is flexible and slow to dry, while 'lean' paint, with little or no oil, is inflexible and dries quickly. Oil paintings can be unstable and prone to cracking if lean paint is placed over fat. For this reason, any underpainting and initial blocking in of colour should always be done using paint that has been thinned with a solvent and to which no extra oil has been added. Oil can be added to the

Glazing with oils ▲
Oils are perfect for glazes (transparent applications of paint over another colour). The process is slow, but quick-drying glazing mediums can speed things up.

Alkyd oil paints

Although they contain synthetic resin, alkyd oils are used in the same way as traditional oil paints and can be mixed with the usual mediums and thinners.

Alkyd-based paint dries much faster than oil-based paint, so it is useful for underpainting prior to using traditional oils and for work with glazes or layers. However, you should not use alkyd paint over traditional oil paint, as its fast drying time can cause problems.

paint in increasing amounts in subsequent layers. You must allow plenty of drying time between layers.

Working 'fat over lean' ▲
The golden rule when using oil paint is to work 'fat' (or oily, flexible paint) over 'lean', inflexible paint that has little oil.

Judging colour ▼
Colour mixing with oils is relatively straightforward: the colour that you apply wet to the canvas will look the same when it has dried, so (unlike acrylics, gouache or watercolour) you do not need to make allowances for changes as you paint. However, colour that looks bright when applied can begin to look dull as it dries. You can revive the colour in sunken patches by 'oiling out' – that is, by brushing an oil-and-spirit mixture or applying a little retouching varnish over the area.

Wet oil paint Dry oil paint

Acrylic paint

Unlike oil paint, acrylic paint dries quickly and the paint film remains extremely flexible and will not crack. Acrylic paint can be mixed with a wide range of acrylic mediums and additives and is thinned with water. The paint can be used with a range of techniques, from thick impasto, as with oil paint, to the semi-transparent washes of watercolour. Indeed, most techniques used in both oil and watercolour painting can be used with acrylic paint. Acrylic paints come in three different consistencies. Tube paint tends to be of a buttery consistency and holds its shape when squeezed from the tube. Tub paint is thinner and more creamy in consistency, which makes it easier to brush out and cover large areas. There are also liquid acrylic colours with the consistency of ink, sold as acrylic inks.

You may experience no problems in mixing different brands or consistencies, but it is always good practice to follow the manufacturer's instructions.

Working with acrylic paint

Being water soluble, acrylic paint is very easy to use, requiring only the addition of clean water. Water also cleans up wet paint after a work session. Once it has dried, however, acrylic paint creates a hard but flexible film that will not fade or crack and is impervious to more applications of acrylic or oil paint or their associated mediums or solvents.

Acrylic paint dries relatively quickly: a thin film will be touch dry in a few minutes and even thick applications dry in a matter of hours. Unlike oil paints, all acrylic colours, depending on the thickness of paint, dry at the same rate and darken slightly. A wide range of mediums and additives can be mixed into acrylic paint to alter and enhance its handling characteristics.

Another useful quality in acrylic mediums is their good adhesive qualities, making them ideal for collage work – sticking paper or other materials on to the support.

Texture gels ▲
Various gels can be mixed into acrylic paint to give a range of textural effects. These can be worked in while the paint is still wet.

Glazing with acrylics ▲
Acrylic colours can be glazed by thinning the paint with water, although a better result is achieved by adding an acrylic medium.

◄ Liquid acrylics
The consistency of liquid acrylic is like writing ink.

Tubs ▲
Acrylic paint in tubs stores easily.

Tubes ►
Acrylic paints in tubes are convenient to carry and use with a palette.

Extending drying time ▲
The drying time of acrylic paint can be extended by using a retarding medium, which gives you longer to work into the paint and blend colours.

Covering power ▲
Acrylic paint that is applied straight from the tube has good covering power, even when you apply a light colour over a dark one, so adding highlights to dark areas is easy.

Shape-holding ability ▲
Like oil paint, acrylic paint that is applied thickly, straight from the tube, holds its shape and the mark of the brush as it dries, which can allow you to use interesting textures.

Lightening acrylic colours ▲
Acrylic colours can be made lighter by adding white paint, which maintains opacity (above top), or by adding water, which increases transparency (bottom).

Palettes

The surface on which an artist arranges colours prior to mixing and applying them to the support is known as a palette. (Somewhat confusingly, it is the same word that is used to describe a range of colours used by an artist, or the range of colours found in a painting.) The type of palette that you use depends on the medium in which you are working, but you will probably find that you need more space for mixing colours than you might imagine.

A small palette gets filled with colour mixes quickly and it is a false economy to clean the mixing area too often: you may waste usable paint or mixed colours that you could use again. Always buy the largest palette practical.

Wooden palettes

Flat wooden palettes in the traditional kidney or rectangular shapes with a thumb hole are intended for use with oil paints. They are made from hardwood, or from the more economical plywood.

Before you use a wooden palette with oil paint for the first time, rub linseed oil into the surface of both sides. Allow it to permeate the surface. This will prevent oil from the paint from being absorbed into the surface of the palette and will make it easier to clean. Re-apply linseed oil periodically and a good wooden palette will last for ever.

Wooden palettes are not recommended for acrylic paint, however, as hardened acrylic paint can be difficult to remove from the surface.

Holding and using the palette ▼
Place your thumb through the thumb hole and balance the palette on your arm. Arrange pure colour around the edge. Position the dipper(s) at a convenient point, leaving the centre of the palette free for mixing colours.

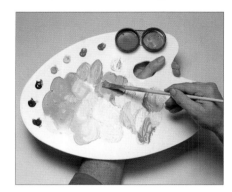

White palettes

Plastic palettes are uniformly white. They are made in both the traditional flat kidney and rectangular shapes. The surface is impervious, which makes them ideal for use with either oil or acrylic paint. They are easy to clean, but the surface can become stained after using very strong colours such as viridian or phthalocyanine blue.

There are also plastic palettes with wells and recesses, intended for use with watercolour and gouache. The choice of shape is entirely subjective, but it should be of a reasonable size.

White porcelain palettes offer limited space for mixing. Intended for use with watercolour and gouache, they are aesthetically pleasing but can easily be chipped and broken.

Wooden palette ▲
Artists working with oil paints generally prefer a wooden palette. Always buy one that is large enough to hold all the paint and mixes that you intend to use.

Slanted-well palette ▲
This type of porcelain palette is used for mixing gouache or watercolour. The individual colours are placed in the round wells and mixed in the rectangular sections.

Disposable palettes

A relatively recent innovation is the disposable paper palette, which can be used with both oils and acrylics. These come in a block and are made from an impervious parchment-like paper. A thumb hole punched through the block enables it to be held in the same way as a traditional palette; alternatively, it can be placed flat on a surface. Once the work is finished, the used sheet is torn off and thrown away.

Paper palette ▲
Disposable palettes are convenient and make cleaning up after a painting session an easy task.

Stay-wet palette

Intended for use with acrylic paints, the stay-wet palette will stop paints becoming dry and unworkable if left exposed to the air for any length of time. The palette consists of a shallow, recessed tray into which a water-impregnated membrane is placed. The paint is mixed on the moist membrane. If you like, you can simply spray acrylic paint with water to keep it moist while you work. If you want to leave a painting halfway through and come back to it later, you can place a plastic cover over the tray (many come with their own lids), sealing the moist paint in the palette. The entire palette can be stored in a cool place or even in the refrigerator, and will keep for up to three weeks. If the membrane does dry out, simply re-wet it using a spray bottle of water.

Stay-wet palette

Containers

A regular supply of containers, such as empty jam jars for cleaning and storing brushes, can be recycled from household waste and are just as good as a container bought for the purpose.

Among the most useful specially designed containers are dippers – small, open containers for oil and solvent that clip on to the edge of the traditional palette. Some have screw or clip-on lids to prevent the solvent from evaporating when it is not in use. You can buy both single and double dippers, like the one shown on the right. Dippers are useful when you want to work at speed, for example when painting on location.

Dipper ▼
Used in oil painting, dippers are clipped on to the side of the palette and contain small amounts of oil or medium and thinner.

Storing brushes ▲
After cleaning your brushes, squeeze the hairs to remove any excess water and then gently reshape the brush with your fingertips. Leave to dry. Store brushes upright in a jar to prevent the hairs from becoming bent as they dry.

Acrylic and oil additives

Artists working with oils and acrylics will need to explore paint additives, which bring various textures and effects to their work. Although oil paint can be used straight from the tube, it is usual to alter the paint's consistency by adding a mixture of oil or thinner (solvent). Simply transfer the additive to the palette a little at a time and mix it with the paint. Manufacturers of acrylic paints have also introduced a range of mediums and additives that allow artists to use the paint to its full effect. Oils and mediums are used to alter the consistency of the paint, allowing it to be brushed out smoothly or to make it dry more quickly. Once exposed to air, the oils dry and leave behind a tough, leathery film that contains the pigment. Different oils have different properties – for example, linseed dries relatively quickly but yellows with age so is only used for darker colours.

A painting medium is a ready-mixed painting solution that may contain various oils, waxes and drying agents. The oils available are simply used as a self-mixed medium. Your choice of oil or medium will depend on several factors, including cost, the type of finish required, the thickness of the paint being used, as well as the range of colours employed.

There are several alkyd-based mediums on the market. They all speed the drying time of the paint, which can reduce waiting between applications. Some alkyd mediums are thixotropic; these are initially stiff and gel-like but, once worked, become clear and loose. Other alkyd mediums contain inert silica and add body to the paint; useful for impasto techniques where thick paint is required. Talking to an art stockist will help you decide which you need.

Types of finish

When acrylic paints dry they leave a matt or gloss surface. Gloss or matt mediums can be added, singly or mixed, to give the desired finish.

Gloss and matt mediums ▲
Both gloss (left) and matt (right) mediums are white. Gloss will brighten and enhance the depth of colour. Matt increases transparency and can be used to make matt glazes.

Gel mediums

With the same consistency as tube colour, gel mediums are available in matt or gloss finishes. They are added to the paint in the same way as fluid mediums. They increase the brilliance and transparency of the paint, while maintaining its thicker consistency. Gel medium is an excellent adhesive and extends drying time. It can be mixed with various substances such as sand or sawdust to create textural effects.

Retarding mediums

Acrylic paints dry quickly. Although this is generally considered to be an advantage, there are occasions when you might want to take your time over a particular technique or a specific area of a painting – when you are blending colours together or working wet paint into wet, for example. Adding a little retarding medium slows down the drying time of the paint considerably, keeping it workable for longer. Retarding medium is available in both gel and liquid form – experiment to find out which suits you best.

Retarding gel

Flow-improving mediums

Adding flow-improving mediums reduces the water tension, increasing the flow of the paint and its absorption into the surface of the support.

One of the most useful applications for flow-improving medium is to add a few drops to very thin paint, which can tend to puddle rather than brush out evenly across the surface of the support. This is ideal when you want to tone the ground with a thin layer of acrylic before you begin your painting.

When a flow-improving medium is used with slightly thicker paint, a level surface will result, with little or no evidence of brushstrokes.

The medium can also be mixed with paint that is going to be sprayed, as it greatly assists the flow of paint and also helps to prevent blockages within the spraying mechanism.

Modelling paste ▲
These pastes dry to give a hard finish, which can be sanded or carved into using a sharp knife.

Heavy gel medium ▲
Mixed with acrylic paint, heavy gel medium forms a thick paint that is useful for impasto work.

Without flow-improving medium

With flow-improving medium

Oils and thinners

If you dilute oil paints using only oil, the paint may wrinkle or take too long to dry. A thinner makes the paint easier to brush out, and then evaporates. The amount of thinner that you use depends on how loose or fluid you want the paint to be. If you use too much, however, the paint film may become weak and prone to cracking. Ideally, any thinner that you use should be clear and should evaporate easily from the surface of the painting without leaving any residue. There are a great many oils and thinners available. The common ones are listed below.

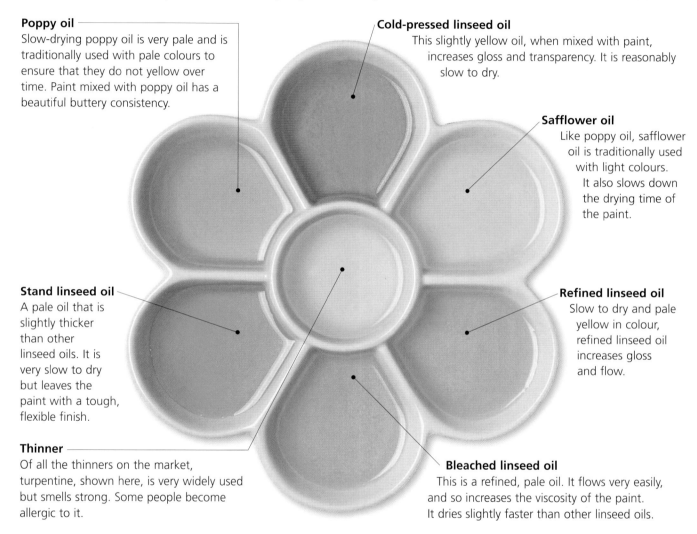

Poppy oil
Slow-drying poppy oil is very pale and is traditionally used with pale colours to ensure that they do not yellow over time. Paint mixed with poppy oil has a beautiful buttery consistency.

Cold-pressed linseed oil
This slightly yellow oil, when mixed with paint, increases gloss and transparency. It is reasonably slow to dry.

Safflower oil
Like poppy oil, safflower oil is traditionally used with light colours. It also slows down the drying time of the paint.

Stand linseed oil
A pale oil that is slightly thicker than other linseed oils. It is very slow to dry but leaves the paint with a tough, flexible finish.

Refined linseed oil
Slow to dry and pale yellow in colour, refined linseed oil increases gloss and flow.

Thinner
Of all the thinners on the market, turpentine, shown here, is very widely used but smells strong. Some people become allergic to it.

Bleached linseed oil
This is a refined, pale oil. It flows very easily, and so increases the viscosity of the paint. It dries slightly faster than other linseed oils.

Turpentine
This is the strongest and best of all the thinners used in oil painting, turpentine has an extremely strong smell. Old turpentine can discolour and become gummy if exposed to air and light. To help prevent this, store it in cans or dark glass jars.

White spirit
Paint thinner or white spirit is clear and has a milder smell than turpentine. It does not deteriorate and dries faster than turpentine. However, it can leave the paint surface matt.

Oil of spike lavender
Unlike other solvents, which speed up the drying time of oil paint, oil of spike lavender slows the drying time. It is very expensive. Like turpentine and white spirit, it is colourless.

Low-odour thinners
Various low-odour thinners have come on to the market in recent years. The drawback of low-odour thinners is that they are relatively expensive and dry slowly. However, for working in a confined space or for those who dislike turpentine's smell, they are ideal.

Citrus solvents
You may be able to find citrus thinners. They are thicker than turpentine or white spirit but smell wonderful. They are more expensive than traditional thinners and slow to evaporate.

Liquin
Just one of a number of oil and alkyd painting mediums that speed up drying time considerably – often to just a few hours – liquin also improves flow and increases the flexibility of the paint film. It is excellent for use in glazes, and resists age-induced yellowing well.

Paintbrushes

Oil-painting brushes are traditionally made from hog bristles, which hold their shape well and can also hold a substantial amount of paint. Natural hair brushes are generally used for watercolour and gouache, and can be used for acrylics and fine detail work in oils, if cleaned thoroughly afterward. Synthetic brushes are good quality and hard-wearing, and less expensive.

Brush shapes

Rigger brush

Liner brush

Rounded or 'mop' brush

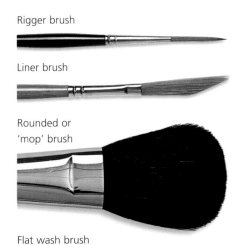

Flat wash brush

Flat brushes ▼
These brushes have square ends and hold a lot of paint. Large flat brushes are useful for blocking in and covering large areas quickly and smoothly, whatever type of paint you are using – ask your stockist to advise which type of bristle or hair is best for your preferred medium. Short flats, known as 'brights', hold less paint and are stiffer. They make precise, short strokes, ideal for impasto work and detail.

Short flat brush

Large flat brush

Brushes for fine detail ◄
A rigger brush is very long and thin. It was originally invented for painting the rigging on ships in marine painting – hence the name. A liner is a flat brush which has the end cut away at an angle. Both of these brushes may be made from natural or synthetic fibres.

Wash brushes ◄
The wash brush has a wide body, which holds a large quantity of paint. It is used for covering large areas with a uniform wash of paint. There are two types: rounded or 'mop' brushes are commonly used with watercolour and gouache, and flat wash brushes are more suited to oils and acrylics.

Round brushes ▼
These round-headed brushes are used for detail and for single strokes. Larger round brushes hold a lot of paint and are useful for the initial blocking in. The point can quickly disappear, as it becomes worn down by the rubbing on the rough support. The brushes shown here are made of natural hair.

Small round brush

Large round brush

Unusually shaped brushes ▼
Fan blenders are used for mixing colours on the support and drybrushing. A filbert brush combines some qualities of a flat and round brush.

Fan blender Filbert

Cleaning brushes

1 Cleaning your brushes thoroughly will make them last longer. Wipe off any excess wet paint on a rag or a piece of newspaper. Take a palette knife and place it as close to the metal ferrule as possible. Working away from the ferrule toward the bristles, scrape off as much paint as you can.

2 Pour a small amount of household white spirit (paint thinner) – or water, if you are using a water-based paint such as acrylic or gouache – into a jar; you will need enough to cover the bristles of the brush. Agitate the brush in the jar, pressing it against the sides to dislodge any dried-on paint.

3 Rub household detergent into the bristles with your fingers. Rinse in clean water until the water runs clear. Reshape the bristles and store the brush in a jar with the bristles pointing upward, so that they hold their shape.

Other paint applicators

Brushes are only part of the artist's toolbox. You can achieve great textual effects by using many other types of applicator, from knives to rags.

Artists' palette and painting knives

Palette knives are intended for mixing paint with additives on the palette, scraping up unwanted paint from the palette or support, and general cleaning. Good knives can also be found in DIY or decorating stores.

You can create a wide range of marks using painting knives. In general, the body of the blade is used to spread paint, the point for detail and the edge for making crisp linear marks.

Regardless of the type of knife you use, it is very important to clean it thoroughly after use. Paint that has dried on the blade will prevent fresh paint from flowing evenly off the blade. Do not use caustic paint strippers on plastic blades, as they will dissolve; instead, peel the paint away.

Steel knives ▲
A wide range of steel painting and palette knives is available. In order to work successfully with this method of paint application, you will need a variety.

Plastic knives ▲
Less expensive and less durable than steel knives, plastic knives manipulate watercolour and gouache paints better than their steel counterparts.

Alternative applicators

Paint can be applied and manipulated using almost anything. The cutlery drawer and toolbox are perhaps a good starting point, but you will no doubt discover plenty of other items around the home that you can use. Card, rags, wire (steel) wool and many other objects around the house can all be pressed into service.

Rag (left) and wire wool

Natural sponge (left) and man-made sponge

Paint shapers, foam and sponge applicators

A relatively new addition to the artist's range of tools are paint shapers. They closely resemble brushes, but are used to move paint around in a way similar to that used when painting with a knife. Shapers can be used to apply paint and create textures, and to remove wet paint. Instead of bristles, fibre or hair, the shaper is made of a non-absorbent silicone rubber.

Nylon foam is used to make both foam brushes and foam rollers. Foam rollers can cover large areas quickly. Sponge applicators are useful for initial blocking in. Both are available in a range of sizes and, while they are not intended as substitutes for the brush, they are used to bring a different quality to the marks they make.

Paint shaper Foam roller Sponge applicator

Natural and man-made sponges ◄
With their pleasing texture, man-made and natural sponges are used to apply washes and textures, and are invaluable for spreading thin paint over large areas and for making textural marks. They are also useful for mopping up spilt paint, and for wiping paint from the support in order to make corrections. Man-made sponges can be cut to shape.

Glossary

Additive A substance added to paint to alter characteristics such as the paint's drying time and viscosity.

Alla prima A term used to describe a work (traditionally an oil painting) that is completed in a single session. *Alla prima* means 'at the first' in Italian.

Blending Merging adjacent colours or tones so that they gradually merge into one another.

Body colour Opaque paint, such as gouache, which can obliterate underlying paint colour on the paper.

Charcoal Charcoal is made by charring willow, beech or vine twigs at very high temperatures in an airtight kiln. It is available in powder form and as sticks. It can also be mixed with a binder and pressed into sticks ('compressed' charcoal).

Colour
Complementary: Colours opposite one another on the colour wheel.
Primary: A colour that cannot be produced by mixing other colours, but can only be manufactured. Red, yellow and blue are the three primary colours.
Secondary: A colour made by mixing equal amounts of two primary colours.
Tertiary: A colour produced by mixing equal amounts of a primary colour and the secondary colour next to it on the colour wheel.

Colour mixing
Optical colour mixing: Applying one colour on top of another in such a way that both remain visible, although the appearance of each one is modified by the other. Also known as *broken colour*.
Physical colour mixing: Blending two or more colours together to create another colour.

Cool colours Colours that contain blue and lie in the green-violet half of the colour wheel.

Composition The way in which the elements of a drawing are arranged within the picture space.

Closed composition: One in which the eye is held deliberately within the picture area.

Open composition: One that implies that the subject or scene continues beyond the confines of the picture area.

Conté crayon A drawing medium made from pigment and graphite bound with gum. Conté crayons are available as sticks and as pencils.

Drybrush The technique of dragging an almost dry brush, loaded with very little paint, across the surface of the support to make textured marks.

Eye level Your eye level in relation to the subject that you are drawing can make a considerable difference to the composition and mood of the drawing. Viewing things from a high eye level (looking down on them) separates elements in a scene; when viewed from a low eye level (looking up at them), elements tend to overlap.

Fat over lean A fundamental principle of oil painting. In order to minimize the risk of cracking, oil paints containing a lot of oil ('fat' paints) should never be applied over those that contain less oil ('lean' paints) – although the total oil content of any paint mixture should never exceed 50 per cent.

Fixative A substance sprayed on to drawings made in soft media such as charcoal, chalk and soft pastels to prevent them from smudging.

Foreshortening The illusion that objects are compressed in length as they recede from your view.

Form *See* Modelling.

Format The shape of a drawing or painting. The most usual formats are landscape (a drawing that is wider than it is tall) and portrait (a drawing that is taller than it is wide), but panoramic (long and thin) and square formats are also common.

Glaze A transparent layer of paint that is applied over dry paint. Light passes through the transparent glaze and is reflected back by the support or any underpainting. Glazing is a form of optical colour mixing as each glaze colour is separate from the next, with the mixing taking place within the eye.

Gouache *see* Body colour.

Graphite Graphite is a naturally occurring form of crystallized carbon. To make a drawing tool, it is mixed with ground clay and a binder and then moulded or extruded into strips or sticks. The sticks are used as they are; the strips are encased in wood to make graphite pencils. The proportion of clay in the mix determines how hard or soft the graphite stick or pencil is; the more clay, the harder it is.

Ground The prepared surface on which an artist works. Also a coating such as acrylic gesso or primer, which is applied to a drawing or painting surface.

Hatching Drawing a series of parallel lines, at any angle, to indicate shadow areas. You can make the shading appear more dense by making the lines thicker or closer together.

Crosshatching: A series of lines that crisscross each other at angles.

Highlight The point on an object where light strikes a reflective surface. Highlights can be drawn by leaving areas of the paper white or by removing colour or tone with an eraser.

Hue A colour in its pure state, unmixed with any other.

Impasto Impasto techniques involve applying and building oil or acrylic paint into a thick layer. Impasto work retains the mark of any brush or implement used to apply it.

Line and wash The technique of combining pen-and-ink work with a thin layer, or wash, of transparent paint (usually watercolour) or ink.

Mask A material used to cover areas of a drawing, either to prevent marks from touching the paper underneath or to allow the artist to work right up to the mask to create a crisp edge. There are three materials used for masking – masking tape, masking fluid and masking (frisket) film.

Medium (1) The material in which an artist chooses to work – pencil, pen, pastel and so on. (The plural is 'media'.) (2) In painting, 'medium' is also a substance added to paint to alter the way in which it behaves – to make it thinner, for example. (The plural in this context is 'mediums'.)

Modelling Emphasizing the light and shadow areas of a subject through the use of tone or colour, in order to create a three-dimensional impression.

Negative shapes The spaces between objects in a drawing, often (but not always) the background to the subject.

Overlaying The technique of applying layers of watercolour paint over washes that have already dried in order to build up colour to the desired strength.

Palette
(1) The container or surface on which paint colours are mixed.
(2) The range of colours.

Perspective A system whereby artists can create the illusion of three-dimensional space on the two-dimensional surface of the paper.

Aerial perspective: The way the atmosphere, combined with distance, influences the appearance of things. Also known as *atmospheric perspective*.

Linear perspective: This system exploits the fact that objects appear to be smaller the further away they are from the viewer. The system is based on the fact that all parallel lines, when extended from a receding surface, meet at a point in space known as the vanishing point. When such lines are plotted accurately on the paper, the relative sizes of objects will appear correct in the drawing.

Single-point perspective: This occurs when objects are parallel to the picture plane. Lines parallel to the picture plane remain parallel, while parallel lines at 90° to the picture plane converge.

Two-point perspective: This must be used when you can see two sides of an object. Each side is at a different angle to the viewer and therefore each side has its own vanishing point.

Picture plane An imaginary vertical plane that defines the front of the picture area and corresponds with the surface of the drawing.

Positive shapes The tangible features (figures, trees, buildings, still-life objects etc.) that are being drawn.

Primer A substance that acts as a barrier between the support and the paints. Priming provides a smooth, clean surface on which to work.

Recession The effect of making objects appear to recede into the distance, achieved by using aerial perspective and tone. Distant objects appear paler.

Resist A substance that prevents one medium from touching the paper beneath it. Wax (in the form of candle wax or wax crayons) is the resist most commonly used in watercolour.

Sgraffito The technique of scratching off pigment to reveal either an underlying colour or the white of the paper. The word comes from the Italian verb *graffiare*, which means 'to scratch'.

Shade A colour that has been darkened by the addition of black or a little of its complementary colour.

Sketch A rough drawing or a preliminary attempt at working out a composition.

Solvent *See* Thinner.

Spattering The technique of flicking paint on to the support.

Support The surface on which a drawing is made – often paper, but board and surfaces prepared with acrylic gesso are also widely used.

Thinner A liquid such as turpentine which is used to dilute oil paint. Also known as *solvent*.

Tint A colour that has been lightened. In pure watercolour a colour is lightened by adding water to the paint.

Tone The relative lightness or darkness of a colour.

Tooth The texture of a support. Some papers are very smooth and have little tooth, while others have a very pronounced texture.

Torchon A stump of tightly rolled paper with a pointed end, using for blending powdery mediums such as soft pastel, charcoal and graphite. Also known as *paper stump* or *tortillon*.

Underdrawing A preliminary sketch on the canvas or paper, over which a picture is painted. It allows the artist to set down the lines of the subject, and erase and change them if necessary, before committing irrevocably to paint.

Underpainting A painting made to work out the composition and tonal structure before applying colour.

Value *See* Tone.

Vanishing point In linear perspective, the vanishing point is the point on the horizon at which parallel lines appear to converge.

Viewpoint The angle or position from which the artist chooses to draw his or her subject.

Warm colours Colours in which yellow or red are dominant. They lie in the red-yellow half of the colour wheel and appear to advance.

Wash A thin layer of transparent paint.

Flat wash: An evenly laid wash that exhibits no variation in tone.

Gradated wash: A wash that gradually changes in intensity from dark to light, or vice versa.

Variegated wash: A wash that changes from one colour to another.

Wet into wet The technique of applying paint to a wet surface or on top of an earlier wash that is still damp.

Wet on dry The technique of applying paint to dry paper or on top of an earlier wash that has dried completely.

Index

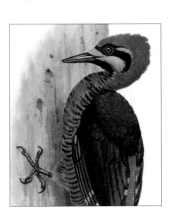